\mathcal{S}OTHEBY'S

GUIDE TO

AMERICAN

FURNITURE

PATRICIA P. PETRAGLIA
ILLUSTRATIONS BY CHRISTOPHER ULRICH

A FIRESIDE BOOK

Published by Simon & Schuster

New York London Toronto Sydney Tokyo Singapore

FIRESIDE
Rockefeller Center
1230 Avenue of the Americas
New York, NY 10020

Sotheby's Books
New York • London
Director: Ronald Varney
Executive Editor: Signe Warner Watson
Specialists: Leslie Keno, Senior Vice President, American Furniture
 Barbara Deisroth, Senior Vice President, Art Nouveau
 and Art Deco
 Elaine Whitmire, Vice President, 19th Century Furniture

Designed by Jennifer Dossin

Manufactured in the United States of America
10 9 8 7 6 5 4 3 2

Library of Congress Cataloging-in-Publication Data

Petraglia, Patricia, date.
 Sotheby's guide to American furniture / Patricia P. Petraglia;
illustrations by Christopher Ulrich.
 p. cm.
 "A Fireside book."
 1. Furniture—United States—Handbooks, manuals, etc. I. Title.
NK2405.P48 1995
749.213'075—dc20 95-321 CIP

ISBN 0-684-80681-9

*This book is dedicated
to the memory of those artisans,
whether known by name or yet to be discovered,
whose inspired designs and craftsmanship remain
an important legacy of our past
in the objects of beauty collectively called
American period furniture.*

\mathcal{A}CKNOWLEDGMENTS

In the eighteenth century, a cabinetmaker's finished product would have stood as proof of the incontestable communal effort put forth by carvers, gilders, or turners working alongside him. Like the furniture it describes, this book, too, is the product of many collaborative efforts. A special thank-you to Sotheby's department specialists Leslie Keno, Barbara Deisroth, and Elaine Whitmire, all of whom benevolently read this text and provided assistance along the way. And a big thank-you to Signe Warner Watson and Allegra Costa in the Marketing Department at Sotheby's. Signe assisted me in clarifying important points and warned me when I was in danger of becoming verbose. Allegra responded with great speed in requesting transparencies and negotiating through the maze of obstacles to reproduce images of American furniture. Lastly, thanks to the editorial and design professionals at Simon & Schuster, without whose efforts this text would not exist. For any errors that may have slipped by the watchful eyes of these dedicated individuals, I assume full responsibility.

\mathcal{C}ONTENTS

WHAT IS CONNOISSEURSHIP?

SOURCES

WHAT IS AMERICAN FURNITURE?

Look at any painting or print source depicting interior settings of the eighteenth or nineteenth century and it is highly conceivable that the male head of the household is seated at a desk engrossed in the analysis of his trade, or posed at a yet more imposing secretary-bookcase. Both objects symbolize references to or display attributes of his intractable business acumen. The mistress of the household sits at a small work table where—ever mindful of the small children at her feet—she attends to simple repairs known as plain needlework or practices "fancy" stitchery, the fine and delicate kind that was a calculated measure of refinement in a lady. These scenes of everyday life, while idealized snapshots, can tell us a lot about custom and usage. They remind those of us who grew up with central heating and lighting how—in the not too distant past—a singular room might house the simultaneous activities centered around the fireplace or close to a portable, and oftentimes temperamental, light source. We can see from these pictures that a small table might serve as a desk in one scene or function as a dining or tea table in another.

Examine the surviving furniture that was once a part of these settings and even stronger images or messages about period life may be laid bare. On a desk, for example, the small, black scorch marks that remain haphazardly embedded in the wood from a carelessly watched candle conjure up images of a bespectacled merchant laboriously reconciling his accounts long into the evening or of those bleak days when a natural light source was insufficient for the detailed nature of the task. As you look at the rich patina of the highly figured wood enhanced through years of wax and wear, or at the brass hardware reflecting candlelight, you may envision a warm, halo-like glow permeating the room from the proximity of the desk. Sit in the rigid-backed roundabout chair that was paired with the desk, and the uncompromising formality of the past will inevitably be revealed. Examine the legs on an old table. The slight imperfections found near the bottom are a gentle reminder of the constant abuse inflicted by the human foot. An auditory response may result from the image of a table being dragged across a bare floor as innumerable occasions demanded, and for which its portability was eminently suited. Feel the decorative treatments on these objects and you can sense in any carving the once-crisp edges that have now softened over time.

Surpassing its value as visual and highly decorative art or its usefulness as objects for storage, writing, dining, or seating, American furniture has left us with a legacy that makes so many powerful statements

about the past. Whether appearing alone or together, these objects are symbolic: a priceless indicator of economic prosperity, a barometer of social hierarchy, part of the paradigm of tradition versus change. Our furniture also reflects the technology of its era, and is part of a design continuum that is constantly evolving.

ECONOMIC PROSPERITY

A trip back to the first years on these shores provides an insightful look at the role of furniture as an indicator of economic prosperity. Indicative of the harsh environmental and economic challenges facing the earliest settlers to this country, furniture making initially took a secondary role. Settlers were concerned first with erecting honest, if not unadorned, shelter, mostly in the form of foursquare floor plans, steep pitched roofs, and exterior clapboard walls framing small casement windows. In the first half of the seventeenth century, furniture produced to supplement what limited artifacts arrived with the Pilgrims was scarce, but it was functional and sturdy, not unlike the determined character of our forebears as they faced the challenges of starting a new life in the colonies. Much of the earliest seventeenth-century furniture was assembled using the same pragmatic joinery that was employed in house building. As more dwellings were raised, and as settlers began to derive a livelihood from the soil, their most primitive requirements for food and shelter were met. In due course and with such settlement concerns addressed, housewrights could devote more attention to the craft of furniture making and its role as an indicator of economic prosperity. That craftsmen could spend increased time shaping furniture was an important turning point, for a large skilled workforce and division of labor were still years away. Consequently, the same individuals who were charged with erecting dwellings were often responsible for creating the furniture. This scenario changed gradually as the seventeenth century advanced, and a persistent influx of immigrants arriving during the Great Migration expanded what had previously been a slim workforce. As a result, by 1690, a large, sophisticated case, or storage form known as the cupboard, defined the embodiment of luxury for magistrates, ministers, or those of visible wealth, validating their status in the community. With its mathematical proportions, repetitive ornament, storage capability, and system of open shelves used to display imported ceramics and metal ware, it clearly separated the more well-heeled colonists from those of lesser means. The cupboard type set a precedent that established in perpetuity the large case form as an indicator of wealth throughout the centuries. For example, an ornate Victorian *étagère,* or open cabinet, popularized in the mid-nineteenth century bestowed on its owners the

same exalted status that its predecessor, the cupboard, did on colonists nearly two hundred years earlier.

SOCIAL HIERARCHY

In the seventeenth century, only the wealthy owned individual chairs with backs, and these were generally reserved for the male head of household or important guests. Most family members were relegated to backless seating forms known as joint stools or "forms" assembled by the straightforward and durable mortise-and-tenon method that kept these low-profile forms firmly rooted to the floor, a standard since the Middle Ages. With American furniture of the William and Mary period came the dovetail joint, a more sophisticated mode of assembling furniture based on a small joint in the shape of a dove's tail. It quelled the need for heavy oak panels to be butted or tenoned together and resulted in lighter components that, in turn, could be stacked to reach new heights.

The arrival in the colonies of this modern era of cabinetmaking, which was radically different from the joinery methods of the past, coincided with increased mercantile activities that fostered the desire and the means to replicate the fashionable goods found on far-flung commercial voyages. By the early 1700s, many enterprising colonists had reached a level of wealth and taste that made them the social and economic peers of their trading partners, assuring them that whatever was in vogue in London or elsewhere around the globe might soon be seen in their homes. Originating in the germinating era of cabinetmaking, the storage form known as the high chest, with its tall case, multiple-turned legs, and sophisticated choice of until-now-unused walnut and brass, was one of these objects of status and became shorthand for the latest in fashionable forms, materials, and ornament.

TRADITION VERSUS CHANGE

The Queen Anne style, which took hold about 1725, embarked on a radical stylistic departure away from the masculine character of earlier colonial designs. It was feminine and graceful, in sync with the ordered and classical designs of eighteenth-century interiors, and was based on the notably unified S-curve component borrowed freely from the prevailing architecture of the period. The sophisticated level of taste exhibited in a fully developed Queen Anne balloon-seat side chair with its tangible, sculptural body has more to say about late colonial elegance than a two-dimensional painting could hope to convey. This paradigm was also embedded some twenty years later in the New-

port Chippendale style in which patrons showed an affinity for the serene block-front case work of late Baroque inspiration at the same time that patrons in its sister city, nouveau-riche Philadelphia, expressed a preference for more curvilinear interpretations that were highly Rococo in feeling and conveyed a sense of movement. These two Quaker cities could not have expressed their preferences more differently, one holding on to the past, the other advancing the fashionable. The paradigm of tradition versus transition was explored once again in the styles of the Victorian period. The Rococo, Renaissance, Neo-Grec, and Egyptian revivals looked romantically back in time as if to soften some of the more disturbing realities of the Industrial Revolution by creating pastiches of earlier styles while the class of furniture known as Innovative simultaneously forged ahead in creating techniques, forms, and materials, bentwood and mechanically contrived pieces among them, that were revolutionary and in accord with the dynamic technological advances occurring at the end of the century.

SYMBOLISM

Furniture is also a logotype for important events in the history of the nation. Specifically, the emergence of the Federal style represented the iconology of America's evolution from a colonial dominion to that of an autonomous nation. The label *Federal* coincides with the formation of the new nation in the late eighteenth century and its central, or federal, government. This iconology was reinforced in the following Empire style, in which archeologically correct forms taken from antiquity suggested a symbolic alliance between America of the early nineteenth century and ancient Rome and Greece. An argument can be made that the Pillar and Scroll style, the final stage of Neoclassicism, was a metaphor for the democratic ideal, reflecting America's emerging self-direction in the arts after generations of designs that were dictated by English and European style centers. By this point, American cabinetmakers, including John Hall of Baltimore, were publishing their own pattern books, and as part of the democratic ideal, an increasing number of households were able to acquire the latest in fashionable goods.

TECHNOLOGY OF THE ERA

Technological innovation is another important theme that can be examined in objects of everyday life—furniture. The impact of technology inherent in a vast amount of Victorian furniture, for example, led to the fabrication of new materials such as compounded *papier-mâché*

and prompted standardization of many components turned out by a growing network of specialized machinery. Certain types of ornament, including incised lines and lacy arabesques once exclusively performed by hand, could now be discharged by machine at a faster pace. Resulting manufacturing efficiencies, such as lower overall production costs and finished products delivered on shorter schedules, were developments that helped bring a certain degree of style or fashion to middle-class homes. Prior to this, the concept of fashion had mainly been the exclusive privilege of the affluent style setters who acquired "bespoke" or custom-made pieces from individual cabinetmakers.

A DESIGN CONTINUUM

The entire scope of American furniture can be viewed as moving along a continuum in which one style gently transitions into the next. The progression of the cabriole leg with a simple pad foot on Queen Anne designs that evolved into a cabriole leg with a fancier claw-and-ball terminus in the Chippendale era is one example of this continuum. Another shift can be observed in the movement from the Federal style to the designs of the Empire. Light-handed Neoclassical ornament applied to spare, contemporary forms was deemed outmoded by full-bodied, archeologically correct models. These are just several snapshots of the range that characterizes American furniture. Arts and Crafts furniture that flourished at the eclipse of the nineteenth century came full circle, then seemingly began the process all over again by employing the honest, durable construction afforded by the mortise-and-tenon joint that, together with the simplified adornment, was a hallmark of seventeenth-century design.

These are just a handful of the reasons why American furniture has and will continue to appeal to us. Any prospective collector will have other, more personal motivations for wanting to learn about the objects of America's past. You may find that an object resembles one owned by family or friends. Another individual may respond to what he or she believes to be an inherently effectual design. Others may be drawn to an object's purely aesthetic charms focusing on the sculptural quality of a turned leg or on the life-like rendering of the carving. Whatever the varied reasons that impel us to commit to these objects of beauty collectively called American furniture, we are acquiring an item that we hope has utility, but beyond that, we are purchasing a beguiling commodity to which an indelible piece of history is attached. Part of this important history embraces a tangible form that can be analyzed in terms of its style, which leads to the purpose of this book. This text will identify characteristics of the major styles that govern American furniture from the seventeenth to the early-twentieth centuries. They are: Pil-

grim (1640–1690); William and Mary (1700–1730); Queen Anne (1725–1755); Chippendale (1755–1790); Federal (1790–1815); Empire (1815–1840); Pillar and Scroll (1830–1840); Gothic/Elizabethan Revival (1830–1865); Rococo Revival (1840–1870); Renaissance, Neo-Grec, and Egyptian Revivals (1860–1885); Innovative (1850–1900); and Design Reform (1870–1915). The text has the twofold mission of introducing you to the forms, materials, and ornament of each of these styles and exploring the attendant issues of connoisseurship, authenticity, valuation, purchase, and care, arming you with enough information to enter an unfamiliar marketplace with confidence.

For purposes of this book, the term *style* means having formal, identifiable characteristics that enable an object to be classified in terms of a specific time or period, location, or design by a person or group. These attributes are sufficiently recognizable against a standard or parameter that applies to the style in general. In the decorative arts, *style* is synonymous with *fashion*. Many historical accounts of colonial life, for example, used the label *fashion* when describing the latest in domestic fixtures. A style is considered a major movement. It can be introduced at different times and with regional variations in many locations depending on the distance from the major style center, also known as the location where the design began. Style centers are also those areas where the style reached a level of sophistication before migrating to new locales. In colonial America, cities such as Boston, Philadelphia, New York, and Charleston were major exchange points for English designs, and the further a location was from these major style-transfer points, the greater the regional variation was likely to be. Connecticut pieces, for example, are often regarded as idiosyncratic versions of the high-style pieces found in Boston.

Our tradition in furniture making theoretically began with the arrival of the earliest settlers, who started piecing together wide boards to form chests to hold what limited artifacts they owned. But where did this tradition begin? Not in a vacuum, because the earliest settlers were concerned with maintaining aspects of the material culture they left behind. The original period styles that we recognize today as American germinated beyond these shores until the late nineteenth century. Consequently, American furniture reflects the design of the locations from which its makers emigrated, notably England and the Continent. These styles migrated to America in essentially three ways: (1) through imported objects; (2) through immigrant craftsmen, whose designs and assembly methods migrated with them; and (3) through imported pattern books that served to keep Americans abreast of the latest English and European fashion as it evolved. By the eighteenth century, cabinetmakers, together with carvers, looked to pattern books that sketched the latest design characteristics coming from Europe. Included were both furniture forms and ornament, which guided Ameri-

can artisans in their own creations. Some pattern books grew out of the tradition established by architectural manuals that laid out building plans and decoration. Furniture design, which was often directly influenced by the shared principles of proportion and symmetry found in architectural work, was well suited to a book format that presented so many variations in an expeditious and cost-effective manner.

The amount of time it took for these English and Continental stylistic influences to reach the colonies varied. In the mid-seventeenth century, for example, time lags of twenty years or more were not uncommon. Delays in transmission began decreasing significantly with the proliferation of pattern books in the eighteenth century, but any attempt to correlate American stylistic intervals year-for-year with their forebears is impossible. In addition to pauses in transmission, American styles are more complex than their antecedents, because they are alternately named after a monarch, as was European custom, or after a cabinetmaker or a specific movement (i.e., Queen Anne, Chippendale, or Neoclassical, respectively). An interesting fact in American furniture history is that many style names commonly in use today were never part of specific period vocabulary. Most labels for the early colonial styles, for example, were coined later in the nineteenth century as America's interest in collecting furniture of the past began in earnest. Consequently, as you progress through this text, bear in mind that individual stylistic periods do not always conform to the historical events for which they were named, nor were they produced exclusively during a specific time span. Rather, style dates are meant to pinpoint a particular interval in which the style may have predominated and to differentiate the original period style from any revivals that may have followed.

Many styles of American furniture overlapped, and pieces with mixed attributes from more than one stylistic period are sometimes labeled *transitional* or *retardataire*. These terms describe new forms that adhere to dated ornamental details or components, or old forms that incorporate advancing ornament. Transitional is often the name used if the more updated features prevail while *retardataire* is the marker for objects in which more of the dated or passing details are noted. Keep this in mind as you begin to look at examples firsthand. Pieces of American furniture mix traits for various reasons. Designers may have been just beginning to work out the characteristics of a new style or a patron may have expressed a preference for a more dated feature. Cost was sometimes a factor: The price of an updated or fashionable feature was one some consumers were unwilling to pay. While this conflation of traits can make style identification more challenging, it is not impossible. One way to avoid the confusion in labeling that may arise with furniture of this type is to date an object by its most recent feature. To illustrate this point, consider a chair that has simple pad feet, first seen on Queen Anne chairs, from 1725 to 1755, a pierced splat

(the pattern formed from the interaction of solid and void space in a chair back) and scrolled ears (the juncture where the crest rail or horizontal element at chair top meet the upright members of the back), which are Chippendale features prevalent from 1755 to 1790. One can determine that the chair must be a product of the Chippendale era, the period with the chair's most recent features. Assuming that construction technique and materials follow period practice, the chair can be dated from 1755 to 1790, and may be more narrowly pegged within that range by other attributes such as general construction technique, carving, or supporting documentation.

While furniture in this book will be examined in light of its English and Continental ancestry, it can further be described as the output of a talented and perceptive group of artisans who eschewed certain European forms and decorative dogma in favor of integrity of form and a decorative vocabulary that appealed to the more restrained eye and pocketbook of an American clientele. For colonial aesthetes, to dress one's home in furniture that was a design "late of London" was equally important as dressing one's person; furniture was a meaningful measure of a family's good taste. Historical accounts of the Rococo edict, which was heralded as "the modern French taste," cite it as the most up-to-date fashion or style in colonial America in the mid-eighteenth century. In European society royalty dictated fashion, whereas American versions were from the outset less elitist and less ostentatious. The resulting designs, whether fairly close renderings or highly idiosyncratic restatements of their antecedents, are what make these objects so appealing, and ongoing research continues to turn up heretofore undiscovered objects and printed ephemera that undoubtedly inspired American designs. Using two heterogeneous derivative styles as examples, American furniture can also be termed derivative in its return to certain design standards. The Rococo Revival of the mid-nineteenth century, although different in scale and temperament, pays homage to the original Rococo style of the mid-eighteenth century. And the rebirth of oak and mortise-and-tenon joinery in the 1900s in the designs of Gustav Stickley finds its precedent in the furniture of the seventeenth century. Many other comparisons can be made between historically dissimilar styles.

The style chapters that follow are arranged chronologically to afford readers the historical background in which the style developed and the dates when it predominated; the design elements that identify the style, including forms, materials, and ornament; an introduction to some of the cabinetmakers or firms significant to the style's development; regional variations where appropriate; and a summary that reinforces salient points. Since space will not permit the analysis of every piece of furniture in a given period, three distinct forms that comprise the majority of household furniture will serve as proxies for the style in

general. They are: (1) case forms, or box-like objects meant to hold textiles and household or personal possessions; (2) seating; and (3) tables. Using these three forms, one can easily learn to identify objects such as bedsteads or looking glasses made in the same style. In the style chapters, important examples held in public collections are noted in parentheses where appropriate, so that a beginner can seek them out for the important information they convey about a particular style in terms of overall design, material, workmanship, or authorship. The following three forms are illustrated below to help you get comfortable with some of the terminology that will appear throughout this text.

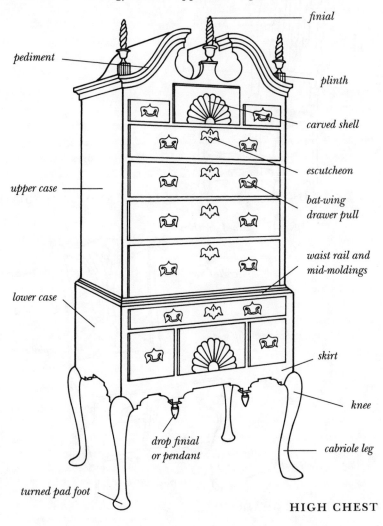

finial

pediment

plinth

carved shell

escutcheon

bat-wing drawer pull

upper case

waist rail and mid-moldings

lower case

skirt

knee

drop finial or pendant

cabriole leg

turned pad foot

HIGH CHEST

21

Through the inclusion of Victorian and early twentieth-century styles, this text is acknowledging a trend in collecting that extends beyond what many American furniture aficionados have long regarded as an arbitrary stopping point for collecting—objects produced before 1830. As the late 1980s witnessed the price escalation in Queen Anne,

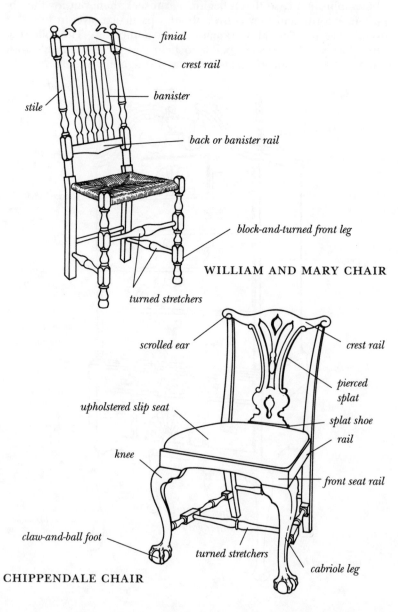

finial

crest rail

banister

stile

back or banister rail

block-and-turned front leg

WILLIAM AND MARY CHAIR

turned stretchers

scrolled ear

crest rail

pierced splat

upholstered slip seat

splat shoe

rail

knee

front seat rail

claw-and-ball foot

turned stretchers

cabriole leg

CHIPPENDALE CHAIR

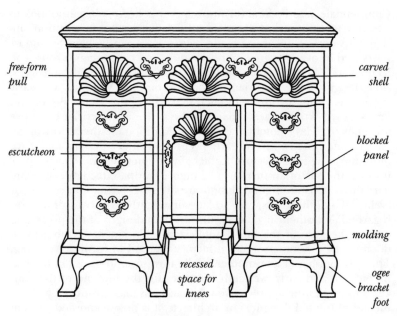

free-form pull

carved shell

escutcheon

blocked panel

recessed space for knees

molding

ogee bracket foot

BUREAU TABLE

BUTTERFLY TABLE

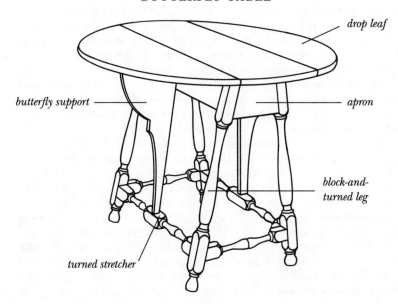

drop leaf

butterfly support

apron

block-and-turned leg

turned stretcher

Chippendale, and Federal furniture, many collectors began to look to late nineteenth-century wares for affordable design. In addition, authentic American furniture made before 1830 can be hard to find or burdened by overly aggressive restoration, and consequently some collections have begun to focus instead on the more affordable and accessible designs of the Victorian period and beyond. Victorian and early twentieth-century furniture by such makers as John Henry Belter and Frank Lloyd Wright have expanded the genre of American furniture for many of today's potential collectors. Additionally, the historical impact of late nineteenth- or early twentieth-century designs may have more meaning for collectors of the baby-boomer generation who grew up with the Victorian furniture of their grandparents. Last, the standards that constitute good design are always evolving and somewhat cyclical. Until the 1980s, mid- to late nineteenth-century furniture was regarded as aesthetically less significant than designs of the preceding century because of the much-publicized replacement of the artisan-designer by the impersonalized factory method of furniture making. This is somewhat of a misnomer. While furniture produced in the late nineteenth and early twentieth centuries for the low end of the market is often of little appreciative value and was mass produced without the aid of trained designers or architects, it is now acknowledged that there were still cabinetmakers and artisans working during this time frame who produced handsome and vigilantly crafted objects for a select clientele. There are Design Reform pieces in the Anglo-Japanese style made by Herter Brothers, for example, or architect-designed furniture by Frank Lloyd Wright and Greene and Greene that rival the best of eighteenth-century works. Some collectors recognize in these designs an attractiveness and purity of form that make them compatible with today's more contemporary settings. In this text, it is some of these cultivated pieces that will shape the discussion of furniture produced in the second half of the nineteenth century. Pieces made after 1830 represent an expanding genre in terms of connoisseurship and scholarship as experts begin to reach a consensus for the criteria by which this furniture should be evaluated and collected.

With the goal of providing insight into the artistic diversity of American furniture from 1640 to 1915, only the formal period styles are discussed in this book. As a reminder, the formal period styles emanated out of large style centers and are considered major movements. The craftsmen working in this arena were part of an established furniture profession that followed imperatives laid out by the trade, maintaining high-style production standards suitable for property-holding and moneyed patrons. By contrast, furniture that grew out of a vernacular or regional tradition was usually practical and unassuming, made for a less affluent consumer, and not associated with the strict cabinetmaking systems of the major style centers. Makers of this second type of

American furniture were often not trained as cabinetmakers, nor were they likely to be employed in the trade full time. The resulting designs were often derived more from ingenuity and know-how than from a formal, rigidly stylistic approach. Many of these designs were successful and warrant our attention. They are highly sought after today by a national collecting audience. However, because vernacular furniture is closely linked to the folk-art market, any analysis of American furniture other than the formal styles—including such diverse genres as Windsor, Shaker, and Pennsylvania German—is better suited to a discussion of the folk-art genre. Collectors interested in this type of furniture, tagged with various labels—country, folk, primitive, or regional—are encouraged to seek out many of the sources devoted to these more colloquial styles.

The issues of connoisseurship, authenticity, valuation, purchase, and care are equally important considerations for all collectors, whether they are novices or more seasoned antiquarians. The American furniture market is a complex one, and there is more demand than ever on the part of buyers to obtain maximum value for their money. This text, following a systematic approach, will help you learn the guidelines used by seasoned collectors, scholars, and dealers to determine what separates a mediocre example of its kind from a masterpiece. Something as simple as using the "squint test" to eliminate excessive detail and let the underlying form project so that the overall success of the design can be judged is just one example of how you will learn to evaluate furniture. By analyzing such critical factors as design, quality, rarity, provenance, and historical importance you will be on your way to grasping what makes one object sell for two, five, or ten times more than another. The last decade has seen demanding criteria applied in regard to repair, restoration, and refinishing, issues that figure solidly in any analysis of authenticity and value. These topics will be explored and are intended to help you prepare a plan of action for entering the marketplace, assured that the object you have selected is stylistically the best you can find and afford. It is hoped that you will use this book as it was intended—as a guide that you will turn to repeatedly as you begin to explore the functional, artistic objects of our history.

SEVENTEENTH-CENTURY/PILGRIM FURNITURE (1640–1690)

When the Pilgrims arrived on the Eastern seaboard in the seventeenth century, they brought with them a strong desire to uphold the traditions and material culture they had left behind. Early cultural life in the colonies was a microcosm of European tradition, and American furniture, originating from this culture, reflects the form and ornament of English sources in New England and in the South. Pieces made in the New York area, on the other hand, often carry strong Dutch characteristics, based on the immigration patterns that prevailed in the region. This influence is especially notable in seventeenth-century storage devices: The cupboard was derived from English sources while the *kas* or *kast* was a large wardrobe that the Dutch immigrants in the New York area re-created after models in their homeland. With a persistent influx of immigrants trained in the styles of their homelands, American furniture continually evolved from European sources until the end of the nineteenth century.

The skilled craftsmen of England and Europe who regularly emigrated to the New World erected houses from a bounteous supply of oak. These homes were raised from hardy timbers held together by the mortise-and-tenon joint, which was to have tremendous implication for furniture design. The technique of mortise-and-tenon joinery was a pragmatic one. Simple to execute and a successful method of joinery proven over hundreds of years in Europe, it was easily incorporated into the practice of furniture making in the colonies. Scant seasoning

of woods was necessary in mortise-and-tenon construction since the joinery allowed for some shrinkage. In the seventeenth century, this proved important to immigrants concerned with the immediate task of erecting a house and building some of its furnishings.

The first immigrants to arrive in this country were primarily of modest means, and the craftsmanship reflected in their furnishings underscores a practical simplicity. But it is in no way crude. Pilgrim furniture serves as testimonial to our forebears' efforts to re-create certain aspects of their material culture while eschewing superfluous European design prerequisites in favor of practicality.

Seventeenth-century Pilgrim furniture was constructed of squared, rectilinear forms not unlike the framework that prevailed in early colonial houses. Sturdy, useful, and made of the indigenous woods oak and pine, much of this furniture was made in the regions that became Massachusetts, Connecticut, Rhode Island, and New Hampshire. Pieces from the New York area and the South survive in fewer numbers partly because these regions were often the hotbeds of political strife over many generations. Consequently, furniture was subjected to the same fate that befell other forms of personal property during international and civil confrontations. It should be generally noted, however, that the surviving quantity of Pilgrim-era furniture from all regions is exceedingly small for reasons that include the ravages of time and climate. Additionally, recent scholarship has enabled scholars and collectors to better distinguish seventeenth-century furniture from reproductions or fakes, leaving even fewer genuine articles.

American Jacobean is one term applied to Pilgrim furniture of this period. The term is derived from the Latin name for *James*. James I (1603–1625) was the ruling monarch of England when the first settlers set out for America. As patrons of the arts, royalty often shaped the style in European society. Traditionally, English furniture is named after the monarch who reigned when a style emerged or was popularized, and this English custom generally persisted in the colonies. Categorizing all Pilgrim furniture as Jacobean, however, is shortsighted as the earliest colonial furniture has its origins not only in English Jacobean work but also in an eclectic mix of Anglo-Flemish and Italian Renaissance design elements. In colonial versions, these disparate influences resulted in a cupboard that borrowed the large bulbous turnings of Flemish origin and the mathematical proportioning and repetitive carving that are hallmarks of Renaissance design. For these reasons, the more general term *seventeenth-century furniture* is currently preferred when describing furniture of this time frame since it is less restrictive and acknowledges multiple influences.

These manifold design elements were transmitted to the colonies in essentially three ways: by immigrant craftsmen; by importation of actual

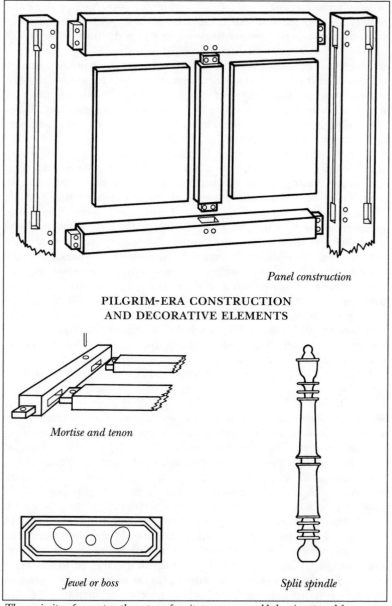

Panel construction

**PILGRIM-ERA CONSTRUCTION
AND DECORATIVE ELEMENTS**

Mortise and tenon

Jewel or boss

Split spindle

The majority of seventeenth-century furniture was assembled using panel-frame construction and the sturdy mortise-and-tenon joint. A turner was responsible for creating the decorative split spindles and "bosses" or "jewels" that were painted black in simulation of ebony and then applied.

objects; and less often, by pattern books. While there is scant evidence that pattern books influenced seventeenth-century furniture, in the ensuing years pattern books would come into wide use, narrowing the time it took for English and Continental design influences to reach the colonies.

Furniture makers of this period were known primarily by the process they employed: They were either joiners or turners. Joiners produced the solid, durable forms that originated in medieval England. Chests, trestle tables, joint stools, and settles fit into this category. Many of these objects were constructed by piecing together wide boards, often with a mortise-and-tenon joint. A mortise hole was cut in one piece of wood, and a tenon, or tongue, was shaped to fit into the mortise. Another hole was drilled through the joined parts to hold a peg or dowel, securing the joint formed at ninety-degree angles.

Turners, on the other hand, were craftsmen who turned wood on a lathe, a woodworking machine that holds and rotates the material about a horizontal axis against a shaping tool. Their output consisted mainly of "stick" furniture, or pieces made entirely from turned members. Turners were also responsible for making the decorative spherical balusters, such as tapered, split spindles and bosses, or oval "jewels," that provided the decorative surface ornament on case pieces. These turned ornaments helped offset the rigid appearance of objects constructed by the mortise-and-tenon technique. Although few examples survive today, much of this ornament was painted black to simulate the exotic ebony that might have been found on an expensive court-level piece in England. Colonial ingenuity was already at work, transforming an agrarian piece of maple or ash into a product that approximated ebony.

Turned decorative elements are especially prevalent on Pilgrim case furniture dating from 1660 onward. Many of these pieces display the precise proportions, geometric partitioning, symmetrical and repetitive carving, and large, bulbous turnings that are the hallmark of Renaissance-inspired furniture of Anglo-Flemish derivation. As previously mentioned, the form and ornament of the massive cupboard is the best example of this influence.

Carving, the process of decorating by cutting designs or figures, was another decorative technique that moved seventeenth-century furniture beyond its value as functional objects. Seventeenth-century carving was not limited to wood (rare carved headstones exist), but it is in wood that most examples survive. Designs were executed on patterns laid out with a compass or marking tool. Representational subjects were rarely executed in wood. Instead, foliate patterns prevailed—the Tudor rose, the tulip and leaf, and the sunflower. Additional stylized motifs included strapwork patterns resembling medieval hammered-iron elements.

CASE WORK

While raw materials were abundant in the seventeenth century, a large, skilled workforce and attendant division of labor were not. Consequently, the same joiner who erected the house was equally likely to have had a hand in making the furniture. In order to understand the nature of seventeenth-century case pieces, it is helpful to examine two of the period's prevailing forms—the chest and the cupboard—and follow the process from concept to design.

CHESTS

Chests made from six wide boards nailed together were the most economical colonial storage devices, because they required little skilled la-

Seventeenth-century chests like this Pilgrim-era oak and pine example from Boston were generally heavy and firmly rooted to the ground.

bor to assemble. This type also made productive use of the ample supplies of lumber that had long since disappeared in Europe. An alternative to the six-board chest, a joined chest was a form that is central to the ensuing discussion of chests. On a joined chest, the rails (horizontal elements) and stiles (vertical elements) made up the frame and were cut with grooves to hold the panels of the body. Mortise-and-tenon joints held the pieces together. This technique is known as panel-frame construction. Based on the European tradition of the dower chest, or *cassone,* these joined chests were the primary household storage device in the seventeenth century, acting as repositories for the family's most esteemed possessions. The top of the chest had a hinged lid for ease in storing larger items such as textiles while drawers in the base made of inch-thick oak boards held smaller items.

By approximately 1650, complex factors were already at work that were to affect furniture design. The phenomenon of regionalism took hold whereby styles were adapted in slightly individual forms in different regions. Regionalism developed in response to the disparate training of the craftsmen and the style centers from which they emigrated. It was also a response to subtle and not so subtle economic, religious, and political differences. One economic influence, for example, was that fashion followed trade routes; mostly English ships reached the New England seaports of Boston and Newport while Dutch ships were likely to carry their goods to a New York destination. These trading patterns played a part in determining which goods were available in a region. Nowhere are these differences more vividly evident than in the chests from the Connecticut River Valley.

SUNFLOWER CHEST

The area around Wethersfield-Hartford, Connecticut, was home to a chest known for its distinctive tulip and sunflower carving. Peter Blin of Wethersfield has been credited with the sunflower design. Scholarship has pointed out that the sunflower is probably a stylized marigold, the traditional flower of the Huguenots, whose influence on colonial designs arrived via England. Made mostly from oak, this form is generally dated between 1675 and 1710. This single object illustrates the seventeenth-century practices of joinery, turning, and carving. Sunflower chests feature joinery and panel-frame construction, usually have one or two drawers, and stand on four short legs. Distinctive features include clearly defined panels of low-relief carving contained within the boundaries of the panels. These carved panels were often conceived as two outside panels of stylized tulips with wavy petals and leaves and one center panel of sunflowers. Bosses and spindles made from softer woods stained black to simulate ebony were supplied by the turner and applied to the front of the chest for additional decoration. The overall design of the sunflower chest is linear and vertical.

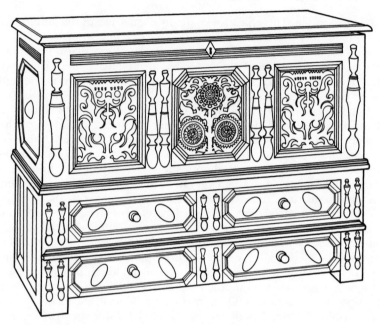

Usually dated between 1675 and 1710, the sunflower chest from the Wethersfield area of Connecticut showcases joinery, turnings, carving, and painting. The three inset panels with low-relief carving would have been painted with red, yellow, or blue-black paint while the applied spindles and bosses would have been painted black to suggest ebony.

HADLEY CHEST

The Hadley chest, named for the Connecticut Valley area surrounding Hadley, Massachusetts, is the product of makers John Allis, Samuel Belding, and their adherents. In construction technique and material, the Hadley chest shares some of the features of the sunflower chest: Oak is the primary wood, and both rely on panel and frame design. The Hadley chest distinguishes itself, however, because it is taller, even more severely linear, and usually a chest over one or more drawers. It is also different in the carving type and placement. Carving on the Hadley chest is a meandering motif, representing leaves, vines, and miscellaneous geometric forms. It is flatter than that on the sunflower chest, and its format is believed to have originated with a closely knit group of artisans who learned their craft in northern England. Hadley chests are usually dated between 1675 and 1720.

The carving meandering over the front surface of the Hadley chest is not rigidly contained within panels as it is on the sunflower chest. The Hadley chest usually displays no applied ornament. Instead, visual interest was created by a coat of paint. This emphasis contrasts with the

fact that sunflower chests rely on all three treatments—paint, carving, and applied ornament. Very few Hadley chests—or sunflower chests, for that matter—survive with their original painted surfaces; many were stripped early in the twentieth century when Pilgrim-era furniture was subjected to overly conscientious refinishing. In their original state, however, panels on Hadley chests were accented with red, yellow, or blue-black paint.

DENNIS-SEARLE CHEST

A chest that best underscores the influence of house building on furniture design is a third type from the Ipswich area of Massachusetts. This chest is rectangle shaped and made of oak panels and frames held together by the mortise-and-tenon joint. It is part of a celebrated group of works dating from approximately 1670 to 1700 attributed to Thomas Dennis and William Searle, who both worked in the Ipswich area. Known as a Dennis-Searle chest, the attribution is based largely on the carving technique that the two Devonshire-trained artisans first learned in England. When dismantled, this chest is a complex assem-

The extremely flat carving on this Massachusetts chest, circa 1685, bears a close resemblance to hammered metal, also known as strapwork, a decorative practice with origins in medieval designs.

blage of carefully notched and fitted pieces. So exact was the fit between parts that each piece was scored with a Roman numeral to ensure the correct sequence of assembly. The practice of scoring parts was borrowed from the practice of house raising, during which individual elements were often cut and hewn at one location, then transported to the building site. This safeguard helped to assure the correct assembly process in what was often a communal effort.

The distinctive scrolled surface carving on a Dennis-Searle chest is reminiscent of medieval metal strapwork, and its curves work to soften the rigid lines of the object's stark form. The overall pattern borrows motifs from nature, geometry, and architecture, yielding a result that often resembles patterns on a Gothic stained-glass window. Vivid coats of paint in tones of red, yellow, and blue-black once worked to add depth and definition to the painstakingly rendered carving. Some examples show traces of the carvers' scribe lines, notations used to lay out the design on the front panels.

Many chests of the period lack side panel ornament, which tends to support the argument that these chests were meant to be viewed frontally. Furniture in seventeenth-century houses was usually placed around the perimeter of the room. This contrasts with modern furniture arrangement in which pieces are often placed in the center of the room or on a diagonal, exposing additional sides. Seventeenth-century craftsmen always practiced economy of labor; superfluous effort was not expended where it would not be noticed. The chests described so far parallel medieval form and ornament in their planar, flat, and horizontal design. Some of these chests could double as seating or, due to portability, function as luggage. The decorative elements, notably the strapwork-inspired carving on the Dennis-Searle chest, further suggest a medieval vocabulary at work.

CUPBOARDS

Seventeenth-century houses were sparsely outfitted, but many households owned chests of the type described heretofore. Only the very wealthy, however, could afford a cupboard, the most expensive and ornate piece of furniture. The cupboard, the other definitive case piece, was a luxury reserved for those of high professional standing in the community, such as magistrates and ministers, or for those of ample fortune. The cupboard went beyond the utilitarian function of storage. It was a showpiece of affluence, used to display costly imported "plate" made up of delft, stoneware, or pewter, luxuries that were alien to families of modest means.

In the history of design, underlying form is often more advanced than ornament, and consequently some cupboards carry carving ves-

tiges indicative of the older medieval style that has been imposed on a Renaissance form. Strapwork-inspired carving on the cupboard form would be an example of this treatment. From an aesthetic perspective, the most successful cupboards employed both symmetrical and geometric carving as well as Renaissance form and proportion. How the maker worked out these factors led to distinctive regional traits. Even

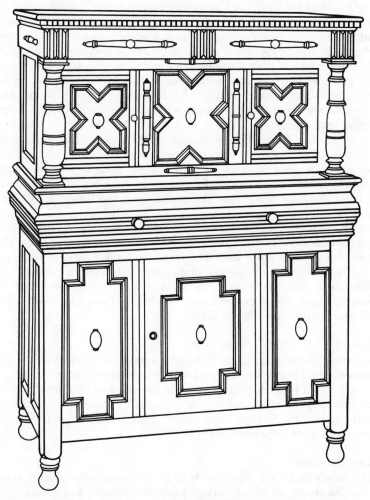

An object of status, the large-scale mathematical proportions evident on this press cupboard were derived from Renaissance principles. The applied spindles, bulbous turnings, and small applied bosses or jewels were the product of a turner who formed their shapes on a lathe.

within New England, cupboards varied in conjunction with the same influences at work in chest design—skill level of the maker, religious and political differences that may have influenced the amount of decorative overlay, and matters of personal taste.

Paint was used to provide the element of visual surprise, setting up areas of light and dark. This implies that the craftsmen who fashioned these pieces were remotely conversant with the fine-art concept of *chiaroscuro* as taught by the European masters. A dark coat of paint contrasted with naturally light oak or pine for climactic effect. Relative to other seventeenth-century forms, these storage pieces were the largest objects in the house. Renaissance concepts of proportion and scale that broke with medieval tradition figured in their design: The top of the case had a direct mathematical relationship to the bottom, and the ornament was symmetrical and proportionate to the form it adorned. Based on surviving examples, some makers understood these concepts better than others.

By nature of their enormous size, cupboards became permanent fixtures, thus dispensing with the concept of portability that typified the genre of medieval furniture. The cupboard was dependent on the straight line for its underlying form, and the form was decidedly more vertical than the dower-type chests known as the sunflower, Hadley, and Dennis-Searle chests. Exuberantly turned balusters, spindles, and bosses painted in imitation of ebony took on a sculptural quality and suggested a sense of movement on an otherwise unyielding form. The resulting product was a study in contrasts—swollen ornament affixed to a flat body, smooth surface juxtaposed with textural carving, and light versus dark colorways. These massive cupboards, some nearly five feet high and four feet wide, were assembled from oak, maple, and pine, and date from 1680 to 1700.

COURT AND PRESS CUPBOARD

In period usage, a cupboard housing a cabinet with doors above and an open shelf below was called a court cupboard. The term *court* aligns closely with a form that was popular in Europe and used for the same purpose. A press cupboard was equipped with cabinets on top and on bottom. In New England, the mostly English settlers preferred the court and press cupboard forms.

KAS OR *KAST*

The New York area, settled mostly by Dutch immigrants, preferred another form, the *kas* or *kast*, a large press or wardrobe. Even more vertical and linear than New England court and press cupboards, the *kas* has a strong architectural underpinning. It was built of heavy, often raised panels and topped with a large overhanging cornice.

The Dutch population of New York was not regulated by the various

sumptuary laws that governed the Puritan lifestyle of New England. Consequently, New York storage forms show an affinity for abundant ornament both inside and out. The Dutch always favored the floral motif, and whether rendered in paint or carving, it is prevalent on New York case pieces that capture the look of high-style European equivalents. Another popular treatment for this form was intricately carved and raised inset panels.

The interior of the *kas* might have been enhanced with delft tile, ceramics, paintings, and even textiles, all stylistic preferences of the European Low Countries from which the craftsmen hailed. Floral painted models were rendered in a monochromatic palette known as *grisaille,* or tints of gray, intended to mimic the high-relief carving on expensive European models. In the continuing seventeenth-century tradition, most *kasses* or presses were built from oak and pine. They are customarily dated from about 1650 into the first decade of the eighteenth century.

SEATING

Early in the seventeenth century, if a family had chairs, they were reserved for the head of the household or for distinguished visitors. Other family members were relegated to stools and benches in long-standing European custom. In the chronology of seating, forms progressed from simple benches and stools to individual chair forms. Chairs, therefore, occupied a unique place in the domestic interior. Toward the end of the century, chairs were produced in larger quantity, and it was common practice for a well-heeled family to have a set of six, twelve, or eighteen chairs. These were placed around the perimeter of a room when not in use and moved about as situations demanded.

SETTLE

The settle, or wooden bench, was a box-like structure with a high, solid back and arms and infrequently a wooden hood. It was made from pine, maple, and less frequently, from oak and walnut boards, all of which were solid to the floor. It served double duty as a storage device for its foundation sometimes contained a hinged seat over a box. Larger models also served as informal room dividers.

The high enclosed back of the settle was perfectly suited to the seventeenth-century house. Houses were riddled with drafts, and period usage often found the settle placed before the hearth. Employing this form settles were made from the end of the seventeenth century right through the middle of the nineteenth century. Dating a single piece, therefore, is a challenge for even the most experienced scholars.

With the exception of the rush seat, this "stick" chair from New York or northern New Jersey was fashioned entirely from turned members. Chairs of this type are judged primarily by the quality of the turnings.

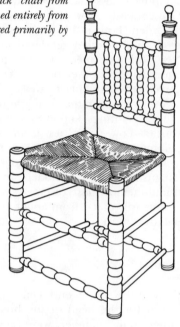

JOINT STOOL AND FORM

Lowest in the hierarchy of seating are the simple joint stool and the "form." The joint stool is the most ancient of all seating types, having appeared in antiquity. Sturdily constructed of oak or pine planks resting on simple turned legs, its value was indispensable. Its key features were portability and the flexibility to serve as a table if necessary. Women and children were most apt to use them, as chairs, if available, were reserved for the male head of household.

A "form" was basically a horizontally extended joint stool. Following the guidelines of earlier medieval models, most forms stood on outwardly splayed legs that provided strength for the object. They were used in conjunction with long, joined trestle tables. With the increasing production of chairs toward the end of the century, the joint stool and form began to lose favor. Few American examples survive today, evidence of the heavy usage they received.

The most common seating forms of the Pilgrim era have not survived. It appears that much of what remains of seventeenth-century seating forms once belonged to influential figures, many of whose names are now associated with specific forms. Brewster and Carver chairs are two forms fitting this description. A turner was responsible for creating both types.

BREWSTER CHAIR

The Brewster chair, named for one in the possession of Elder William Brewster of the Plymouth Colony, was made of four upright-turned members with vertical spindles beneath the arms and seat. The four upright members make up the foundation or body of the chair and typify the four-post construction process that results in a severely square form. The aesthetic appeal of a Brewster chair is enhanced by a finely turned set of spindles, which project a gentle rhythm that off-

An example of a "stick" chair, this version has the characteristic mushroom-turned finials on the front stiles and the bobbin-shaped finials on the rear stiles that accentuate seventeenth-century examples. A model of this type with spindles only on the back is called a Carver chair.

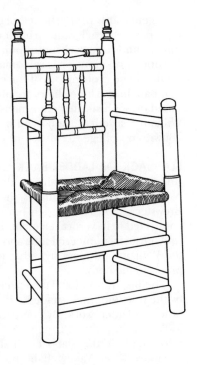

sets the overtly linear and vertical stature of the form.

CARVER CHAIR

Carver chairs, named after one in the home of Governor John Carver of Massachusetts, share similarities, such as four-post construction, with the Brewster chair. Unlike the Brewster, however, Carver chairs have turned vertical spindles only on the back of the chair. Stretchers, consisting of crossbars placed horizontally between the legs to strengthen the chair, are void of the spindles below the seat and arms that appear on Brewster chairs.

Dated from the 1620s through the last quarter of the seventeenth century, both types were erected from turned ash, maple, hickory, or elm. Seats were made from boards or plank, rush, or splint. Alternate names for these chairs include stick chairs or thrown(e) chairs, having been constructed from members that had been thrown on a lathe.

The distinguishing features of Brewster and Carver chairs are the turnings, often the only characteristics that distinguish the work of disparate artisans. Well-turned mushroom finials on the front stiles, sausage-turned armrests, or bobbin finials on the rear stiles provide clues to the maker's skill as a turner.

WAINSCOT OR GREAT CHAIR

Larger than any other singular seventeenth-century seating form, the imposing oak wainscot chair was a product of the joiner. The term *wainscot* is derived from the Dutch *wagenschot,* or a prime grade of oak that was found originally in Russia and Germany. It was brought to Holland where it was thereafter shipped to England and other European countries. The reference to the term in colonial chairs is simply a coined one since colonial examples relied on an indigenous supply of oak to build these chairs. They are also known by the term *great chairs.*

A generously proportioned plank seat softened by a down cushion, a high-paneled back, and ornament that often included carved dates, initials, and strapwork motifs point to symbols of authority. Many recall European religious or ceremonial chairs inspired by models from antiquity, some evolving out of the marriage of a seat attached to wooden wall paneling. These chairs are almost exclusively associated with men. Based on sophisticated craftsmanship and detailed carving, the name of William Searle has again been linked with the most intricate example (Bowdoin College Art Museum) to be found in the colonies.

SLAT-BACK OR LADDER-BACK CHAIR

Another Pilgrim-era chair was the slat-back or ladder-back chair from New York. The chair utilizes the same four-post construction of the Brewster and Carver models but it differs in the chair back, where it is connected to its vertical elements or stiles with horizontal slats. The slats, which usually numbered four and as many as six in the taller versions of the William and Mary style that followed, lend a more horizontal emphasis to the body.

The inspiration for slat-back chairs is decidedly Dutch as evidenced by the thin and finely shaped slats and the flange turnings of the finials noted in Dutch work. By comparison, the Brewster and Carver chairs took their inspiration from provincial English models. The greatest development of the slat-back chair was found in eighteenth-century Delaware River Valley chairs born of the earlier type. The slat-back chair eventually evolved into one with characteristically pronounced turnings and thinner, taller, and narrower proportions.

CROMWELLIAN OR FARTHINGALE CHAIR

Another chair, an armless type, served a practical purpose: It accommodated the full clothing (farthingale hoop dresses) of the period without constricting the sitter. It is thought that the armless form found its way to the colonies from England via Spain and Holland during the short period (1649–1660) of Puritan domination under Oliver Cromwell. These chairs are known by both names—Cromwellian and farthingale.

This chair is rectangular in shape with a clearly defined open space between the back and seat that was filled in by a large cushion. Maple, oak, and occasionally walnut were the primary woods used in its construction. Most farthingale chairs were simply turned. However, a select group were artful assemblages of twisted wood with rippled surfaces. These were referred to as "twist turn'd." American chairs of this description date from the last quarter of the seventeenth century, increasing in popularity into the 1680s, especially in the Philadelphia area. Some farthingale or Cromwellian chairs were horizontally elongated into couch form.

Cromwellian chairs marked a turning point in chair design, one that separated them from their contemporaneous models. The appearance of fixed upholstery indicated a concern for comfort, a notion that was missing from most seating forms to date. Upholstery complemented the decoratively simple form, which consisted of a rectangular back separated from a square seat. Leather was one type of covering used on these chairs. It was stretched tautly over a filling of grass or wool pile. The verticality of the chair is outlined by brass nails, often referred to as "rose-headed" after the shape of the hand-forged tapered sides.

Turkey work, a jewel-colored knotted pile fabric, was used as upholstery on some Cromwellian chairs. This busy geometric fabric was woven in England in imitation of Near Eastern rugs and was a luxury used to make bed hangings, cushions, or turkey-work "carpets" that adorned tables. Chairs with original turkey-work surfaces are extremely rare due to the fragile nature of the textile. Its preciousness was recognized in the period, with some turkey work passing through families as a treasured heirloom.

TABLES

Seventeenth-century living arrangements often included several generations of a family. This fact, coupled with a lack of central heating, often forced families together in several rooms. The principal room in the Pilgrim household was multifunctional; it was common for a large family to perform multiple activities simultaneously in one room, often known as the hall, which was a throwback to the medieval great hall. A chair that could be converted to a table by tilting down the back on which the top was attached was the ultimate utilitarian object. Chair-table is the name given to this dual-purpose form that performed as a table when the top was down and as a chair when the top flipped up. A simple oak stool formed the basis for this object, and a small drawer beneath the seat provided essential storage space in an era when chests were frequently in short supply.

TRESTLE TABLE

The tables that fit the Pilgrim pattern of living were of pragmatic design. Using simple joinery, knockdown tables and trestle tables could be easily taken apart by lifting off the tabletop board or slab and by removing those members that held the frame together. Oak, maple, and walnut were used in their construction. Ornament on these tables was nonexistent; refinement came in the form of chamfered legs and rails, all parts that have experienced softening or rounding over hundreds of years.

TILT-TOP TABLE

Another type, the tilt-top table, had a top that pivoted to an upright position. Period usage called for these tables to be stored with their tops in a vertical position against a wall when not in use. In the seventeenth century, they were ideally suited to modest houses due to their space-saving feature when the top was tilted up. Like trestle tables born of medieval design, they are marked by simple, unadorned oak or pine bodies. When the social craze of tea drinking arrived in the colonies in the early eighteenth century, however, the character of these tables was to change. They became highly decorative, and utility, while important, assumed a secondary role in relation to ornament.

FOLDING TABLES

Starting about mid-century, folding tables emerged as an alternative. They were as simple as a model with one leg and as complex as a table with twelve legs. If the legs have stretchers, the table is generally classified as a gate leg; swing-leg tables are those without the stretcher connecting the legs and typify the tables more popular in the eighteenth century. Walnut was the favored material for these space-saving tables and when fully extended the solidity of the large, round top resulted in an interesting contrast with the attenuated turned legs. A particularly luxurious version with finely turned balusters or spindles was often draped with a crisp white linen cloth or turkey work.

*J*UMMARY OF STYLE

Dates: 1640–1690
Distinguishing Features: generally heavy proportions; mortise-and-tenon joint; square rectilinear forms; low-relief carving; split spindles; applied bosses or jewels
Materials: oak, pine

COLLECTOR'S TIPS

1. *Look for (good example):* successful turnings and in-place joinery
2. *Look for (outstanding example):* successful integration of form and ornament, which is especially notable on large court and press cupboards
3. *Problems/what to watch out for:* Due to its age, some seventeenth-century furniture has been heavily restored. Feet and lids on chests are common sites of repair. Total replacement of parts is not favored. Applied ornament including bosses and split spindles are often newer replacements and can be mistaken for the original. Most painted surfaces are not original. A good deal of Pilgrim-era furniture was heavily restored in the 1920s and 1930s when collectors sought to make these pieces "like new."
4. *Conservation issues:* Maintain constant temperature and humidity as one way to protect seventeenth-century furniture. Avoid aggressive refinishing that strips away old surface.
5. *Cabinetmakers/firms important to style:* Peter Blin, John Allis, Samuel Belding, Thomas Dennis, and William Searle
6. *Where public can see best examples:* Metropolitan Museum of Art, New York, New York; Boston Museum of Fine Arts; Wadsworth Antheneum, Hartford, Connecticut; Winterthur Museum, Wilmington, Delaware; Chipstone Foundation, Milwaukee, Wisconsin; Yale University Art Gallery, New Haven, Connecticut
7. *Department expert wish list:* wainscot or great chair; Brewster chair; court or press cupboard; Hadley or sunflower chest
8. *Miscellaneous:* The universe of authentic seventeenth-century furniture is exceedingly small. Collectors must be vigilant about seeking professional advice, especially where large sums of money may be involved. Caution is the watchword.

\mathscr{W}ILLIAM AND MARY FURNITURE (1700–1730)

Early in the eighteenth century, increased trade with London continually stimulated colonial interest in English and European style and fashion. Further, large groups of emigrating craftsmen inevitably affirmed that a product seen in London would eventually be available on these shores. In matters of commerce, mercantilism took hold in America.

As settlement woes lessened, colonists began to map out the structure of their society. People became more astutely aware that their homes now reflected their social status. Houses began to take on a symmetrical and orderly comportment, which was a natural outcome of the logical thinking that marked the period. Formal interior architectural paneling was introduced, and fashionable homes counted among their contents porcelains, silver, and textiles, all luxuries of Europe and the Orient.

The William and Mary style progressed from two distinct themes. The first one can be traced to the simultaneous convergence of multiple stylistic influences from around the world, including simulated lacquer, spoon-backs, veneering, and gyrating serpentine forms. The second leitmotif aligns with the development of a new system of joinery known as the dovetail joint. Both themes were to effect radical changes in furniture design and construction. The evolution of the dovetail joint significantly marked the beginning of the modern age of cabinetmaking, an age in which designers cast aside antiquated medieval and Renaissance forms.

Instrumental in inducing sweeping stylistic changes were William III of Orange, ruler of Holland, and his English wife, Mary Stuart. They moved from the Dutch to the English throne in 1689 after the Glorious Revolution of 1688. Joining them were Dutch and Huguenot craftsmen who spawned a revolution of their own in furniture design,

forever linking England and the Continent. These artisans helped synthesize the dominant stylistic influences of the era that included components emanating from such far-flung locales as Portugal, Holland, Italy, France, and from an even more mysterious location—the Orient. Portugal and Holland were centers of world trade with overseas empires, and the trading companies they sponsored were partly responsible for introducing elements of Oriental design to European furniture through their commercial activities. Contributions from Italy and France grew out of a larger body of work known as the Baroque. The Baroque movement was a design mandate that emphasized drama and exaggeration in form and decorative embellishment, a progression that moved away from late Renaissance dogma. It developed fully by 1620 in Italy, and under the demanding direction of Louis XIV in France, it was immortalized.

While in the employ of William and Mary, Daniel Marot, the French Huguenot architect, introduced the richness of Baroque treatments to England. The style gained momentum in England, ultimately surfacing in the early 1700s in what is today called colonial William and Mary furniture. The Baroque style came to European centers during a period of vast political and economic changes, and its arrival in America was no less propitious. Historians have suggested that the arrival of the William and Mary style in the colonies marked a shift in power from the potent Puritan oligarchy to members of the merchant class who had strong ties to England. An additional name given to furniture of the William and Mary style is early Baroque, although this label is infrequently used in American nomenclature.

The American strain of the William and Mary style is recognized by elaborate turnings, high-relief carving, elongation, and contrasting surfaces. It often retained the flat, rectilinear forms of earlier Pilgrim works, but new to the period were the elements of restrained movement and vertical emphasis that softened the strongly masculine attributes of the earlier style. A new form, the tall chest or highboy, still resembled a box-like structure or cabinet, but its exuberantly turned base with shaped stretchers lent this case piece a totally different personality.

Old systems of construction were discarded. The assembly process was now entrusted to the accomplished hands of a cabinetmaker. The long-standing tradition of joining and pegging oak panels within frames was no longer applicable to the thinner and more attenuated William and Mary pieces, which necessitated a new system of joinery. Cabinetmakers, as distinguished from simple joiners, discarded the mortise-and-tenon joint in favor of the more sophisticated dovetail joint, which joined boards at the ends with interlocking tenons in the shape of a dove's tail. This lighter construction technique ushered in designs that literally reached new heights.

Sophisticated style centers were able to duplicate a high-quality dovetail joint. Other more provincial craftsmen turned out immature

versions, perhaps a drawer with one large crude joint instead of the multiple, finely cut dovetails that typify high-quality work. Dovetailing revolutionized the way furniture was put together and fostered cabinet-making practices that continue in use today. Changes in the division of labor were occurring as well. Due to the complex interaction of a new construction technique that in turn brought about the process of veneering—as well as new guidelines for turning and carving—objects were no longer turned out by a single artist working from start to finish.

In the lexicon of William and Mary furniture, carving became almost sculptural. Following the general trend toward exaggeration, chairs grew in height, and painstakingly carved scrolls adorned them. Some chairs had caned seats and curved "spoon" backs, two influences from the Orient. Decorative turnings joined in the thrust toward robustness; trumpet, vase, and bun shapes prevailed. Serpentine X-shaped stretchers intensified the sense of movement. The technique of veneering, a labor-intensive method of cutting, fitting, and gluing thin decorative strips or sheets of wood onto a solid surface or carcass, was the preferred method of enhancing decorative effect. Inlaid strips of contrasting grains often outlined these strips, guaranteeing areas of light and dark.

Japanning, another type of surface ornament, simulated Oriental lacquer. The term was coined to explain the Western interpretation of the Oriental technique. The process, which dates to Eastern antiquity, found its way to Europe in the 1600s and, ultimately, to North American shores in a modified version in the 1700s. Oriental lacquer work is the art of coating the surface wood with varnishes that are then dried in heated chambers. In the Western process, animal, figural, or floral

DOVETAILS ON DRAWER SIDE

The introduction of the dovetail joint marked the beginning of the modern age of cabinetmaking. This joint, in the shape of a dove's tail, did away with the need to butt or mortise and tenon together heavy panels. As a result, furniture made with dovetail joints was lighter and taller than its seventeenth-century predecessors.

motifs were built up on a painted body with gesso (a mix of chalk, whiting, glue, and water that acts as a primer) and gilded or silvered.

William and Mary furniture made abundant use of imported brasses (furniture hardware including drawer handles), which prior to this date were absent from colonial furniture. Imported from England, these brasses were crafted into drawer pulls and escutcheon plates (backing drawer pulls or surrounding keyholes). Their inclusion helped reflect light, important to households that had just discovered the light-reflecting quality of the looking glass.

Along with the dovetail joint came another important shift in the selection of materials. Walnut became the wood of choice. It was easily carved, and its beautiful grain could be polished to a lustrous finish. Nature provided the variations in color and burl, but cabinetmakers extrapolated these traits, cutting from burl or roots to produce rippling surfaces that moved the eye. William and Mary furniture ushered in the age of walnut, although maple and pine occasionally substituted as a primary wood. Maple and pine, however, were more likely to make up the secondary woods in a piece, which are not usually visible when a piece is fully assembled. When used as a secondary wood, maple and pine were chosen for their structural and cost-conscious qualities rather than for their aesthetic merits. As was the case in the seventeenth century, the notion of economy of labor and materials prevailed.

In a departure from European tradition, there were no formal guilds in the colonies to oversee the work of craftsmen. Instead, the colonies favored an apprenticeship program. Some locales enacted regulations governing this trade. Apprenticeships in Boston and New York, for example, were set at four and seven years, respectively. This paternalistic system helped to foster regional practice, since apprentices worked in the manner of the shop in which they trained. Young teenage boys worked under the supervision of a master craftsman. When objects were assembled, the division of labor was set up so that the cabinetmaker pieced together a carcass or chair, turners supplied the shaped legs, stretchers, and balls, and carvers supplied the ornamental C-scroll crests. Upholsterers supplied textiles, and even more important, became purveyors of taste in the domestic interior. Since colonial workshops were not as rigidly controlled as those of European guilds, there was no single standard that applied to all workshops. Some shops were large enough to house all operations; others relied on journeymen or day laborers for skills such as carving that they lacked.

Swept up in the tide of economic activity that marked the early-eighteenth century, furniture making grew from a cottage industry to part of a larger mercantile economy in the cities of Boston, Newport, New York, and Philadelphia. Rural areas acknowledged these changes. But due to the time lags inherent in disseminating a style and its distance from major style centers, rural New England—like the provincial areas

around London—reproduced the underlying forms of European style but continued to simplify urban embellishment or decoration.

CASE WORK

HIGH CHEST

In the age of cabinetmaking, furniture makers were no longer the same individuals who built houses. Continuing waves of immigrants, "late of London," provided an abundance of skilled labor to interpret designs from around the globe. One of the latest fashions, the high chest, supplanted the prestigious cupboard as the object of status in the eighteenth-century home.

The dovetail joint presented the cabinetmaker with more freedom of design. Consequently, materials were used more effectively, since the cabinetmaker could frame drawers and chests of thinly sawed pine and veneer the surface with a more expensive wood. Veneering is the art of using wood or other materials for their color or markings. It is accomplished by gluing a thin layer of decorative wood to a thicker backing. Dovetail construction further encouraged the stacking of lightweight drawers and eliminated the need to butt heavy boards together to create a case. Compared to seventeenth-century drawers, which were often made of inch-thick oak, William and Mary drawers were considerably thinner. Chests were taller than their seventeenth-century counterparts, and their carcasses were infinitely lighter.

The high chest of drawers, with its exaggerated Baroque-inspired turned legs, often challenged the tenets of sturdy design. The high chest, or highboy, as it is often labeled today, had a top geometric section or case. In New England, a high chest with a carcass of maple and maple-and-walnut curled veneer was common. Its composition consisted of an architectural cornice resting on a square form of drawers that were graduated in size. Molding outlined the drawers, visually offsetting the richly patterned and veneered surfaces. Additional molding was applied where the top case met its base or frame. The two-part components made it easier for the chest to be moved. Models from around 1700 had a single horizontal drawer as part of the base while high chests dating from about 1720 onward often had multiple drawers in the base.

The arched skirts and ornately turned legs in the form of trumpets, cups, or vases were the obvious traits that supplied a feeling of restrained movement. Thin beading often delineated the arches, making the most of this curvature. These arches were transition points between the horizontal emphasis of the top and the vertical character of the turned legs. In a carefully thought-out design, stretchers con-

necting the legs followed the curve of the skirt and provided a small level of support to the vulnerable legs. Small bun feet connected the horizontal stretchers at the floor.

The early eighteenth-century practice of veneering assured that the surface of the New England high chest was inescapably its most dramatic design statement. The path that colonial veneering took was a practical response to the rich, often decadent surface treatments that typified European Baroque design. Many of these patterns resembled seaweed or tortoiseshell, recalling boulle work, an ornamental treat-

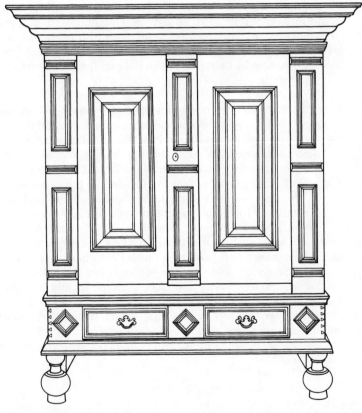

Even larger than its New England counterpart, the cupboard, this kas *from the Hudson River Valley, would have appealed to the mostly Dutch inhabitants of the New York area. The large overhanging cornice and inset panels created a heavy architectural emphasis and were stylistic preferences of the European Low Countries from which its maker originally hailed.*

ment named for André-Charles Boulle (1642–1732), the *ébéniste,* or French cabinetmaker, who worked under the patronage of Louis XIV. He is credited with introducing inlays of brass, pewter, ivory, and mother-of-pearl to wood or tortoiseshell.

The veneer process was well suited to flat surfaces; conversely, turned components were painted to mimic the veneer or were ebonized. The decorative painting on William and Mary chests mimicked japanning. Due to the especially flat quality of the paint and the lack of a gesso undercoat on some colonial examples, this type of decoration is decidedly more in tune with *trompe l'oeil* painting than with the Oriental technique. Most of these painted chests, dating from about 1700 to 1725, are indicative of a provincial or vernacular aesthetic that unites masculine form with delicate painting. Highly figured maple-and-walnut veneers added an element of depth and movement that earlier chests achieved only rarely with paint and carving. Imported brasses or hardware—often in the shape of a teardrop— was a conservative novelty that deferred to the highly figured surface.

REGIONAL VARIATIONS
Regional traits became even stronger. A high chest from the New York area was interpreted differently. Its format was more geometric, and it had a relatively plain surface compared to its New England counterpart. It is wider and rigidly contained, and straight bands of light-colored inlay define the graduated drawers. Since a highly figured surface was not standard in New York, the eye tends to rest on the surface polishing, which brought out the wood's inherent qualities. Brasses and escutcheons had a more prominent role to play as they did not compete with heavily figured veneers. Legs and feet on New York examples are generally more flared and less rounded than those on New England chests.

Eastern Massachusetts and coastal Connecticut chests were essentially squared boxes with swelled bun feet that offset an inherent linearity. As for ornament, coastal Connecticut examples still displayed the tulip and vine motif, whereas eastern Massachusetts works showed an affinity for foliage and representational or architectural ornament. These motifs were rendered with paint, which contrasts with the treatment used on earlier seventeenth-century chests on which the motifs were usually carved.

LOWBOY

Another form, the dressing table, or lowboy as it is classified today, was a companion piece to the high chest. Its coordinated arrangement with a high chest made an even stronger statement of status. The dressing table was a short profile case of drawers that stood on turned legs,

many of the trumpet variety. Outfitted to hold toiletries and jewelry, some dressing tables were equipped with a separate device, usually in the form of a small standing mirror to assist the grooming process, but these fragile components have not survived. A standard arrangement called for two deep drawers flanking a shallow center drawer. Square tops were common, as were arches across the apron and small drop pendants, which followed English examples. Rare models had canted-corner tops. Small imported teardrop brass pulls were attached to the drawers.

CHEST OF DRAWERS WITH DESK

The William and Mary period witnessed for the first time the integration of the writing part of the desk with its base. Prior to this point, small portable hinged boxes held on the lap or used on top of chests or dressing tables served as a writing surface. The new form, an integrated desk with base, is called a chest of drawers with desk. The writing surface came in the form of a slant top that opened over a base with drawers. The French *escritoire,* or writing desk with drawers and pigeonholes, probably served as the inspiration for the integration. The term *scriptor* was sometimes used in this country to describe the form, a bastardization of French terminology.

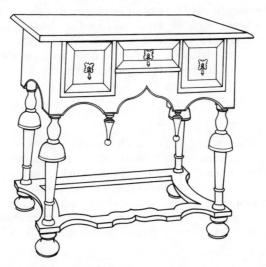

Trumpet- and vase-turned legs, drop finials on the apron, and arched or scalloped stretchers help define this lowboy, or dressing table, as William and Mary. Many lowboys were made as companion pieces to high chests, from which they have become estranged over the years.

51

The slant-front desk marked the integration of the writing compartment and its base for the first time. The teardrop drawer pulls are typically found on case pieces of the William and Mary period.

With the exception of its box-like shape, this slant-top desk with drawers was highly sophisticated compared to the primitive portable desk boxes that were in service since the Middle Ages. The writing desk with drawers was another form that acknowledged the design latitude afforded to cabinetmakers by dovetail construction.

SEATING

During the William and Mary era, chairs represented the largest component of the intracolonial furniture trade. This marked a complete metamorphosis from the previous decade, when most people still used backless stools for seating. Following the imperative of Baroque design, chairs took on a leaner and taller look than their seventeenth-century predecessors. The slender, vertical proportions, turned members, and carved surfaces epitomized an early Baroque philosophy.

FLEMISH SCROLL CHAIR

Stylistically, chairs adopted regional quirks, but most were heavily influenced by English examples. Certain organizational prerequisites

were standard. Primarily formed from maple painted black, these chairs had turned front and rear stiles (vertical members of sinewy and block form) and turned horizontal stretchers, caned seats, and caned insets in the back, which were distinct from the rails. Tall backs were usually topped with carved crest rails, sometimes repeating the pattern in the bottom rail.

The strongest Baroque blueprint in chairs can be seen in the art of carving. The Flemish scroll was especially popular: The C-scroll, the lower curve, is separated from the reverse C-scroll, the upper scroll, by a ninety-degree angle. Daniel Marot, the French Huguenot architect and designer, is often cited as the father of this fluid and detailed carving style. A boulle protégé, he was one of many talented artisans who followed William and Mary to England.

The appearance of caning coincided with growing trade with the Orient and the fascination that eastern exotica held for Anglo-colonial cultures (lacquer or japanning, porcelains, and tea were other manifestations). Most Flemish scroll chairs used cane in their designs. In the process of caning, woven split strips of Asian rattan are incorporated into the chair seat and back, substituting for leather, wood, or other textiles. The finest cane chairs combined a Baroque form with an Oriental material to create graceful forms that set up interesting contrasts of solid and void.

The front legs of the Flemish scroll or cane chair ended with the Spanish foot, although the foot's origin was Portuguese. A gentle sloped and ribbed foot, it has a forward-curling bottom. It is alternately known as the paintbrush foot, so called for the carved ribs that resemble the bristles of a brush. Distinguishing a colonial cane chair from its English precedent can be difficult because of their strong stylistic similarities, but as a rule, colonial versions tend to be less ornate.

BOSTON CHAIR

Compared to the gratuitously carved Flemish scroll chair, the Boston chair (its period name) was simple. It was the most ubiquitous of the William and Mary seating forms, produced in assembly-line fashion in large quantity and shipped throughout the colonies. This tall leather-upholstered chair of painted wood lacks the carving that earmarks chairs of the scroll type. The back was fashioned from plain stiles, and the crest rail is markedly more modest.

Turned legs end in Spanish, double ball, or scroll feet. The space between the stiles was partially filled in with a back. Toward the end of the period, Boston chairs began to incorporate a rounded or spoon back, a feature of Chinese origin that began to anticipate the

This ubiquitous seating piece in the William and Mary period formed the basis of the furniture trade in Boston; hence its period name, the Boston chair. One arrangement called for brass tacks to secure leather upholstery on a painted wood frame. Paintbrush feet occasionally substituted for the simple ball feet shown here.

approaching Queen Anne style. A stalwart of Boston's furniture trade, the chair was made well into mid- century.

Painted maple frames—and rarely bare wood frames—had leather-upholstered backs and square seats, following in the tradition of earlier Cromwellian types. The taller proportions and Spanish feet, on the other hand, are elements of Baroque composition. Double rows of brass-headed nails held down the leather and made up the only applied ornament.

BANISTER-BACK CHAIR

The banister-back chair of coastal New England demonstrates a provincial quality compared to the advanced spoon back found on a Boston chair or the stylish ornament on a Flemish scroll chair. The banister back had a back made from vertical-turned banisters or balusters. Finishing details include a carved cross rail and a turned stretcher. The narrow vertical spindles are suggestive of balusters that were used in staircases, forming a link between the decorative art of the period and its architecture.

Even with its provincial appearance, the banister-back side and "elbow," or armchair, bespeak many Baroque imperatives, namely tall proportions, turned four-member construction from maple, scrolled carving of flat projectile, and crested tops. These chairs flaunt provincial idiosyncrasies, with the coastlines of New Hampshire, Massachusetts, Connecticut, and New York serving as centers of manufacture.

The Stratford, Connecticut, area turned out a version of the banister-back chair that is known as the heart and crown chair after the motif on the crest rail. The shop of Thomas Salmon is one of several credited with this motif. Other economical versions of the banister-back chair used rush for the seats in place of the costlier imported cane. With the exception of the banisters, these chairs had the same

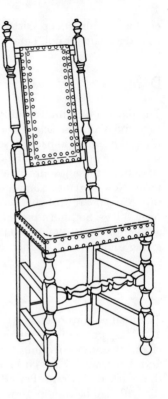

Attenuated proportions and lean turnings on this William and Mary side chair, New York, circa 1720, are in marked contrast to the heavy and weighted forms of Pilgrim chairs of a decade earlier.

skeleton as other William and Mary chairs. The most discriminating feature of the group appears in the carving of the crest, and scholars often look there first in determining regional attribution.

GAINES CHAIR

One chair form that portends the coming Queen Anne style enjoyed popularity from about 1710 to 1730. It has a stylized splat and crest and a sculptural silhouette. Often made of ebonized maple, the turned frame aligns with other banister-back chairs, except that it substitutes one wide and flat vase-shaped splat in the chair back for the multiple vertical members of other banister backs. Sweeping ram's head hand rests and Spanish feet add Baroque drama. Popular in eastern Massachusetts and New Hampshire, this form is attributed to the Gaines family of Portsmouth, New Hampshire, a cabinetmaking group that served clientele in the region.

CORNER CHAIR

Roundabouts or corner chairs were an unusual form used at desks and card tables. They are also referred to as writing chairs. An invention of the William and Mary period, the somewhat awkward-looking chair has one leg in front, one in back, and one at each side. The back is a horizontal rail that has been bent or rounded to accommodate the sitter's back. Corner chairs made in the early 1700s had no splats between the seat and rail while later models added wide splats for a measure of comfort. Many of these chairs were originally

equipped with a deep skirt and an easily removable slip seat that concealed a chamber pot. Later collectors often removed the pot.

DAYBED

The daybed or armless lounge chair was designed for daytime repose. Like today's *chaise longue,* the daybed had a back that was canted or tilted. The seat and back on some examples were made from cane, and some were upholstered. Standing on six to eight multiturned legs and stretchers, these low-profile couches set up interesting geometric patterns. New England examples rivaled their English equivalents, replete with carved crowns and scrolls, foliage, and bulbous blocked-and-turned legs. Southern models often regressed to the sturdier mortise-and-tenon construction methods of the past and had less carving, giving them a much plainer demeanor.

EASY CHAIR

The dual notions of comfort and luxury that flourished in the William and Mary period found their best expression in the upholstered easy chair, a century-spanning form still made today. Overstuffed maple-and-pine-frame chairs covered in a wide range of fabrics had "wings" that warded off drafts. Period inventories pinpoint their placement in the bedchamber, where those of ill health or advanced age could seek the warmth that a partially enclosed chair provided.

The easy chair signaled a dramatic shift in the furniture trade that elevated the status of soft goods. Upholsterers sold imported textiles, selected bedding and window treatments, and served as general purveyors of design. Upholstery fabric made from plain-twilled or fancy-patterned wool had to be imported since fabric mills were not yet operational in the colonies. Regional traits in the easy chair usually appear in turned bases, seat and crest profiles, and the shapes of arms and wings. A Massachusetts easy chair, for example, is recognized by multiple turnings in the stretchers, double-rolled arms, a raked back, and a scalloped front skirt under the seat.

TABLES

William and Mary tables were classified by the function they served: dressing tables, side tables, and candlestands. Walnut was a favorite choice in most areas while fruitwood and gumwood were sometimes favored for pieces in the New York area.

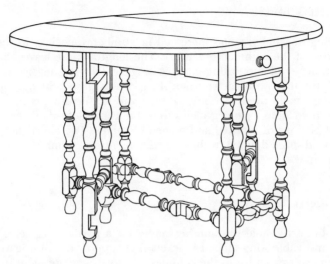

(top) When closed, the gateleg table saved space as it could be stored against a wall according to eighteenth-century custom. When opened, however, the multiple turned legs on this William and Mary example set up interesting contrasts between solid and void space.

(bottom) This highly portable table with butterfly supports under the leaves was a popular form in Connecticut. The out-curved legs help break the cube-like confines of earlier seventeenth-century tables.

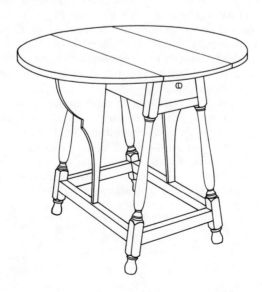

GATELEG TABLES

Folding or gateleg tables increased in number, especially in the first quarter of the eighteenth century. The length of the leaves dictated the number of supporting gates. A single-gateleg or tuck-away had a small top that swung down when the gate was closed. Such pragmatic features made these portable tables requisite furnishings in smaller households. Most gateleg tables were built with legs that were artful combinations of blocked and turned elements. The alternating solid and void space defined by these arrangements was a unique feature of the period.

BUTTERFLY TABLE

The butterfly table was another name for a particular gateleg table with moveable wing-shaped brackets that support the oval leaves. Although not exclusive to the colonies, the form was prevalent in Connecticut. The butterfly table stands on outward-slanting turned legs that break from the cube-like configuration of earlier seventeenth-century tables.

STRETCHER TABLE

Compared to gateleg tables, stretcher tables are considered a simple form. With the exception of a shallow drawer under a slab top, they have no moving parts. The stretcher table takes its name from the horizontal stretchers close to the floor that brace the legs. Oval-top tables of this form were usually paired with splayed, turned legs while square tops were likely to be affixed to a rectangular base with blocked and turned legs. The simple ball or the more decorative paintbrush foot were options for either form.

Of the many regional variations in table design in the early eighteenth century, the most notable features are: baluster and cup turnings, sharply scrolled legs, and serpentine stretchers in New York or New Jersey; butterfly supports in New England; cup and trumpet turnings separated by reels, and noticeable spaces between drawers in Pennsylvania. Unevenly sized adjacent drawers are also a fixture of some stretcher tables from Pennsylvania and the South.

\intUMMARY OF STYLE

Dates: 1700–1730
Distinguishing Features: dovetail joint; sculptural, high-relief carving; tall
 proportions; contrasting surfaces; japanning; veneering; elaborate
 turnings; bun and paintbrush feet; teardrop pulls
Materials: walnut, maple, pine, lampblack, gesso, gilt

COLLECTOR'S TIPS

1. *Look for (good example):* sophisticated turnings; tall proportions, es-
 pecially in case work and chairs; matched veneers
2. *Look for (outstanding example):* above qualities plus authentic period
 japanning; well-formed dovetail joints and "lightness," compared to
 Pilgrim-era pieces
3. *Problems/what to watch out for:* Due to compositions that often
 paired a heavy case with a base built of thin, multiple-turned legs,
 bases are often a weak spot, and many have been heavily restored or
 replaced. Many japanned pieces purporting to be eighteenth-cen-
 tury work were not painted in the William and Mary period but
 later in the nineteenth century. Due to their age, pieces often have
 replaced hardware, which collectors should be alert to. Repairs to
 feet are common, and large amounts of veneer replacement or re-
 pair can devalue a piece significantly.
4. *Conservation issues:* A veneered surface needs a stable temperature
 environment; wide fluctuations cause the veneer to lift away from
 the body and split. Japanned pieces require special attention since
 the surface is difficult to repair once it is damaged.
5. *Cabinetmakers/firms important to style:* Edward Evans, Philadelphia;
 the Gaines family of Ipswich, Massachusetts; Samuel Clement, New
 York. Current scholarship is working toward identifying additional
 names associated with the William and Mary style in the colonies.
6. *Where public can see best examples:* Metropolitan Museum of Art,
 New York, New York; Boston Museum of Fine Arts; Wadsworth An-
 theneum, Hartford, Connecticut; Winterthur Museum, Wilming-
 ton, Delaware; Yale University Art Gallery, New Haven, Connecticut;
 Colonial Williamsburg, Virginia; Philadelphia Museum of Art
7. *Department expert wish list:* gateleg table, highboy, or dressing table.
 These were popular forms in the period and continue to be highly
 sought after today. Although rarely found, original materials such as
 turkey work or leather upholstery command a premium.

\mathcal{Q}UEEN ANNE FURNITURE (1725–1755)

Prosperity and greater leisure time were just two outcomes of the ever-widening mercantile economy. Colonists also sought intellectual stimulation to a greater degree than they had in the past. A thorough grounding in architecture was both intellectually stimulating and a necessary component of a good education. Out of this arose a new-found respect for such long-standing ideals as proportion and the classical orders. One way colonists became enlightened about these concepts was through the use of imported architectural books, whose principles had a dual influence on both building and furniture design. Englishman William Salmon, for example, published the architectural manual *Palladio Londinensis: or The London Art of Building* in 1734, and in 1740, the first edition of *The City and Country Builder's and Workman's Treasury of Designs* was published in England, eventually becoming available to colonists. Along with housewrights and others engaged in the building trade, cabinetmakers sought guidance from the principles outlined in these books as well as in countless others. Many of the greatest colonial residences from the discordant areas of Boston, South Carolina, and Pennsylvania were built during this period.

Gradually, the exaggerated, heavy C-scrolls and bulbous turnings that characterized William and Mary furniture gave way to the refined, graceful, and sublime curvature of the Queen Anne period. What has come to be labeled as the Queen Anne style had little, if anything, to do with the personage of Queen Anne, who ruled England from 1702 until her death in 1714. This departs somewhat from earlier English convention, which heretofore named a style after the monarch who popularized it. In fact, by the early eighteenth century in England, nomenclature did not necessarily follow royalty.

Additionally, the Queen Anne style witnessed a departure from European stylistic trends more than did earlier English work. It was during this late-Baroque period through mid-century that English furniture came close to reaching stylistic domestication. It is more accurate to describe Queen Anne furniture as a fashionable amalgamation of characteristics from multiple English periods: Queen Anne (1702–1714), George I (1714–1727), and George II (1727–1760). With lags in transmission time, the so-called Queen Anne style did not appear in the colonies until the 1720s, a full decade after the death of Anne. During its era, there was no readily discernible label for this up-to-date fashion; furniture of this description was often referred to in the colonies as simply "late of London," a term borrowed from the previous era and which occurred frequently in references to imported furniture all through the eighteenth century. As is the case with much American furniture, the Queen Anne label was coined much later in the nineteenth century by antiquarians looking for an emblem for the distinctive curve of the furniture that was dominant in America in the second quarter of the eighteenth century. In any case, the Queen Anne label helps to crystallize an aesthetic in vogue from 1725 to 1755, and in some cases, even longer.

The architectural underpinning that guided all designs of this time span created unity between the interior and its furnishings. Another unifying element was the overwhelming emphasis on a single design component—the S-curve. The S-curve has been described as the "line of beauty," the phrase first composed by the eighteenth-century English painter William Hogarth. The S-curve was echoed everywhere—on skirts on case pieces and tables; in the scrolled pediments on high chests; and in the silhouettes of chairs. If the early Baroque style of William and Mary was a metaphor for juxtaposition and restrained movement, the Queen Anne style signified continuing movement and unity of design. Successful Queen Anne furniture derived its beauty from interaction; it isn't a style about transitions or contrasts between thick and thin. The S-curve emerged as the primary shape of the period, reaching its ultimate expression in the cabriole leg. Formed with an outward curved knee and a tapered, inward curved ankle, the cabriole leg was a total about-face from the square or turned legs of the past. It was fashioned after a form found in nature. There are many sources for the cabriole form—the *pied de biche*, or doe's foot, popular on late Baroque or French Régence furniture; the Italian *capriola*, or hind leg; or the dragon's foot clasping a jewel, brought from East Asia by Dutch explorers. All three shapes, in turn, were influenced by one from antiquity.

The idea of a unified design was reinforced because objects espoused a three-dimensional quality rather than the rigid, frontal look of the past. Large case pieces were topped with bonnets that repeated the flowing curves of architectural pediments. And like the architec-

ture of which it was spawned, furniture of this period broke free from the geometric constraints of linear construction. Undulating lines and surface ornament were often carried through to the sides of an object. Decorative carving was used judiciously, outlining the form's inherent simplicity. It was usually limited to the crest rail, the knees on legs, and, on case pieces, to the crowning finials or arches of the skirt.

Recurring motifs included the stylized scallop and the acanthus leaf. Veneering continued to appear on drawer fronts and chair splats, eventually waning at mid-century with the advent of Rococo design. The increasingly curved surfaces of the Queen Anne style eventually made it impractical; veneering is a process best suited to straight surfaces.

With the S-curve imparting immeasurable grace to any form, the prevalence of decorative inlay decreased as well, but several inlay patterns remained popular, among them the star or compass inlay. Japanning, the surface ornament popular with William and Mary pieces, advanced with Queen Anne furniture, although colonial interpretations were foreshadowed by sophisticated European prototypes. Boston artists carried on the technique of japanning. A surface, usually of maple or pine, was coated with several layers of vermilion streaked with lampblack to create a tortoiseshell effect. The japanner then laid out a design, raising some of it with gold. Certain details were painted on the tortoise surface with gold; raised gold portions received more lampblack. A finishing layer of varnish provided the desired lacquered effect. The eighteenth-century practice of japanning resulted in pieces that, due to changes in humidity, were susceptible to flaking and cracking. Precious few pieces of eighteenth-century japanned work exist today, and all owe their survival to some degree of restoration. Only about three dozen objects with eighteenth-century japanning and American provenances (written or oral histories that authenticate a piece) are extant. Similarly decorated objects were japanned at a later date, most likely in the nineteenth century, when the technique came into vogue again.

Walnut was by far still the preferred wood, with chestnut, maple, pine, and cherry close behind. Fruitwood and yellow pine tended to be used for objects made in the southern area of the Atlantic seaboard. Growing international trade brought durable, insect-resistant Santo Domingo mahogany, with its richly figured surface, into the workshops of colonial cabinetmakers for the first time, and Newport and Philadelphia artisans advanced its use well into the early nineteenth century.

REGIONAL VARIATIONS

In the colonies, the arrival of the sophisticated Queen Anne style met with intensifying regional preferences. Conservative New England

held on to incidental William and Mary features, at least initially. Stretchers connecting legs were no longer necessary, yet they were often found on Queen Anne chairs from the region. Patrons in Massachusetts preferred tall, lean pieces and generally slender cabriole legs. Chairs from New England were decidedly restrained in ornament as compared to their Philadelphia counterparts. As Philadelphia continued on a path of economic and social expansion, generally in the 1740s and 1750s, it turned out many graceful Queen Anne forms. Chairs in particular marked the apotheosis of late Baroque artistry in that city.

Newport, Rhode Island, embarked on its climb to commercial prosperity, supporting a furniture trade that became the center for original design throughout the eighteenth century. The Quaker craftsmen of Newport originally built a version of Boston high chests and tables, featuring signature pointed feet known as slipper feet. Later, this closely knit group of artisans, particularly the related Goddard and Townsend families, became associated with one of the most decorative contributions of the period.

Specifically, these craftsmen immortalized the Continental concept of blocking and carried it to a height unheard of in Europe. The process of blocking, or forming raised and depressed areas from solid pieces of wood, was an extremely labor-intensive process that demanded incredible skill on the part of the cabinetmaker. Blocking was practiced in Boston and in the regions that were under its stylistic sway, but it was in Newport that the technique produced objects of timeless beauty. Blocking was a novelty for American furniture making in the Queen Anne period, reaching its zenith in Rococo case work. Fashionable in New England, it endured in Newport long after it fell from favor on the Continent. The process called for the cutting of raised blocks of wood from a solid surface. These panels were sculpted or cut from the facade, not applied. Consequently, only an accomplished cabinetmaker could execute it successfully. In the block-front process, the facade is divided into three panels. The center panel is concave, the two flanking sections convex. A skilled cabinetmaker would turn out a raised blocked panel that was primarily flat with gently curving edges. On the best examples using this technique, the eye glides over the surface.

In the late colonial period, New York City was another center of the furniture trade. Like the seaport of Newport, it was influenced by coastal trade. Certain high chests from these two disparate areas shared the feature of removable legs, which allowed for ease in shipping. These types of patterns suggest that craftsmen moved with some ease throughout coastal trade routes that linked Newport and New York, introducing the concept of removable parts in the port cities where they found employment. New York City was largely comprised of

Loyalists, and the furniture produced there dutifully followed the form and ornament of English precedents. In the discussion on chairs to follow, it will become clear that the broad proportions and hoof-foot rear legs found on some New York chairs follow the same pattern.

Major American style centers influenced their surrounding regions. Furniture from the middle colonies of New Jersey and Maryland, for example, often followed Philadelphia practice while pieces from the South, like those made in New York City, leaned toward English proto-types, both high style and provincial. Southern pieces are differenti-ated from those of New England by exhibiting shorter and stouter proportions and the preference for local woods such as fruitwood and yellow pine.

CASE WORK

FLAT-TOP CHEST

At the beginning of the Queen Anne period, the high chest was not unlike its William and Mary predecessor in which the developed char-acteristics of the old style coexisted with the emerging traits of the new one. This type of high chest was known as a flat-top due to its straight cornice and flattened arches in the skirt, or the horizontal section or cross member of the table where the legs meet the top. Its newest fea-tures were the four cabriole legs that replaced the multiple-turned legs of the past. Most of these chests date from the second quarter of the eighteenth century.

SCROLLED OR PEDIMENTED CHEST

The next version of the Queen Anne high chest began to appear about 1740, encouraging the demise of the flat-top form. This newer form featured a scrolled top that originated out of architectural plans that once dictated building designs, including the scrolled pediments that topped colonial door frames. It was at this point that Queen Anne case work reached its high point, the perfect marriage of architectural pro-portion and gently rhythmic S-curves. Characteristics that allude to New England origins include such features as five-section upper cases, four-drawer lower cases, flat-top arches in the skirt, and a carved shell drawer in flat-top chests. Stylistically, newer high chests with pediments may have also contained another shell in the upper case.

One of the most celebrated high chests from this region is the Pimm high chest (Winterthur Museum), named for the inscription of its maker, John Pimm. Made approximately 1740 to 1750, its japanned

decoration is believed to be the work of English-trained artist Thomas Johnston (also known as Johnson), who was active in the Boston area between 1732 and 1766. The architectural pediment, overall S-curve format, and japanned surface juxtaposed Classicism and Orientalism, offering a defiantly proud rebuttal to costlier European models.

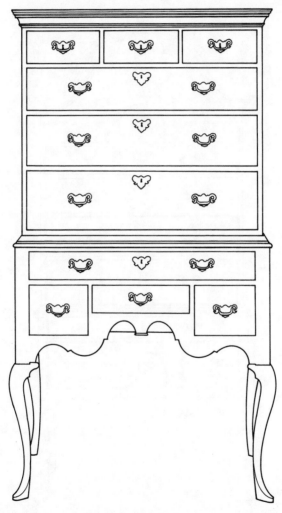

The finely pointed slipper feet on this flat-top high chest were a specialty of Newport cabinetmakers. The angular cabriole legs were removable, a feature of some furniture made in coastal towns for shipping.

NEWPORT CHEST

Some of the finest Queen Anne furniture made in southern New England came from Newport. Early flat-top high chests dating from around 1730 were made from walnut with chestnut and pine, with richly figured Santo Domingo mahogany found on the best examples.

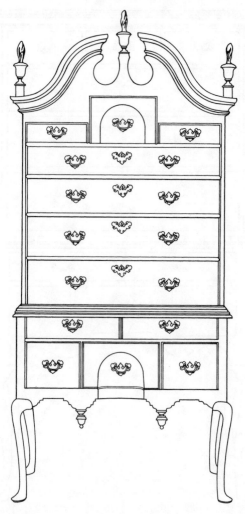

The scrolled top and cabriole legs on this high chest from Boston are fully developed attributes of the Queen Anne style, circa 1755. Imported brass bat-wing drawer pulls were an innovation of the period meant to reflect candlelight.

Flat-top high chests by the Goddard-Townsend cabinetmaking dynasty were unique for their squared cabriole legs (with removable legs on models to be shipped) and narrow knee brackets (curvature where the cabriole leg is widest) terminating in fine, pointed slipper feet.

Newport case work is typically remembered for a scrolled cornice, and the claw-and-ball foot with an undercut talon. The shell-and-volute pattern often appeared on objects made by the Townsends. Precisely rendered dovetailing is another hallmark of the Goddard-Townsend shops. Together with masterfully blocked cases, these details were indicative of the Newport school of cabinetmaking at the end of the eighteenth century.

PHILADELPHIA AND DELAWARE RIVER VALLEY CHEST

In their bodies, Philadelphia and Delaware River Valley pieces borrowed the square forms of New England case work, occasionally incorporating a trifid foot of Irish derivation. The trifid foot has three sections that resemble toes covered with a sock. Other variations include a high-curved skirt with a curved cutout drop substituting for the classically inspired pendant drop of New England versions. Delaware River Valley pieces in general have a more robust scale since they stand on heavier and sometimes straighter legs.

Boston, New York, and, to a lesser degree, Philadelphia were fairly well-contained style centers, and their influence can be seen in the furniture in locales within a fairly close radius. The geographically dispersed area of the Connecticut River Valley, however, reflects multiple influences from many areas. Thus in Connecticut the Queen Anne style was less the output of a cohesive regional school and more the idiosyncratic and charming arrangement of certain high-style blueprints.

DESK WITH BOOKCASE

The desk with bookcase was the most ambitious Queen Anne form; some examples stand more than ninety inches high. Models from the 1740s and early 1750s, featuring door panels with arched tops, were outfitted with a system of pigeonholes, shelves, and drawers. Later models included serpentine edges surrounding the door panels and versions with glass fitted into the panels that followed high-style English examples. Since the glass in these panels was fragile, original glass-paneled doors are rarely found today.

DRESSING TABLE

Early Queen Anne dressing tables consisted of a slab top resting over one long drawer on top of an arched skirt with cabriole legs. In some instances, dressing tables surpassed simple tables to become full-blown case pieces, especially after 1730. New England block-front dressing tables fit this description best. Examples from Pennsylvania often feature a molded lip between the slab top and the case, and in many instances, these tables have wider spaces between the drawers. Another New England characteristic is a top that sits directly on its case. In all locales, one of the clues to a cohesive and graceful composition is a top whose edge repeats the curve of the skirt.

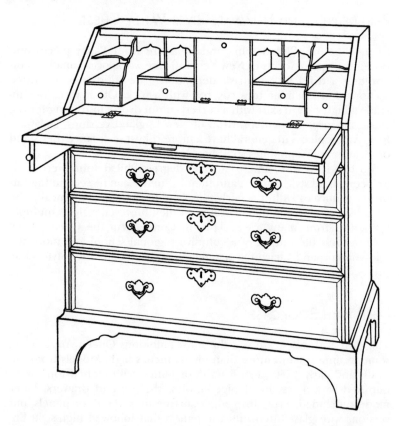

The bracket feet and bat-wing hardware on this slant-front desk from Boston, circa 1740, replace the bun feet and teardrop pulls of earlier William and Mary models. The valanced pigeonholes on the interior indirectly reflect the influence of the S-curve that was so integral to Queen Anne designs.

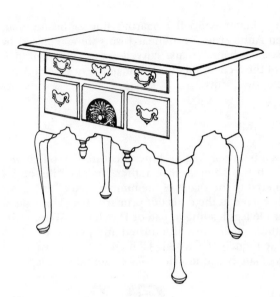

Gilt rendered in the shape of a fan in the lower center drawer of this Massachusetts lowboy, circa 1740–60, suggests the carved fan that might be found on similar Queen Anne case work. The small disks at the bottom of the leg were a subtle variation of the pad foot that some New England cabinetmakers favored.

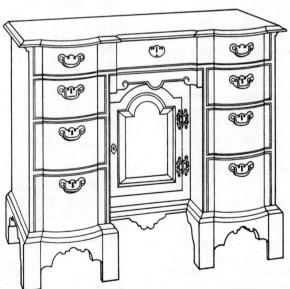

This sophisticated case form known as a bureau, or dressing table, has a recessed area for the sitter's knees. On these cases, cabinetmakers often divided the front into three sections, two convex and one concave, to create the blocked or "sweld" facade.

SEATING

No household object better defined Hogarth's line of beauty than chairs in the Queen Anne style. Rectilinear forms were replaced by cabriole legs, horseshoe-shaped seats, curved splats, and rounded stiles, all attributes of the S-curve theme. The majority of Queen Anne chairs followed one of two forms.

ANGLO-CHINESE CHAIR

One form offered a mixture of Anglo-Chinese features, an outgrowth of the Boston chair. It was composed of rather straight stiles and a spoon back that adhered to the shape of the lumbar area of the spine. The crest was gently curved at the ends but primarily flat. This type of chair stands on cabriole legs leading to pad or Dutch feet. Waning elements on some of these chairs were the turned and joined stretchers on early Queen Anne models. The Anglo-Chinese chair incorporated certain refinements of late Baroque style, notably the cabriole leg.

HOOP-SHAPED CHAIR

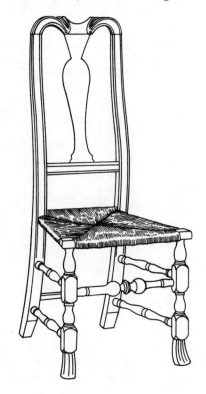

The hoop-shaped chair, on the other hand, was the fully mature embodiment of mid-eighteenth-century elegance. Recognized by its wider, carved hoop-shaped crests, wide compass or horseshoe slip seats, and cabriole legs, this was an incredibly sculptural form.

This Queen Anne side chair could appropriately be labeled transitional, meaning that it carries features of more than one style. The curved crest rail and solid splat are Queen Anne details while the block and turned legs, stretchers, and paintbrush feet are holdovers of the preceding William and Mary style. When identifying transitional objects, always date them by the most recent feature. The most updated features here are those of the Queen Anne style, so the chair is identified as such.

The compass seat, named for the compass tool, called a scribe, that cabinetmakers used to score or mark the lines of the seat frame, had a very rounded front curve. Today, this seat is frequently described as a balloon seat.

Simple pad or claw-and-ball feet were often at the discretion of the consumer. Claw-and-ball feet were an expensive option, worked out between the artisan and his patron. Their inclusion on a chair does not necessarily signify a later date of construction as antiquarians once believed.

REGIONAL VARIATIONS

TEMPLATES

Regional preferences were fully expressed in Queen Anne chairs, and one way scholars have been able to differentiate these regional practices is through the analysis of the templates or patterns for chair backs that may refer to a specific cabinetmaking shop.

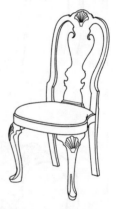

On an assembled chair, the voids or open spaces between the splats and side stiles that these templates create provide clues for regional attribution. Owing to the interaction of a solid splat and surrounding void, many of these patterns mimic birds' heads. For example, Massachusetts chairs depict round-headed birds with short bills. The solid-void relationship on a Newport chair results in an alarming bird-of-prey head with a sharp beak. Philadelphia chairs often capture the crispness of the Newport head but soften the beak.

CONSTRUCTION TECHNIQUES

While general cabinetmaking rules prevailed, regional construction techniques were readily apparent. A Rhode Island chair, for example, has squared rear legs connected by stretchers to the front legs. Its front cabriole legs terminate in claw-and-ball feet, and the claws are undercut and crisp, a feature of Newport workmanship. Newport makers frequently used what were by this point dated stretchers of flat or block-shape and gently curved thin splats to adorn their chairs, following the lead of Boston chair makers. Other Newport quirks include a C-curve on the knee and a deeply cut front rail. A Con-

Paneled feet as well as the sharp bird-of-prey silhouette formed by the solid vase-form splat and its surrounding void point to Philadelphia workmanship, circa 1750. The horseshoe, or compass seat, is a highly desirable Queen Anne attribute acknowledged by many collectors.

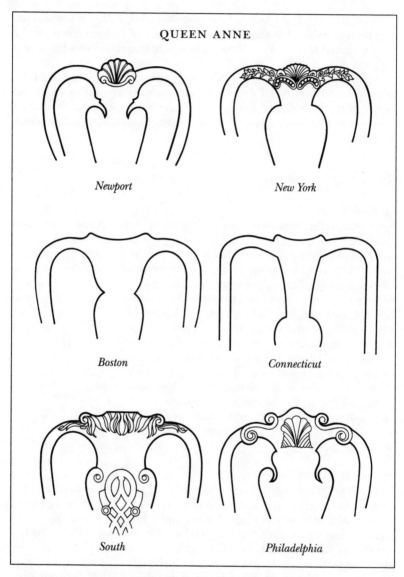

QUEEN ANNE

Newport

New York

Boston

Connecticut

South

Philadelphia

Learning to recognize regional variations in chair-back designs is an important element of connoisseurship. Each region had a preference, and these ranged from the simple rounded crests popular in New England to the more decorative variety in Philadelphia reflecting the fully developed Queen Anne aesthetic.

QUEEN ANNE CHAIR CONSTRUCTION

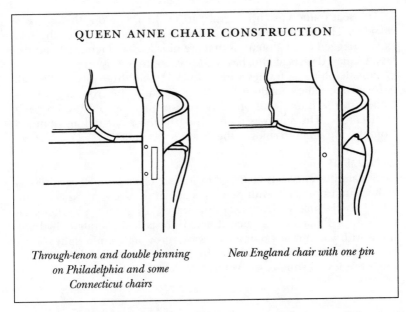

*Through-tenon and double pinning
on Philadelphia and some
Connecticut chairs*

New England chair with one pin

*New England cabinetmakers customarily secured the seat rail to the rear stile by means
of one pin (right) while Philadelphia and some Connecticut chairs were assembled
with a through-tenon and double pins (left).*

necticut chair of this type has an extremely thin splat and often a double, or cyma, curve on the front seat rail and a slightly rigid format. A trapezoidal seat with square corners and the use of cherry, a locally available wood, also suggest Connecticut workmanship.

The high point of Philadelphia and New York Queen Anne chair making can be found in the very decorative and generously proportioned hoop-shaped chair of Georgian heritage. Stretchers are conspicuously absent, and in Philadelphia, the rear legs are formed from rounded stumps or are chamfered; the front legs end in the more flattened claw-and-ball foot. In New York, hoof-foot rear legs appear and front cabriole legs end in the drake, or trifid foot.

SEAT JOINERY

As do other elements, seat joinery differs regionally as well. Newport chair seats were mortised and tenoned together, with one pin supporting the seat. Philadelphia seat frames were also assembled with the mortise-and-tenon joint connecting the seat to the frame, an additional feature being the visibly exposed tenon in rear view. Two pins support this seat. Some Connecticut chairs sport this visible through-tenon.

The seat frame was an integral part of the frame on Rhode Island versions. The front cabriole leg is fastened at the corner of the seat frame, pegged through tenons that are mortised and tenoned into the leg. A squared vertical glue block adds strength to this union.

Philadelphia seat frames were fashioned from three pieces of wood. A formed molding made up the seat rim and the front leg was attached to the frame with one large dowel that pierced the frame at each corner. The side was then joined to the front rail and pinned from the top on both sides of the dowel.

ORNAMENT

Regional differences also emerge in surface ornament. Stylized scrolls with C-curves or shells with pendants adorn the Newport knee. Naturalistic shells, boldly carved acanthus leaves, or "grass" typify the ornament on a Philadelphia knee. Carved crests incorporated rhythmic shells with voluminous plume-like waves growing from a tight volute, or spiral scroll, on either side of the lower edge. Philadelphia carved shells are less rhythmic; the volutes flank the shell and are resolutely separate.

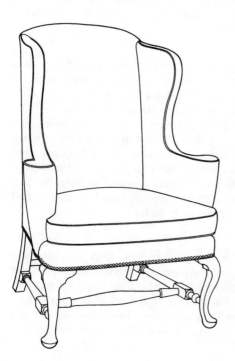

EASY CHAIR

Boston and New England area chair makers repeatedly made versions of the easy chair with arms that rolled out vertically. The addition of cabriole legs brought the form fashionably into the mid-eighteenth century, but some models clung to their outdated stretchers. Philadelphia easy chairs were more up to date; they rarely had stretchers.

The easy chair was often placed in the bedchamber where those of ill health or old age could seek the warmth and comfort provided by an enclosed upholstered chair. The vertically rolled or outscrolling arms on this 1750 Massachusetts example are a regional trait of New England workmanship.

Front cabriole legs, stump rear legs, and a distinctive C-scrolled arm point conclusively to the full-blown Queen Anne aesthetic in Philadelphia examples.

SOFA AND SETTEE

New forms—the sofa and settee—reached design pinnacles in Philadelphia, although their mainstream acceptance was several decades away. The sofa, derived from the *sopha* of Eastern origin, combined a long upholstered seat with a back and arms at

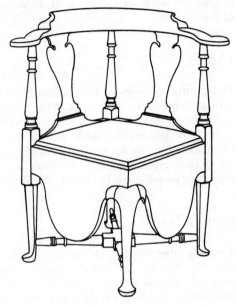

This Queen Anne corner, or roundabout, chair from Connecticut was typically paired with a desk. On some models, the deep apron beneath the seat concealed a chamber pot.

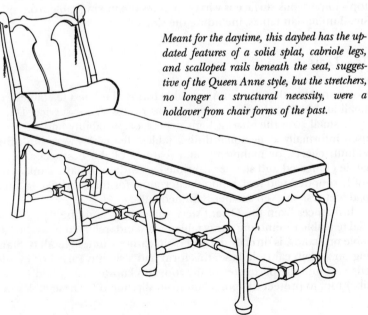

Meant for the daytime, this daybed has the updated features of a solid splat, cabriole legs, and scalloped rails beneath the seat, suggestive of the Queen Anne style, but the stretchers, no longer a structural necessity, were a holdover from chair forms of the past.

each end. Eighteenth-century colonial sofas had cabriole legs and conveyed a sense of beauty with their high backs and curvaceous rolled arms. The settee was a lighter version of the sofa, often an open seat double the width of a chair. Both forms eventually led to the demise of the daybed.

TABLES

Along with increases in the standard of living in the mid-eighteenth century came extended leisure time activities. Card playing and the social act of "taking tea" were just two of these events. Special table forms were created to accommodate such patterns of living. New England is often hailed as the locale that produced some of the finest tables of the period, especially highly portable tea, gaming, and mixing tables with their long legs and tapered, well-shaped ankles.

MIXING TABLE

A mixing table was used, as its name implies, to mix something, usually alcoholic drinks. Some models were equipped with a marble top or with delft tiles that offered a degree of protection from the damage that spilled potables would otherwise inflict on a wooden top. The top's impervious surface is what separates the mixing table from other small utilitarian tables, including the side table.

TEA TABLE

Compared to other Queen Anne table forms, the finest tea tables were small and held only what equipage was necessary for service. Due to their small size, they had a high degree of portability and were also used informally as personal dining tables. Tea tables were built from walnut, cherry, or mahogany, and features of the best examples include elongated and slender cabriole legs with well-shaped ankles and softly rounded pad feet, a popular terminal for the cabriole leg. Some pad feet rest on even smaller flattened balls.

Influences from the Orient were still strong, and one type of colonial tea table resembling a tray table on a stand, referred to as the "tray table on stand," is directly derived from earlier Chinese models. Standing on a plain cabriole base, this form had a slightly raised or molded edge around the perimeter of the top, also known as a dished (saucerlike) top, to protect the porcelain from slipping off. These tables were

such successful marriages of balanced form and graceful line that sur-
face carving was not used on this type.

A second version of the tea table united an arched skirt—an added
feature—to cabriole legs, creating a proportionately larger table than
the shallow Chinese tray table on a stand. Tables of this second type
also have tops with square surfaces and molded edges, in keeping with
the Chinese tray-table versions. The carving that was notably absent on
Chinese-inspired tables is employed discreetly on tables of this second
type, usually on the leg and in the shape of a shell. Additional regional
variations include thin, pointed slipper feet on legs made by the God-
dard-Townsend school in Rhode Island; New York was the only other
region to employ the slipper foot to any degree. Button feet, an ex-
tremely small rendering of the larger pad foot, can be found on New
England tables. Connecticut makers incorporated the curvaceous lines
of the Queen Anne style into the top so that the top's molded edges
matched that of the skirt from a bird's-eye view. Tea tables from the
South and the middle states often have straighter, heftier legs and bul-
bous feet. Conical, or cone-shaped, legs were a less sophisticated
choice for tables than the fully developed S-shaped cabriole leg for
which most Queen Anne forms are admired. A product of the turner,
conical legs were used in New England as well as in the South.

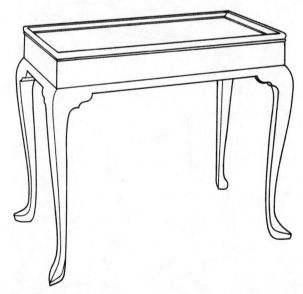

*The simple design of this Newport tea table belies its elegance. The angular cabriole
legs with pointed slipper feet are characteristic of the Goddard-Townsend shops.*

DROP-LEAF TABLE

Swing leg is the label given to drop-leaf tables lacking stretchers. Drop-leaf tables with swing legs replaced the gateleg form thanks mainly to the development of the cabriole leg. The curvaceous cabriole leg was not in keeping with the more complex and confined geometric forms created by the stretchers and legs intrinsic to earlier gateleg tables. The drop-leaf table was used foremost for dining, but could also be pressed into service as a writing table. When in use the top was covered with a cloth. When not in service, the leaves were dropped and the table was stored against a wall.

The usual configuration of the drop leaf called for four cabriole legs, two of which were stationary. The other two legs were attached to rails that swung, giving them the alternate name of swing-leg tables. Larger tables of this type might have four swing legs. Eighteenth-century drop-leaf tables are inherently more fragile than earlier gateleg models since the drop-leaf configuration is supported by thinner cabriole legs that lack stretchers. On drop-leaf tables with cabriole legs, the tops were attached with invisible metal fasteners in the top or blocks glued to the frame. Tables with turned or conical-shaped legs had a

A small portable table such as this drop-leaf version served as a writing, tea, or dining table. Delicate and graceful cabriole legs and a curvaceous apron are quintessential markers for this Boston form.

stiffer look than the more graceful cabriole leg models. Turned-leg tables generally had round or oval tops secured with wooden pins. Relatively few drop-leaf tables were made with drawers, and the same is true for models with two stationary legs. An ovolo, or convex molding in the shape of a quarter circle, sometimes shaped the edge along the top on many drop-leaf tables, suggesting how thoroughly the concepts of proportion and unified design were incorporated by eighteenth-century cabinetmakers.

TILT-TOP TABLE

Tilt top refers to a form known by many different names during the period. The English called them pillar-and-claw tables, regardless of whether the table had claw-and-ball feet, and they were also referred to as tea tables. No matter the label, they all had a top hinged to a base, which permitted it to tip to a vertical position. The base or pillar is the most distinguishing feature on many of these tables. The round tilt top connected to its pillar or column and then to its base with short, tripod cabriole legs. Square tilt-top tables usually had rounded or serpentine edges, and in Philadelphia, tilt-top models used a birdcage device between the top and the pillar that permitted the top to both tilt and rotate. Philadelphians also seemed to prefer claw-and-ball feet, as well as dished tops. In Massachusetts, both claw-and-ball and snake feet were popular. The snake foot, named for the swelled curve that resembles a snake's head in profile, often indicates a north-shore Massachusetts origin.

CARD OR GAME TABLE

In form, most Queen Anne card or game tables are rectangular in shape and contain a swing leg that supports the top in an open position. Some models were outfitted with "guinea holes" or "fish ponds," dished compartments in which counters were placed that kept score during game playing. Elaborate models had separate dished corners for candle stands. Like the tea tables from the region, New England artisans turned out some of the most unified designs based on simplicity of form, beauty of materials, and integrated S-curves.

\mathcal{S}UMMARY OF STYLE

Dates: 1725–1755
Distinguishing Features: refined curves based on S-shape; cabriole leg; bonnet top; japanning; blocking; hoop-shaped seats; solid splats; discreet carving
Materials: walnut, mahogany, cherry

COLLECTOR'S TIPS

1. *Look for (good example):* S-curve as unifying component; successful proportions; cabriole legs
2. *Look for (outstanding example):* bonnet-top case pieces instead of flat-top form; delicate and attenuated cabriole legs; hoop-shaped chairs; japanned pieces; undercut talon in Newport work
3. *Problems/what to watch out for:* The Queen Anne style is the most forged of all American furniture. Tray-top tables and highboys have been heavily faked; alteration of form into more desirable shape is common, as is marriage of parts that were not originally connected. Beware of pieces such as dressing tables that were once the bases of highboys with rectangular top boards added later. Totally replaced or pieced together cabriole legs turn up frequently.
4. *Conservation issues:* veneer loss; japanned pieces require constant monitoring. Queen Anne pieces have touches of gilding and some have been re-gilded. Original gilding, even if worn, is preferred over re-gilding, which can often appear too bright.
5. *Cabinetmakers/firms important to style:* Goddard-Townsend school, Newport; Thomas Johnston, japanner working in Boston; William Savery, Philadelphia; Ebenezer Hartshern, Boston; and John Pimm, Boston
6. *Where public can see best examples:* Metropolitan Museum of Art, New York, New York; Boston Museum of Fine Arts; Winterthur Museum, Wilmington, Delaware; Yale University Art Gallery, New Haven, Connecticut; Philadelphia Museum of Art; Chipstone Foundation, Milwaukee, Wisconsin
7. *Department expert wish list:* hoop-shaped chair from Philadelphia, Newport, Boston, or New York; pedimented secretary-bookcase with fan/shell carving; fully developed card, tea, or dressing table; Newport blocked piece; southern case piece with good proportions
8. *Miscellaneous:* High-style pieces from major style centers of Boston, Newport, and Philadelphia command the highest prices at auction. Painted pieces, if they retain any original paint, are also desirable.

CHIPPENDALE FURNITURE (1755–1790)

The Chippendale aesthetic prevailed in the colonies from the mid-eighteenth century until about the time of the American Revolution. Its primary influence was Rococo, which was often capriciously combined with Chinese and Gothic novelties to form what is now regarded as the Chippendale style. The term *Chippendale* is another catchall term for a style that was more multifarious than the individual for whom it was named.

By this point in the development of American furniture, imported pattern books had taken the lead over imported objects in both assimilating a style philosophy and disseminating its salient features to cabinetmakers. Although it was not the first treatise to espouse a body of design elements, Thomas Chippendale's 1754 publication, *The Gentleman and Cabinet-Maker's Director*, was both timely and influential. Chippendale was thus immortalized for his efforts in establishing a comprehensive source of design ideas that could be imposed on indigenous English furniture forms. Chippendale interpreted French design with angular Chinese and Gothic architectural enhancements, making the *Director* a shorthand for three stylistic crosscurrents, elements of which can be found singularly or in tandem in American colonial furniture covering the years from 1755 to 1790.

Rococo, a highly feminine or Junoesque proclamation and the major component of the tripartite influences that made up the Chippendale style, developed in the eighteenth century in response to the classically oriented mandates of late Baroque design. It originated in France during the reign of Louis XV and is characterized by lightened, curved, and irregular forms. Ornament consisted of organic shapes made up of *rocailles*, or rocks, and *coquilles*, or shells. The name

Rococo—a bastardization of the two terms—first surfaced in nine-teenth-century France, having been appropriated by followers of the academic artist Jacques-Louis David to deride what they believed to be a frivolous style. David and his followers aligned themselves with Neo-classical imperatives of symmetry and order, a philosophy that was dia-metrically opposed to the more playful, asymmetrical Rococo designs of the eighteenth century. The Rococo style was an international one, coinciding with a desire for gracious and intimate living. What once re-flected the exclusive privilege of court life in the seventeenth and early eighteenth centuries, Rococo became the coveted lifestyle of the bour-geoisie. This was particularly important for England and for its colo-nial dominion, America.

In England, the affluent and socially liberal Whigs embraced Ro-coco, and their cabinetmakers in turn diluted the more opulent French Rococo into a more restrained domestic version. In England, the Rococo blueprint was a decorative surface embellishment rather than the comprehensive feast of feminine, irregular forms and or-ganic ornament that originated in France. Chippendale's French or "modern" illustrations borrowed the ribbons, rocks, and shells of Ro-coco ornament and applied them to underlying forms that were usu-ally more classically derived. The fascination with the styles of the Far East (japanning, spoon backs, and tray tables on stands) that began in the William and Mary period continued in England and in America. *Chinoiserie* is the term applied to the Western interpretation of Orien-tal motifs. New to the Chippendale edict were elements including pagoda tops and Oriental fretwork, or open-work patterns of interlac-ing lines formed by a fretsaw, a long narrow-banded saw used to cut perforations in thin wood. Pagoda tops recall the pointed and more or less pyramidal or tower-like configurations of Oriental architec-ture. The top of case work was a favorite location for pagoda tops, and crest rails on chairs were adorned with them, but very rarely. Fretwork was more widely used than pagoda tops, appearing most often as a decorative border on case work, seating, and tables.

The third major component of the Chippendale style was the Gothic element. It was the logical progression of England's inward focus in early eighteenth-century furniture design. Starting in the Queen Anne era, England was less influenced by European trends, particu-larly in the feminization of certain rooms—including the bedchamber and sitting room—which worked in tandem with curvaceous French Ro-coco designs. Being a mostly English phenomenon, the Gothic ele-ment was particularly favored in the library, which in English culture was a male bastion where intellectual activities were pursued or, occasionally, business was conducted. The Gothic (also known as *Gothick*) style began in the 1730s, and like its two counterparts, Rococo and Chinese, was es-sentially a style of detail rather than form. It evoked the essence of me-

dieval design, but not specific historical accuracy. Elements from different historic intervals within the Gothic time frame were mixed capriciously; a skeleton framework, pointed arches, quatrefoils, and ogee curves were several of these decorative combinations.

Regardless of what was happening on the political front, in matters of style and fashion, colonial Americans continued to look to England for ways to preserve and perhaps enhance certain aspects of their material culture. Pattern books made such style transfers easy, and the ubiquitous *Director* testifies to the importance of design books in these years. It circulated quickly among colonial cabinetmakers, strongly influencing Philadelphia and Charleston artists.

It was the ornamental component of English prototypes found in many of these pattern books that surfaced in colonial furniture. Conservative New England artisans, especially those in Newport, continued to turn out designs of late Baroque form sprinkled with modern ornament. The Newport secretary-bookcase with its large architectural pediment (late Baroque feature) and multiple, stylized shells or claw-and-ball foot with undercut talon (Chippendale features) illustrates this blatant mixing. But in most regions, the graceful curves that were the hallmark of Queen Anne designs became more pronounced and angled in the 1760s. Chair crests gained ears, the circular junctures where crest rails meet the vertical stiles of the chair back, and plain vase-shaped splats were replaced with those that were pierced and carved. Chair carving was usually confined to the leg, foot, crest rail, and splat. Case pieces were covered with foliate ornament, and high chests often incorporated a cartouche, or carved, often asymmetrical, finials in their bonnet tops. Some case pieces reflected an even stronger Rococo heritage, which grew out of their curvilinear, serpentine, and oxbow bodies. Serpentine curves move in, out, and in across the body. The opposite of the serpentine curve, an oxbow curve flows out, in, and out across a surface. Both curves lent a measure of fluidity and movement to otherwise staid case forms.

Mahogany was the preferred wood for Chippendale designs for many reasons. It was important to colonial work because its richly figured grain was visually exciting and capable of substituting for the ostentatious ornament (all-over carving, for example) sometimes found on European models. In addition, mahogany was a strong wood, well suited to the sometimes delicate balance between a thin interlaced splat and its void. Because of its durability, carvers were able to experiment with multiple motifs including scrolls, foliage, and shells. Mahogany had the added benefit of being impervious to insects, an important feature in the warm climate of Charleston. For Charlestonians who demanded the most *à la mode* wares, mahogany was a perfect choice.

Decorative hardware became a signature characteristic of Chippen-

dale furniture. The standard patterns for drawer pulls and escutcheons included flattened U-shapes and meandering urns with bail handles. A more intricate option for pulls featured intricate cutouts like those found on chair splats. Many of these were imaginative blends of Rococo, Gothic, and Chinese traits, as were the variations on legs and feet. Chippendale offered the French scroll, or whorl foot, as an option for the claw-and-ball variety. The Marlborough leg, a square leg sometimes terminating in a blocked foot, was another option well suited to the more angular Gothic and Chinese styles. But it was the cabriole leg with claw-and-ball foot that remained a particularly colonial trait long after it had reached its apex in England.

At a glance, the Chippendale style is recognized by:

- curvaceous forms, possibly with angular and or architectural enhancements;
- brilliantly figured surfaces that break free of the bilateral symmetry that dictated selection of woods up to the mid-eighteenth century;
- lighter, organic-based carving comprising swirls, shells, and foliage that suggests movement and vitality; and
- hardware that both captures and reflects light.

REGIONAL VARIATIONS

Regional characteristics became especially pronounced in legs and feet in the major style centers. While Philadelphia is often remembered as the preeminent center for Chippendale furniture, masterful examples of pieces from other regions strongly suggest that the Chippendale style was widespread. A Massachusetts claw-and-ball foot generally has a high ball with slender talons slightly swept back. The talon often forms a triangle in side view on a Massachusetts leg. A Newport claw-and-ball has crisp, elongated talons curving away from the ball, which results in an undercut talon. Some of these feet have webbing between the toes. The Philadelphia claw-and-ball foot was precisely carved with a sturdy claw grasping a flattened ball. In New York there was a preference for squared talons resting on flattened balls. And a Connecticut claw-and-ball has broad, roughly carved talons.

Knee carving followed regional practice as well. Massachusetts knees typically have flat acanthus leaves carved in a slightly stiff manner. Philadelphia carving, which is very fluid, produced knees that were rounded, frequently with two-part foliage that meets in the center of the knee. Cross-hatching in the center of the knee and flat acanthus carving often indicate New York legs.

CASE WORK

The high chest continued its ascent as a peculiarly colonial form. While the form existed in England, it never achieved, at any point, the level of popularity that it did in the colonies in the mid- to late eighteenth century.

PHILADELPHIA

The most ambitious Chippendale designs were found in Philadelphia. Classical proportions and quarter columns predominated, with decorative overlay superimposed. A quarter column is a narrow piece of wood that has been cut into four evenly sized vertical columns. Primarily a decorative treatment, the quarter column is used on either side of the front of case work to suggest architectural capitals or columns.

A high chest, known as the Pompadour highboy (Metropolitan Museum of Art) for the carved bust that sits atop the piece, is one of the best examples of the Chippendale style as interpreted by Philadelphia cabinetmakers in the years from 1765 to 1775. The bust, a type of figural sculpture, is a rarity in colonial work. Purportedly the image of Louis XV's mistress, there is no historical basis for the attribution; portrait busts grew out of a tradition for library busts, which enjoyed a revival in England at mid-century. Library busts were often in the images of such renowned literary figures as John Locke and John Milton, and their customary placement was on the desk with bookcase form, a type of portable library. On the Pompadour highboy, there is an abundance of fluidly carved detail in the foliage that breaks out of the pierced, scrolled pediment, as well as in the rendering of the serpent and two swans on the bottom drawer, guiding the eye past the underlying squared form replete with quarter columns at the edge of the case. The richly figured case of the Pompadour highboy stands on well-proportioned cabriole legs that end with sturdy claws and flattened balls. Free-form organic mounts hold U-shaped bails, or metal loops or rings used as drawer pulls.

Telltale Chippendale features evident in this piece include the organic and representational motifs and the open-scrolled pediment. Acanthus leaves and flora meander over the legs and skirt, and in one of the closest renditions of the Rococo taste, huge acanthus leaves break out of the confines of the pediment. Additive details include Oriental fretwork applied just beneath the cornice and at the waist, or where the top case meets its base. The horizontal cornice and Oriental fretwork served as a transition point for the cabinetmaker as he worked out the integration of a scrolled pediment with the flat surface of the drawer fronts on the same plane.

The Pompadour high chest reigns as the finest example of American furniture conceived through the creative adaptation of multiple pattern books. The horizontal cornice and dentil, or rectangular, teeth-like moldings, as well as the two draped urns sitting on top of the

On this chest-on-chest, circa 1765, Massachusetts cabinetmakers limited blocking to the lower case exclusively. The spiral finials atop the upper case suggest the notion of movement toward which all successful Chippendale designs aspired.

cornice are taken from several of Chippendale's illustrations in the *Director*. The carved scene on the bottom drawer follows a motif laid out in a chimneypiece drawing from 1762 that appeared in another pattern book, *A New Book of Ornaments,* by Thomas Johnson. Exceptionally

This high chest is an archetype for the fully developed Rococo aesthetic as understood by Philadelphia cabinetmakers. The open-flame finials are characteristic of Philadelphia practice, as is the carving, where free-form organic ornament was applied to an essentially classical form.

realistic carving, figured wood suggestive of rippled water, and free-form, organic mounts with an efflorescent quality typify the deification of the Rococo aesthetic in Philadelphia.

NEWPORT

In Newport, Quaker cabinetmakers could not have built the high chest more differently than did makers in its sister city, Philadelphia. In addition to differences in case construction, the archetypical Newport high chest is more tightly configured. Quarter columns are fluted, emphasizing a linear quality. The scalloped bonnet is solid, or extended to the rear of the upper case. This contrasts sharply with a Philadelphia version, on which the bonnet is merely a facade. The Newport surface is serene, and the mahogany is less highly figured. The brasses and finials are symmetrical and tight on a Newport high chest. The cupcake finial, usually attributed to the Goddard-Townsend shops, is a tautly spiraled flame resting on a fluted cupcake-shaped base. By comparison, Philadelphia finials are typically more free form, usually taking the shape of an open flame.

The Goddard-Townsend shops turned out another form in Newport—the desk with bookcase—that is coveted today for originality of design and unsurpassed workmanship. It held on to Queen Anne proportion and architectural undertones while advancing the blocked or "sweld" facade. The facade of the Newport desk with bookcase was divided into three sections—two convex and one concave. Beginning with the door panels on the top case, the blocking extends down to the base. Cut from solid blocks of wood, the overall effect was one of sculptural beauty and a marked contrast of planes. Three shells adorn the top blocked panels, and three adorn the fall-front board of the desk.

The rhythmic convex-concave-convex shell grouping replaces the single concave shell that appeared on many Newport chests of the Queen Anne period. These carved shells were more organic than those of the previous era, but when compared to the naturalistic carving on Philadelphia objects, they still appear highly stylized.

Fluted Doric quarter colonettes keep the eye focused on the surface and underscore the verticality of the form. The massive case rests on ogee bracket feet that contain small scrolls on the inside of the foot, another Newport quirk. Finials were a finishing detail, and three cupcake finials were standard fare on scrolled pediments in Newport.

Blocked facades are also seen on the furniture of Connecticut and New Hampshire, each with a distinct regional charm. Connecticut shells and blocked panels tend to be looser and flatter than their Newport equivalents. Portsmouth blocking tends to be flat and rectilinear in shape. The blocking is crisp at the corners but slightly flat in profile.

In Massachusetts, cabinetmakers limited blocking exclusively to the bottom of large case pieces.

CONNECTICUT

Connecticut case work continued to be influenced by several regions. Norwich, Connecticut, for example, often followed the lead of Newport while pieces from the Hartford area were amalgamations of Philadelphia, Boston, and New York styles. Eliphalet Chapin of East Windsor, Connecticut, is remembered for mixing regional elements. He created a cohesive style that included the use of native cherry and certain Philadelphia structural and ornamental techniques that he learned during his four-year apprenticeship in Philadelphia. Some of these influences can be seen in a Connecticut chest. A Chapin high chest shares many of the attributes of its Philadelphia counterpart: proportions, cabriole leg, skirt, scrolled bonnet, and "sea horse" cartouche. The lighter, delicate rendering of the scrolled bonnet and sea horse cartouche on a Chapin chest and the use of cherry, however, were strictly Connecticut preferences, as were the narrowly shaped finials.

NEW HAMPSHIRE

In New Hampshire, the Dunlap family of cabinetmakers produced high chests with an idiosyncratic Chippendale format. Dating from the last quarter of the eighteenth century, this chest is recognized by a body of maple and soft pine often stained to resemble the more costly mahogany. Its configuration, consisting of a top case of five or more tiers of drawers over a lower case of three tiers of drawers, resulted in a massively vertical chest that contrasts with the majority of high chests that rest on a base, with one—or at most two—tiers of drawers. Curves and shells decorate the skirt, and a deep cornice was fitted with a pierced basket-weave band of fan carving, modified with small broken-scroll pediments. The fans are sometimes referred to as "spoon handles" for the spread-out, radiating shapes that resemble the handles of a spoon. These spoon handles represent another idiosyncratic regional interpretation of a Chippendale motif, probably reflecting the influence of the stylized Newport shell. The proportionally short and slender cabriole legs with creased knees tend to make these chests look top-heavy. Most models have claw-and-ball feet or pad feet resting on angled disks.

NEW YORK

Due to close ties to England, patrons in New York preferred a form that was popular in the motherland, the chest-on-chest configuration that merged two approximately even-sized cases, one on top of the other. The high chest, different from versions in New England, was more likely to have a flat top with an architectural cornice and short bracket feet instead of a scrolled top and cabriole legs. The case was square and occasionally had fluted and chamfered corners. Sweet gum provided an alternative to mahogany.

The chest-on-chest or linen press was the preferred form in New York and, less frequently, in Philadelphia, where the scrolled-top high chest was still in favor. Most chest-on-chests followed English models; they were architectural in design, with columns and flat cornices enhanced with dentil moldings. Some examples were finished with ogee bracket feet that provided a stable base. The ogee bracket is a cyma reverse-profile curve, or a double curve that is convex and then concave. This produces a short stocky foot.

CHARLESTON

In Charleston case work, cantered corners and complicated fretwork are often attributed to London-trained cabinetmaker Thomas Elfe. Elfe's influence was foremost in the period and it was he who introduced these traits to Charleston workmanship in general.

OTHER CASE FORMS

Other case forms popular in the last half of the eighteenth century include the oxbow and serpentine fronts. Remember that the serpentine facade undulates in, out, and in along the surface; the oxbow reverses the serpentine curve and moves out, in, and out. The oxbow is alternately called a reverse-serpentine facade and is seen frequently in English work. Preeminent Philadelphia cabinetmaker Jonathan Gostelowe assembled some of the finest serpentine chests using large polygonal ogee bracket feet and cantered corners with fretwork.

In the South, the unique colonial form of the mahogany library-bookcase (Museum of Early Southern Decorative Arts) is a reminder of Charleston's once-strong ties to English taste. Made between 1755 and 1775, it copies almost line for line Plate 93 of the 1754 edition of Chippendale's *Director.* In the top case, two smaller sections flank a taller mid-section. The three compartments house shelves, and the doors are fitted with glass decoratively outlined with a stylized Gothic

Large carrying handles were commonly found on case pieces such as this mahogany block-front chest of drawers from Boston, circa 1760.

motif in the mid-section—appropriate since a Gothic motif was favored on library pieces. The flanking compartments have a foliate Rococo motif. Combined with the fretwork on the lower case, these details exemplify how a single object might combine the entire mélange of Chippendale ornament.

Bombé or kettle-shaped bases, on the other hand, were peculiar to the Boston-Salem area. Recognized by their outward bulging sides and fronts, *bombé* chests transcended standard fare because they were up to date in both form and ornament, which happened infrequently in colonial work.

SEATING

Chippendale chairs changed their form as well as their ornament, and the details that point to a successful composition include:

- a pleasing silhouette (often determined through the "squint test" that eliminates superfluous detail);
- balance between solid and void spaces in the pierced splat;
- easy transition between components (skirt to legs, for example); and
- carving appropriate in scale and execution.

Broken down into components, crest rails took the shape of bows that terminated in ears at the corners. Seat frames were square, and

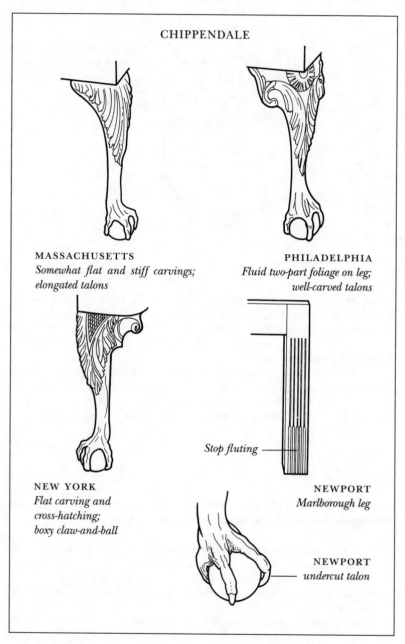

CHIPPENDALE

MASSACHUSETTS
Somewhat flat and stiff carvings; elongated talons

PHILADELPHIA
Fluid two-part foliage on leg; well-carved talons

NEW YORK
Flat carving and cross-hatching; boxy claw-and-ball

Stop fluting

NEWPORT
Marlborough leg

NEWPORT
undercut talon

In the Chippendale style, each region expressed different preferences for leg and foot treatments. Most of these decisions were made jointly by the cabinetmaker and his patron.

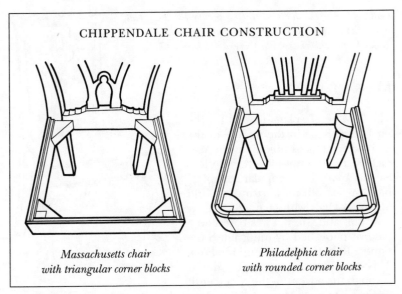

CHIPPENDALE CHAIR CONSTRUCTION

Massachusetts chair
with triangular corner blocks

Philadelphia chair
with rounded corner blocks

(left) Interior view of Massachusetts seat-frame construction featuring triangular corner blocks. (right) Interior view of Philadelphia seat construction featuring rounded corner blocks.

the overupholstered seat became popular. Stiles straightened out, losing the hoop shape that marked Queen Anne predecessors. Carving could be as simple as a single shell or as complex as all-over acanthus or foliate detail.

Cabriole legs and claw-and-ball feet on Chippendale chairs were holdover features from the Queen Anne style. In fact, they became even more bird-like with long, raked talons. The whorl foot and Marlborough leg were fashionable options. The hairy paw foot was a rarer option, appearing on high-style Philadelphia work and even less frequently on Massachusetts chairs. Knees lost a measure of fluidity and took on a more sharpened stance. The largest portion of Chippendale chairs provided vertically positioned splats. They were carved in a variety of ways ranging from interlaced loops and Gothic tracery to ruffles or ribbons. The opposite of vertically arranged splats, chair backs with thin, horizontal pierced splats were known as riddle backs and were the Chippendale equivalent of the slat- or ladder-back chair popular earlier in the eighteenth century. Unlike earlier slat-back chairs that received their inspiration from Dutch prototypes, the undulating lines of the Chippendale riddle-back chair were derived from more angular Chinese chairs.

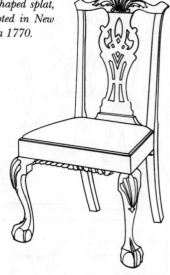

Gadrooning across the front rail, a diamond-shaped splat, and square claw-and-ball feet are typically noted in New York Chippendale chairs, like this example, circa 1770.

MASSACHUSETTS

The "owl's-eye" splat—named for the bird's-eye shape in the middle of the pierced splat—was ubiquitous in Massachusetts, especially in the Boston-Salem area. This popular template pattern spread to Portsmouth and Maine. A chair with characteristically thin rails and stiles, it was based on a pattern published by the English designer Robert Manwaring in 1765. This was a popular style that endured through the advent of the nineteenth century. On most Massachusetts chairs, the side and front seat rails are tenoned into the upper part of the front legs. Cut with the horizontal grain, triangular corner blocks were glued and nailed to the square seat frame to provide another measure of support.

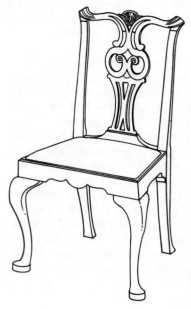

NEWPORT

Newport was perhaps the slowest in embracing the Chippendale style. Many chairs retained their stretchers and hoop-shaped backs, commingled with the more timely Chippendale pierced splats and ears. Stretchers and knee carving are flat, resulting from the depressed *intaglio* technique, in which the carving is worked into

With its distinctive circular designs, this chair splat is nicknamed "the owl's eye." Thin seat rails and owl's-eye splats were especially popular in the Boston-Salem area. The simple pad-like feet were an option that was likely decided by the purchaser.

the leg rather than projecting from it, as does carving on most Chippendale legs. The cabriole legs have four flat sides, another characteristic of Newport workmanship. The rear legs and seat are square.

Another type of Newport side chair was more up to date. Reminiscent of the owl's-eye splat chair from Massachusetts, the Newport version has eyes less crossed than those on the Massachusetts chair, projecting downward instead. The Newport rendition was more rectangular due to stop-fluted Marlborough legs, a type of squared leg in which part of each concave hollow is filled in with reeding (reeding is the opposite of fluting and consists of tightly gathered vertical convex lines), resulting in both positive and negative space. Most of these chairs were made in mahogany, with walnut as second choice.

The square seats were either slipped into the frame or overupholstered. In addition to the stop-fluted legs, a cross-hatched crest, fine scrolls, and shallow carving were the specialty of John Townsend. This chair is admired today for its clean silhouette. It has the ability to convey a Chippendale message in a decidedly sleek way. Its clean outline portends the Neoclassical designs that followed in the early nineteenth century.

CONNECTICUT

Connecticut chairs integrated influences from several regions. Hartford chairs, for example, share some features with Philadelphia models. Cabinetmaker Eliphalet Chapin, trained in Philadelphia, was instrumental in imparting through-tenons, stump rear legs, interlaced scrolls, and shell-carved crests onto native Connecticut cherry. Another Connecticut tendency is flared rolled-back ears.

NEW YORK

Regional nuances on New York chairs include rear legs with a slight flare or kick-back (also called hooved legs) at the bottom, and seat frames that were often sculpted with gadrooning, or thickly applied repetitive carving. The broad proportions of the seat and knees closely followed the format of English George II chairs. The cabriole leg was the preferred shape, and the foot had a boxy claw-and-ball terminus. Some colonial models retained their outdated compass seats. Several popular chair-back designs included a pierced splat with a diamond intersecting interlaced loops and those with a strong Gothic flavor. New York, like Philadelphia, expressed a heightened demand for Gothic ornament. Chippendale's *Director* inspired many of these designs, as did imported chairs. Plate 15 of the *Director,* for example, was the impetus behind New York chair splats with carved tassels and pendant ruffles.

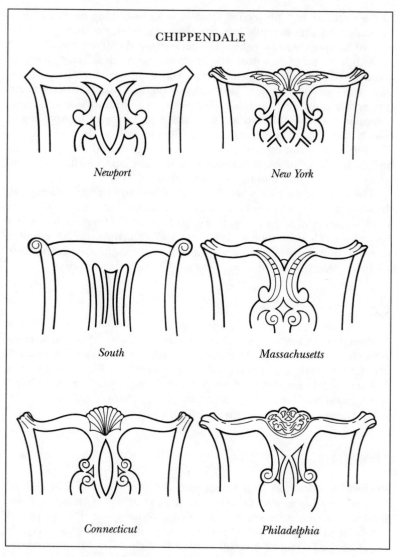

Regional Chippendale chair-back designs featuring pierced splats. The shape of the splat as well as that of the scrolled ears differed from one region to another.

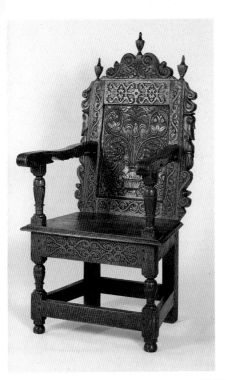

This oak wainscot or great chair is the finest extant example of a seventeenth-century joined chair. The distinctive carving is the work of William Searle, who, together with Thomas Dennis, is known to have favored its strapwork-inspired design. (Courtesy The Bowdoin College Museum of Art, Gift of Mr. Ephraim Wilder Farley.)

With its tall case of stacked drawers resting on turned legs, the status-affirming highboy marked the beginning of the modern era of cabinetmaking. Its vertical design was an innovation of the William and Mary period, during which the mortise-and-tenon method of assembling furniture was replaced with the dovetail joint. Because it was an important indicator of wealth, it would have been placed in the best parlor, which was customarily designated a "public" space.

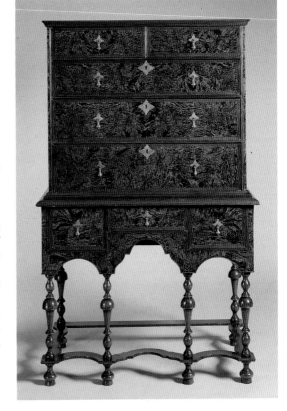

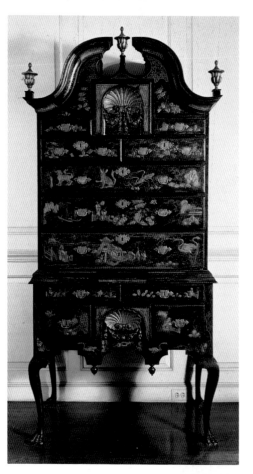

Called the Pimm highboy after its maker John Pimm, this signed japanned high chest from Boston is the consummate example of the Queen Anne aesthetic, with scrolled top and cabriole legs. (Courtesy Winterthur Museum.)

OPPOSITE PAGE, CENTER
Known as the Thomas Willing Chippendale carved mahogany card table, this extremely artistic form, which retains its original Rococo brass handles and inset keyhole, is one of a select group of approximately five masterfully carved Philadelphia pieces believed to have been carved by the same individual. Combined with an important provenance, this table depicts fashionable Rococo decoration as defined by eighteenth-century artisans.

Tray-top tea tables originated from Chinese trays on stands, and are some of the most collectible examples of Queen Anne cabinetmaking to be found. Many of the finest models were made in New England, and their thin, graceful cabriole legs lend these small, portable tables a sculptural outline that many aficionados consider their most beguiling feature.

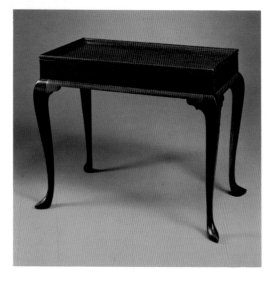

Every beautiful detail on this thoughtfully designed mahogany Chippendale side chair, circa 1770, is of the finest magnitude. The carved foliage that meets in the center of the knee and the articulated talons grasping a flattened ball are regional traits of Philadelphia workmanship. The gadrooned shoe that holds the vase-form splat and the carved shells gracing the crest and seat rails made this example one of the most expensive of its era.

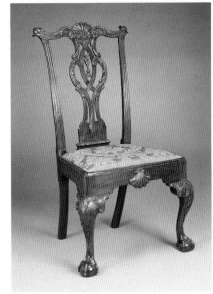

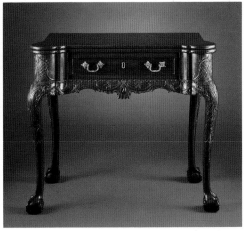

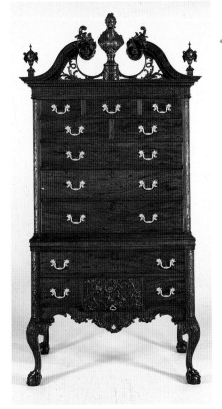

One of the most sophisticated high chests ever made in colonial America in the Rococo style, this beautifully proportioned case piece is referred to as the "Pompadour highboy" for the portrait bust of a supposedly French character that sits on the pediment. The exceptional carving was probably the work of an English-trained carver who was employed in that capacity in Philadelphia. (Courtesy The Metropolitan Museum of Art, John Stewart Kennedy Fund, 1918. Photograph by Richard Cheek.)

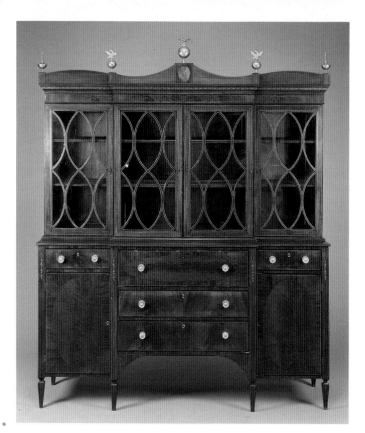

This breakfront bookcase, occasionally called a gentleman's secretary, demonstrates the fineness of scale inherent in the Federal style, circa 1800, and this form was a specialty of Boston-Salem cabinetmakers. The pointed oval muntins, as well as the contrasting oval veneers in the lower case, reinforce the emphasis placed on symmetry and geometry in this early Neoclassical period.

This celebrated rosewood, satinwood, and mahogany swivel-top card table, New York, circa 1815, is attributed to Charles-Honoré Lannuier. It is likely that the winged figure and animal-paw feet were derived from French print sources. The juxtaposition of the gilded surfaces with brass-and-ebony-inlaid borders are labor-intensive traits long the practice of the French ébéniste.

Made in 1809 by Thomas Seymour for the Derby family of Salem, this European-inspired form was a collaborative effort among cabinetmaker, painter, and carver, mirroring high-style Massachusetts artistry. The lunette on the top of the case and shells were painted by John Ritto Penniman. (Courtesy Museum of Fine Arts, Boston, Gift of Martha Codman.)

This maple and painted klismos chair, attributed to makers John and Hugh Finlay, offered the form that Empire chairs followed consistently. This version is a successful compromise between the delicate proportions of ancient Greek models and a more masculine Roman rendition. (Courtesy The Metropolitan Museum of Art, Purchase, Mrs. Paul Moore Gift, 1965.)

Derived from a Continental form, the secrétaire à abattant, or desk with a fall-front writing surface, was popular mainly in New York, Philadelphia, and rarely, Boston. Given the high quality of its materials and workmanship, this example was probably a product of the Duncan Phyfe workshops. (Courtesy The Metropolitan Museum of Art, Gift of the Manney Collection, 1983.)

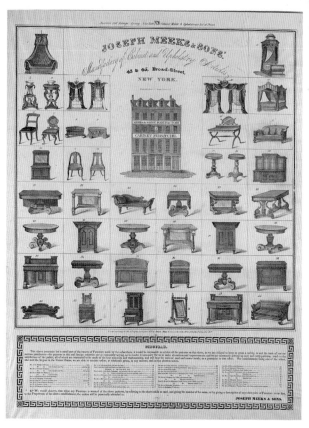

Joseph Meeks & Sons advertised a large assortment of the heavy, plain furniture that characterized the Restauration or Pillar and Scroll style in this 1833 broadside. Many firms around the country turned out pieces in this format, and, thanks to the newly implemented mechanization of parts, middle-class consumers could own fashionable furniture on a timely basis and at an affordable price. (Courtesy The Metropolitan Museum of Art, Gift of Mrs. R. W. Hyde, 1943. Photograph by Paul Warchol.)

Attributed to John Henry Belter, this rosewood side chair has all the attributes of the Rococo Revival style: laminated wood, cabriole legs, scrolled feet, and lacy arabesques in a tall back, all worked into a curvaceous body. (Courtesy The Metropolitan Museum of Art, Gift of Mr. and Mrs. Lowell Ross Burch and Jean McLean Morron, 1951. Photograph by Paul Warchol.)

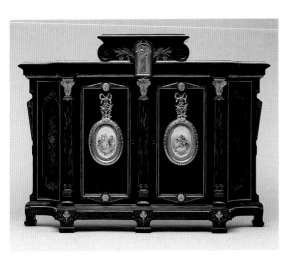

Made by premiere cabinetmaker Alexander Roux, this imposing Renaissance Revival credenza or cabinet is an eclectic and harmoniously blended form. The collection of materials used in its making include rosewood, ebonized cherry and poplar, gilt bronze, and XVI-inspired porcelain plaques. Like earlier colonial court cupboards and high chests, this is an object of status as it was interpreted in the second half of the nineteenth century. (Courtesy The Metropolitan Museum of Art, Purchase, The Edgar J. Kaufmann Foundation Gift, 1968. Photograph by Schecter Lee.)

OPPOSITE PAGE, BOTTOM
This Gothic Revival couch with one enclosed end is of the récamier type, due to its asymmetrical design. Pierced stiles, clustered finials, and a trefoil crest are conclusively Gothic details recalling the spire or steeples of medieval cathedrals. (The Metropolitan Museum of Art, Friends of the American Wing Fund, 1983.)

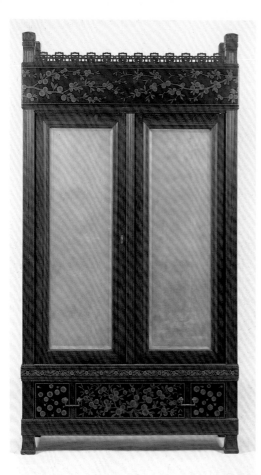

Case forms such as this one by the top-tier firm Herter Brothers illustrate the simplicity of form and ornament which came to dominate furniture in the Aesthetic or Art-inspired manner.
Its uncomplicated and relatively flat presence was a marker for late-nineteenth-century Design Reform furniture.

Conceived by Frank Lloyd Wright, these chairs showcase the architect's unique spatial perspective by creating a design of essentially level planes or surfaces. Whereas most designers working in the Arts and Crafts mode employed obvious construction features such as through-tenons and pegs, these details are usually absent in Wright's designs.

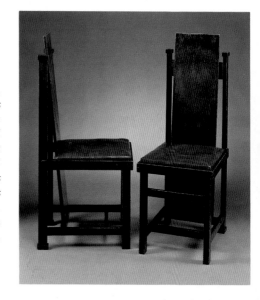

PHILADELPHIA

As was the case in Queen Anne seating, strong contrasts are found between Philadelphia and Newport chairs of the Chippendale persuasion. They lean toward the ornamental and sculptural, respectively. Stump rear legs were the only holdover from the Queen Anne style. Crest rails, splats, and seats were fully fashioned Chippendale components. Tenons were mortised through the rear leg and exposed through the back of the stiles. Vertically grained corner blocks were affixed to the inside of the square seat frame.

Philadelphia chairs are also noted for their sinewy claw-and-ball feet with smooth knuckles and highly organic carving. These components contrast with the stylized, low-relief carving found on New England chairs. With some exceptions, three template patterns were used for Philadelphia splats: a baluster with scrolled strapwork; Gothic tracery; and a vase or baluster with uninterrupted lines.

NEW JERSEY AND MARYLAND

Chairs made in New Jersey and Maryland were influenced by those made in Philadelphia. Maryland cabinetmakers in particular simplified the Philadelphia form while exaggerating other features. Broad proportions, broadly flared ears, and straight legs with H-shaped stretchers typify countless Maryland chairs.

CHARLESTON AND THE SOUTH

Southern chairs were generally rectilinear with square slip seats. H-shaped stretchers and straight legs predominated; the cabriole leg with claw-and-ball foot was an occasional option. Some Virginia chairs resemble provincial English hall chairs with their tall and

Attributed to maker Thomas Tufft, this is one of the most graceful of all Chippendale chair designs. An extremely sophisticated chair with a pierced Gothic-inspired splat, this chair would have graced the best parlor in a Philadelphia home.

Flared-back ears, vertically ribbed splats, and H-shaped stretchers characterize designs and craftsmanship employed in the South. However, the upholstered slip seat, like the kind on this Chippendale chair from North Carolina, was standard on chairs from all geographical areas.

predominantly square shapes, elements especially notable in the Virginia crest rail, which was straight or only gently curved. The back was moderately flared and designed with flat stiles. Four vertical ribs made up the splat, with horizontal bars at midpoint on some versions. Circular, tightly scrolled ears are another feature that point to southern craftsmanship.

As previously stated, Charleston patrons strongly favored English fashion. Most Charleston chairs, therefore, were made with straight legs and stretchers based on English precedents. A large group of Charleston chairs have straight stiles and softly modeled ears. Intricately looped splats of the finest order were the hallmark of Thomas Elfe.

OTHER SEATING FORMS

EASY CHAIR

Period usage continued to dictate that the easy chair was a form designed foremost for use in the bedchamber. Very rarely, easy chairs in Philadelphia were made with carved seat rails and arm supports, suggesting that these high-style models may have been displayed in a more public setting. In general, models with C-scrolled arm supports point to Philadelphia, vertically rolled arms characterize New England models, and broad proportions and flared wings suggest New York. Additive Chippendale features include ornately carved cabriole legs.

SOFA

The sofa, the most stately piece of colonial upholstered furniture, was still reserved for the households of the well-to-do. Philadelphia and New York artisans turned out two handsome shapes. The New York model was constructed with a deeply serpentine back and curved front rail. A coveted Philadelphia form was a sofa with three cuffed front

Until the nineteenth century, sofas were largely a luxury reserved for the wealthy and their upscale households. The sweeping curves of this mahogany-upholstered sofa from Philadelphia place it firmly in the Chippendale period.

legs (Marlborough type) and straight stretchers. A serpentine back, which was also known as a camel back with double peaks, provides a degree of movement inherent in the best Chippendale examples.

TABLES

PEMBROKE TABLE

Some pre-existing table forms underwent changes that brought them up to date with current Chippendale designs. The Pembroke table, popularized in the *Director,* was a variant of the drop-leaf table. It is smaller than a drop leaf, and its center section is usually wider than the leaves. Earlier drop-leaf tables reversed these proportions. Designed as a breakfast table or occasionally for use in serving tea and small meals, the standard Pembroke table has square Marlborough legs, two hinged leaves, and a drawer. Philadelphia examples follow Chippendale's illustrations, integrating flat pierced stretchers and scalloped edges on the leaves, whereas Rhode Island versions include pierced X-shaped stretchers, stop-fluted legs, pierced brackets, and straight leaves.

SPIDER-LEG TABLE

A new form associated with New York was the spider-leg table. A delicate and almost painfully thin form, it was based on a popular English

design. It is characterized by a small-scale, square mahogany top, and thin turned legs joined with equally thin stretchers. Compared to the elaborate organic carving and curvaceous forms found on other Chippendale tables, this form is decidedly straight and quiet, prefiguring the arrival of the delicate Federal style that followed in the 1790s.

FIVE-LEGGED CARD TABLE

The sculptural five-legged card table was a specialty of New York shops. The strong modeling of this form puts it at odds with the highly architectural component of most New York case furniture. A unique fifth leg swings open to support the opened top. Strong cabriole legs with blocky claw-and-ball feet were attached to a mahogany veneer on a beech body. Serpentine curves on the sides and top soften blunt corners. The knees were often decorated with acanthus and C-scroll carving. Cross-hatching on the knees was another New York quirk, as was gadrooning, or swirled fluting, across the skirt.

TEA TABLE

Tea tables were still heavily sought after, thanks to the social craze of drinking tea, which was reaching near-mainstream acceptance. Two

The kidney-shaped nugget in the center of this card table's apron, known as the Philadelphia peanut, is thought to have been introduced in the 1750s.

Stop-fluted Marlborough legs and clean yet graceful proportions were the understated aspects of Newport artistry. This serene table appealed to the conservative tastes that generally prevailed in New England even in the Chippendale era.

forms prevailed: the rectangular form that grew out of the earlier tray on a stand and the round, tilt-top variety.

RECTANGULAR TEA TABLE

On tables of the first type, turreted corners are found on Philadelphia and Massachusetts tea tables, with the turret top being highly coveted in Boston. One Massachusetts example of this form (Boston Museum of Fine Arts) avoided the straight line in any plane. In addition to the top, the entire apron of the mahogany skirt is turreted, juxtaposing positive and negative alternating spaces for fourteen cups. Besides the turreted corners, delicate attenuated legs are another Massachusetts hallmark. Aside from Boston, highly skilled English cabinetmakers were busy in Portsmouth creating pieces with Chippendale aspirations, and their work reflects that city's once-strong economic position and ability to lure first-rate artisans. One example, a tea or silver table from Portsmouth, is taken directly from Plate 34 of the *Director*. This unusual form in colonial work, of which only a handful of similar ex-

TURRET TOP

From a bird's-eye view, this turret top avoids the straight line completely and produces a highly sculptural design. Tables with turret tops convey a sense of movement and set up positive and negative space within the same object.

amples are extant, consists of a rimmed rectangular body of mahogany with a pierced-fret gallery surrounding the top. Four Marlborough legs are enhanced with decorative brackets where they meet the skirt, and a domed stretcher made up of double C-scrolls is topped with a spiral finial designed to clear the floor and provide foot room while standing at the table. Utility and ornament peacefully coexist to make this an enduring statement of a Chippendale form.

Piecrust Tilt-Top Table

Although tilt-top tables were made in many locales, Philadelphia cabinetmakers excelled in the design of the piecrust tilt-top form, the second variety of tea tables. Along with the high chest, the form is associated with the finest Philadelphia artistry of the colonial period. A piecrust top has scalloped edges that resemble the crust of a pie. To enable the top to tilt, the top sits on a birdcage support made up of

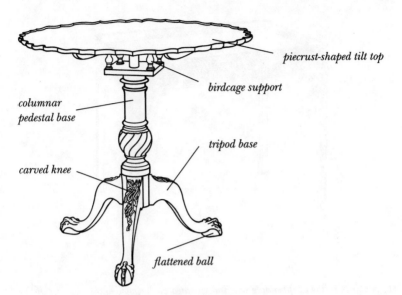

piecrust-shaped tilt top

birdcage support

columnar pedestal base

tripod base

carved knee

flattened ball

"Piecrust" is the name given to the scalloped edge of this tilt-top tea table. An especially popular form in Philadelphia, these tables are judged for the quality of the scalloped top as well as for the shape and carving of the legs and pedestal.

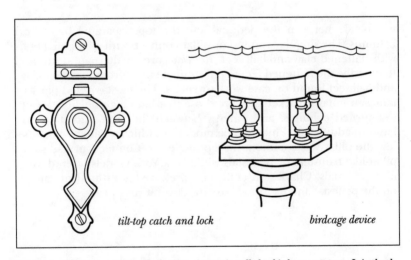

tilt-top catch and lock

birdcage device

This small component beneath the piecrust top is called a birdcage support. It is the device that permits the top to tilt and pivot.

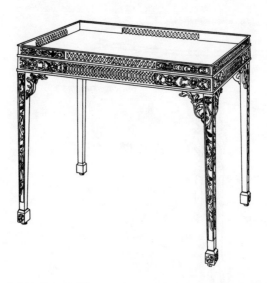

Many objects in the Chippendale style incorporated one or more of the three decorative influences—French, Gothic, and Chinese. The pierced fretwork on this mahogany china table from Williamsburg, Virginia, circa 1765, is typical of the Chinese influence, while the delicate floral carving suggests the "modern French taste."

two blocks between the pedestal and the top, separated by vertical columns. The singular column or pillar connects with a base that ends with flattened claw-and-ball feet. *Rat claws* are an alternate term used to describe the flattened feet to differentiate them from the taller claw-and-ball feet found on case work or chairs. The most coveted piecrust tables in today's marketplace are those that have high quality carving, well-turned columns, and synergy between the table and its tripod base. In addition to Philadelphia models, in which a flattened ball below the pillar was common, tilt-top models in Connecticut had stout, pillar-like balusters or pedestals while New York models offered long, lean pedestals. Charleston craftsmen preferred acanthus-leaf carving on the pedestal and its tripod base for decorative appeal.

\intUMMARY OF STYLE

Dates: 1755–1790
Distinguishing Features: curvaceous forms; organic ornament; claw-and-ball foot; Marlborough leg; pierced splats; French, Chinese, and Gothic novelties
Materials: mahogany

COLLECTOR'S TIPS

1. *Look for (good example):* well-defined claw-and-ball feet; successful use of figured wood, especially mahogany
2. *Look for (outstanding example):* carving integrated with the form; bonnet-top case pieces with foliate detail made in Philadelphia and the South for their especially ornamental quality; New England pieces for their sculptural quality
3. *Problems/what to watch out for:* alterations made in ornament or form to make the object more desirable, including addition of carving or changing flat edge to a scalloped one. Pierced splats are prone to heavy repairs, as are legs and feet. Chair crests and stretchers on legs are other vulnerable areas. As in the Queen Anne style, many forgeries abound. Another problem area includes the interior of desks and secretary-bookcases, in which the writing compartment has been restored. Any object that comes in parts (highboys, for example) stands a chance of having had the parts separated at some point and increases the likelihood of fakery. Tops are commonly replaced.
4. *Conservation issues:* Thin wood fretwork is very fragile, especially on Gothic pieces; applied carving of foliate nature is also fragile.
5. *Cabinetmakers/firms important to style:* Goddard-Townsend school, Thomas Affleck, Bernard and Jugiez, Thomas Elfe, Eliphalet Chapin, John Cogswell, Benjamin Frothingham, Benjamin Randolph
6. *Where public can see best examples:* Metropolitan Museum of Art, New York, New York; Boston Museum of Fine Arts; Winterthur Museum, Wilmington, Delaware; Yale University Art Gallery, New Haven, Connecticut; Chipstone Foundation, Milwaukee, Wisconsin; DeWitt Wallace Collection, Rhode Island School of Design, Museum of Art, Providence, Rhode Island; Hennage Collection, Williamsburg, Virginia
7. *Department expert wish list:* Salem or Boston bonnet-top highboy, lowboy from same area; blocked chest; high-style Philadelphia highboy or lowboy; Williamsburg or Portsmouth tea table with fretwork gallery
8. *Miscellaneous:* When evaluating Chippendale or any period, consider (1) quality; (2) rarity; (3) condition; and (4) provenance (written or oral history authenticating a piece).

\mathcal{F}EDERAL FURNITURE
(1790–1815)

A dramatic shift in American furniture was spawned by changes that occurred in English and French furniture in the late 1760s. This trend was influenced by the discovery of classical antiquity in late eighteenth-century archeological digs at Herculaneum and by the unearthing of the Pompeiian ruins. In the Western world, this romantic design philosophy is called Neoclassicism.

Neoclassicism, or *le style antique,* as it was dubbed in Europe, was introduced to America shortly after the Revolution. Federal furniture, as one part of this influence, borrows a term that was used to describe the new nation and its central, or "federal," government. Federal furniture is, therefore, part of the iconology that heralded America's transformation from a colonial dominion to that of an autonomous nation. Along with the Empire and Pillar and Scroll styles that followed, it forged one of three critical pathways that marked the progression of Neoclassicism in American design.

Whereas in the colonial era, transatlantic transmission of style came foremost from the British Isles, during the Federal period France would come to influence design trends to a degree unequaled in the past. A growing cadre of intellectuals disseminated the credo of Neoclassicism, and one of the most influential was the Scottish architect and designer Robert Adam. After a four-year stint in Italy, Adam returned to England fully entrenched in the classical idiom. In 1773, Adam, along with his brother, authored *The Works in Architecture of Robert and James Adam, Esquires.* Part of this Neoclassical mandate was concerned with design integration; interiors should reflect the exterior, and all fixtures and furnishings were microcosms of this decorative scheme. No detail was considered trivial enough to elude the intense scrutiny of the classically trained architect. A room was broken into a series of squares, rectangles, circles, and ovals by the manipulation of symmetrical ornament, plaster work, and paintings. Floor cov-

erings repeated ceiling designs. Originally designed for the great English country estates, Adam's philosophy was introduced to a broader middle-class market by a host of pattern books.

As in the Chippendale years, imported pattern books were the primary mode of style transmission. This reversed the transmission patterns set by imported objects and immigrating craftsmen that marked earlier colonial furniture. The most famous pattern books to disseminate Adam's Neoclassical message were George Hepplewhite's *The Cabinet-Maker and Upholsterer's Guide* of 1788 and Thomas Sheraton's *The Cabinet-Maker and Upholsterer's Drawing Book* (1791–1794). Hepplewhite's *Guide* and Sheraton's *Drawing Book* did for the Federal style what the widely circulated *Director* did for Chippendale design. Hepplewhite and Sheraton did not execute the designs that bear their names. Like Chippendale, they created a forum for design integration and dissemination. Hepplewhite's drawings depicted furniture with straight, tapered legs and spade or flared bracket feet. Chair backs consisted of curvilinear shield, oval, and heart-shaped patterns. Light wood "stringing" (a narrow band of inlay), marquetry, or inlay on dark woods were also noted. Sheraton's *Drawing Book* emphasized the rectangular shape; square-back seating predominated, and legs were straight. Reeding, a series of convex vertical lines, was the reverse of eighteenth-century fluting, a series of parallel channels. A Sheraton signature was a color field using contrasting light and dark woods.

Antiquarians often refer to pieces as being in the Hepplewhite or Sheraton style, which is appropriate for English work. Due to the hybrid nature of American furniture, however, it is preferable to describe early nineteenth-century pieces spanning the years 1790 to 1815 as early Neoclassical or Federal due to overlaps in time and treatment that would render English labels inaccurate. The broader Federal label acknowledges that objects of this time frame are an agglomeration of several influences. American Federal furniture is noted for its fineness of scale, reaching in some pieces excessive leanness. Additional components include classical symmetry, delicacy, and geometric shapes. The sense of movement that prevailed in eighteenth-century furniture dissolved as highly linear stringing and banding worked to box in or restrict the eye to a series of geometric arrangements. Case work lost most of its architectonic undertones while chairs and tables were remarkable for their fineness.

The French influence in Federal furniture can be seen in the work of Charles-Honoré Lannuier, a French *émigré* who settled in New York in 1803 and remained active until 1819. He began producing furniture for an American following that was derived from the French *Directoire* style, named in honor of the five leaders who governed France immediately following the Reign of Terror. The *Directoire* style was a more banal rendition of the opulent Louis XVI style that relied on simple,

straight lines and delicate, symmetrical ornament. New York was to be outdone only by Philadelphia in its taste for things French. Philadelphia was, in fact, the only city in Federal America to passionately embrace the Louis XVI style. Lannuier continued the practice of labeling or stamping his work, a procedure that was the habit of his mentors.

Federal carving is the antithesis of flowing, organic Rococo compositions; it is decidedly less sculptural and less pervasive, absent altogether on some pieces. And in another about-face from the Chippendale style carving that preceded it, shallow-relief carving on Federal forms was integrated with the surface instead of projecting from it. Inlay supplanted carving as the most important decorative process in the Federal style, reaching a level of sophistication in the early nineteenth century that has yet to be outdone in American orchestrations. The inlay process creates designs on the surface by mixing grains, color, or texture. The technique ranges from applying patterns to solid wood to mixing small pieces of veneer and affixing them to a backing. It was well suited to the straight lines of Federal forms. Inlay can be classified by the patterns it takes: Wood mosaics that form geometric patterns are called parquetry while pictorial designs are usually called marquetry and include flowers, shells, and any non-linear design. Stringing is used to highlight broad surfaces like drawers.

As a point of connoisseurship, inlay is a very exacting pursuit, and its beauty is best appreciated on the actual object rather than a secondary source such as a photograph. Each geographic region had preferences for particular inlays, but it is wise to avoid making regional attributions based solely on inlay work since remarkably similar patterns were made both domestically and imported.

Federal motifs drew inspiration from antiquity: Swags, ribbons, urns, paterae (round or oval forms arranged in radiating patterns), and Prince of Wales feathers were ubiquitous. Neoclassical design

EXAMPLES OF STRINGING (INLAY)

Stringing, a thin band of inlay, was used as an accent on Federal case work, seating, and tables. These decorative bands were made both locally and imported, so it is wise to avoid an American attribution based on this feature alone.

mandated that these motifs be applied symmetrically and repetitively. The eagle motif was a popular one, crossing many mediums to include carving, gilding, and inlay. Whether stylized or naturalistic, it appeared throughout the decorative arts of this time frame. While the eagle is thought to be the definitive motif of American Federal furniture, it was clearly part of a larger opus of Neoclassical ornament that was borrowed from antiquity. On a broad level, many objects are often misattributed as American for this reason. Since English work often used this symbol, any American attribution based solely on an eagle motif is overzealous.

In the use of materials, there was a gradual shift away from mahogany to light-colored woods such as satinwood, beech, and bird's-eye maple. These light woods provided color field contrasts with mahogany. Ebony was used sparingly to exaggerate small details such as spade feet, and rosewood occasionally replaced mahogany. Painted surfaces were a fad with a small group of aesthetes in Baltimore and, on a limited basis, with patrons in Boston. Hardware was less ambitious than that on Chippendale pieces. By reiterating the geometry of the forms to which they were attached, oval brasses with bails or rosettes with rings were a logical choice for drawer pulls.

REGIONAL VARIATIONS

Unlike Paris or London, where styles were the outgrowth of a singular ruling taste with limited cross-fertilization across borders, the diffused American geography had no single style center. Further, the population included more and more immigrants from England, Scotland, Ireland, and the Continent, all with differing aesthetic proclivities. These influences worked to foster regional preferences. In addition, many American cabinetmaking shops began to build inventories that, based on economies of scale, may have nurtured regional routines. The custom of labeling furniture, largely sporadic up to this point, soon became more widespread, providing important clues to regional practice.

New England clientele remained conservative in taste and spending. Economically, the region was less well poised than it had been earlier in the eighteenth century. Furniture in the older styles was too expensive to be cast off with each approaching fashion. Consequently, new Federal forms coexisted with dated ones, or older pieces were remaindered in less public places. In Newport, the Goddard sons carried on the legacy of their father, John, but the town was no longer a leader in the furniture trade, due partly to the general economic decline that affected the region. Newport was upstaged by larger, wealthier cities such as Philadelphia and later, Baltimore, which began its rise to economic prosperity in the early nineteenth century.

Opposed to prevailing conditions in the region, the New England city of Salem saw its status advance mostly because of its prosperous maritime activities. Home to shipping magnates, Elias Hasket Derby among them, the city became synonymous with Federal design both in architecture and the decorative arts. As America's first millionaire, Derby kept artists from Salem to Philadelphia busy furnishing his house with all the luxuries the China trade afforded this savvy merchant. Samuel McIntire, an architect and carver, was the principal behind the design schemes for Derby's home and attendant furnishings. McIntire, who executed his own carving and ornamental detail, is remembered for his distinctive style of carving that often featured a basket of fruit, cornucopia, and snowflake-punched backgrounds. Using his training in architecture, he was able to form a symbiosis between the architecture of a room and its furniture, achieving a harmonious result. This New England furniture is admired for its elegant, slender line.

Other pre-eminent cabinetmakers working in the Federal style included Englishman John Seymour and his son, Thomas, who worked in the Boston area. Along with McIntire, they turned out some of the best crafted and aesthetically endearing forms. The Seymours' work is characterized foremost by exceptionally fine inlay.

CONNECTICUT

In Connecticut, Eliphalet Chapin and his son, Aron, made the transition to the Federal style. Cherry continued to be a favorite material, and a popular inlay pattern featured wavy lines shaped as pinwheels.

NEW YORK

Along with Charles-Honoré Lannuier, another name that has been indelibly wed to the Federal style in New York was Duncan Phyfe. A Scotsman, Phyfe came to America in approximately 1783, settling first in Albany, then in New York City by 1790. He was both a skilled craftsman and an expert merchandiser, turning out exquisitely crafted and delicate mahogany forms incorporating reeding (rounded convex lines in the shape of vertical reeds). In addition to excellent craftsmanship, lyre, leaf, plume, and bowknot motifs are associated with his work. As testament to his merchandising skills, his New York shop employed more than one hundred artists and journeymen in an age when furniture retailers were only beginning to grow from shops employing fewer than a dozen workers to complex enterprises. With so many journeymen working in the reeding technique, Phyfe influences can be seen in the furniture of other New York cabinetmakers, includ-

ing that of Michael Allison and George Woodruff, who undoubtedly employed many of Phyfe's one-time journeymen.

PHILADELPHIA

In Philadelphia, Henry Connelly and Ephraim Haines helped make the transition from sensual, free-form design to broad, unadorned geometric surfaces by using large contrasts between light and dark veneers and stringing. Separately, cultural links between France and America grew during this period, prompting Francophiles such as Jefferson, Monroe, and Adams to seek out imported French furniture or commission pieces made in America in the French style. Extremely straight forms with raised-gilt decoration and light-colored painted backgrounds made up the majority of pieces in the French Louis XVI and *Directoire* formats characterizing Philadelphia furniture in the early nineteenth century.

BALTIMORE

Prior to the Revolution, Baltimore artists labored under the stylistic preferences of Philadelphia. In the early nineteenth century, however, Baltimore became an independent style center. Patrons did not, for example, endorse as strongly the French-inspired designs popular in Philadelphia. Baltimore furniture, instead, forged a kinship with contemporaneous English examples. A select group of ladies' secretaries are lifted from Sheraton's designs. The technique of *verre églomisé*, or reverse (usually pictorial) painting or gilding on glass, was another Baltimore trait occasionally seen in New York objects of the same period. One inlay pattern that appears frequently in Baltimore furniture is the bellflower with an elongated central petal.

A London fad that caught on in Baltimore was painted, or "fancy," furniture, the nineteenth-century equivalent of japanned furniture. Representational landscapes, flora, and bows were rendered in polychrome paint, contrasting significantly with the delicate floral motifs that were popular in Boston. Brothers John and Hugh Finlay of Ireland practiced this technique with great success in Baltimore.

CHARLESTON

In the South, Charleston continued to acknowledge its penchant for designs following the English paradigm. After the Revolution, the city began to import domestically made objects from Philadelphia and

New York that influenced local craftsmen, especially in their choice of inlay. Consequently, there is a strong correlation between some Charleston and New York chairs, namely those of the shield-back variety. Rice pattern inlays are usually attributed to the Charleston area, symbolizing the economic importance of the grain to that region.

CASE WORK

One of the biggest changes in Federal case furniture was the demise of the high chest as the definitive storage form. The wide, low chest supporting a slightly narrower upper chest had run its course stylistically from the box-like structures of William and Mary designs to the more curvaceous bodies of Queen Anne and Chippendale work. The high chest was replaced by the chest-on-chest or double chest of drawers, a form with a large surface area well suited to decorative geometric partitioning and color-field contrasts using inlay and alternating light and dark woods.

MASSACHUSETTS

A group of chest-on-chests commissioned by Elias Hasket Derby reign as the models of early nineteenth-century cabinet work thanks to the quality of workmanship and ornament. These high chests share the characteristics of a serpentine lower section standing on elaborately carved ogee bracket feet, an upper case with straight drawer fronts, highly figured matched mahogany veneers, and carving of the highest order. This group of chests, which is believed to number four, is also remarkable for being the cooperative output of disparate specialists with specialties in cabinetmaking and carving. Among the names associated with this impressive group of chest-on-chests are cabinetmakers William Lemon and Stephen Badlam and carvers John and Simeon Skillin and Samuel McIntire.

Salem was a mecca for Federal case work, and another notable example is the Derby family demilune commode (Boston Museum of Fine Arts). While in keeping with the geometric format that typified the era, the demilune form was rare in American cases. The demilune is a half-round shape in plan and typifies most commodes or low-standing chests of drawers used in Europe. The presence of the demilune form in Salem signifies how quickly the Neoclassical style was assimilated, even if some forms were the cache of an exclusive few. Made in 1809 by Thomas Seymour of Boston, it boasts mahogany and veneers of mahogany, maple, and satinwood. John Ritto Penniman, a Boston artist, was selected by the Seymour shop to paint decorative shells in a lunette on the top of the case. The painting has a technical quality that

equates it with still-life paintings. Radiating out of the lunette of painted shells are alternating bands of light and dark inlay. Due to the complex nature of the work and the myriad hands involved in the cabinetmaking, inlay, painting, finishing, and hardware application processes, it is difficult to pinpoint every artist associated with a piece

The finest chest-on-chests fashioned in the Federal period were a group of four, of which this is one example. The appliqués *consisting of a basket filled with fruit and flowers are attributed to Samuel McIntire, a carver who executed masterpieces in furniture and architectural carving for Elias Hasket Derby of Salem in the early nineteenth century.*

of this magnitude. Thomas Whitman may have carved the mahogany columns that hold three sections of graduated four-tier drawers. The case is finished with brass animal-paw feet and imported lion's-head pulls that, like most hardware on Federal case work, were imported from Birmingham and Sheffield, England.

As seen on the legs, reeding, or vertical convex parallel lines, was a popular treatment in the early nineteenth century. The overall absence of carving lends this Salem secretary the quiet presence for which Federal pieces are admired.

In Massachusetts, as in many locales, secretary-bookcases lost the mammoth proportions of earlier models. A form known as the Salem secretary after models popular in that city fused the features of a bookcase and cabinet. Given its diminutive size, this desk and bookcase was

Symmetrical arrangements such as the ovals on each door of this linen press from New York, circa 1810, underscore the heavy emphasis on partitioning that was incorporated into Federal furniture. The bracket feet are derived from Hepplewhite designs.

probably made for women. The format consisted of simple linear shapes—a box-like case with curtained glass doors resting on another square base. Simple finials rest on a decidedly flat pediment. The bottom case concealed a secretary drawer, an innovation that replaced the slant-top configuration of previous decades. This feature permitted the writing surface to fold up vertically so that it was indistinguishable from the drawers over which it rests. After years of cabriole legs and claw-and-ball feet, simple splayed bracket feet must have made these objects seem overtly modern. Well-matched veneers accented by simple brasses often define the best examples.

The gentleman's secretary, an expanded version of the Salem secretary, was another popular form in Salem and on the north shore of Massachusetts. The top houses four glass cabinets instead of two. This piece is quintessential geometry in wood—a series of triangles, half circles, and combinations of the two. Compared to the large, scrolled pediments on Chippendale antecedents, the pediment on the gentleman's secretary was restrained, even small. Compact urns or balls replaced open flame finials. Another series of linear compartments made up the bottom case, the center portion of which contained the writing compartment. Next to the writing compartment were storage compartments with surfaces cajoled into a variety of contrasting geometric forms superimposed on one another. Short, thin, turned legs ending in spade feet were an alternative to straight bracket varieties.

Another form seen first in the period was the tambour desk, a specialty of Massachusetts cabinetmaking shops. It is a close approximation of the French *bonheur-du-jour,* a desk that stands on legs, with a flat cabinet and fall-front surface. In American work, the tambour is a compact secretary with sliding doors of heavy cloth on which ultra-thin vertical strips of wood have been glued. It is considered a space-saving design.

The Seymour shop is linked with only a handful of the numerous tambour desks extant, and increased scholarship has narrowed Seymour attributes to exceedingly fine inlay that incorporates rhythmic movement of light and dark patterns and interior pigeonholes that were originally painted robin's-egg blue, although the presence of blue interiors should not be interpreted as conclusively pointing to Seymour authorship.

PHILADELPHIA

Philadelphia secretary-bookcases were more vertically oriented than those from Massachusetts. Prevailing standards included severely geometric cases with contrasting surfaces divided into ovals that in turn are superimposed on yet another series of contrasting surfaces of squares and rectangles. The bottom case often contains large areas of

contrasting light and dark veneers instead of the plain mahogany veneers or smaller color fields that prevailed in New England.

BALTIMORE

Some of the highest style secretary-bookcases were made in Baltimore. One example, lifted from Plate 38 of Sheraton's 1803 *The Cabinet Dictionary*, was known as the Sister's Cylinder Bookcase (Metropolitan Museum of Art). It survives as the most ambitious piece of Federal furniture lifted from an English pattern. The exclusivity of this design to Baltimore, as well as the arrival of the oval-back chair form, strengthens the perception that Baltimore furniture was the most "English" of all.

The body is H-shaped with two narrow cabinets that form the verticals. A rectangular writing compartment with drawers, pigeonholes, and a drop-front writing surface replaces the cylindrical Sheraton design. The top of each vertical pedestal houses a glass door that rests on another cabinet. This cabinet rests on another set of drawers that form an inverted pyramid.

Inlaid satinwood ovals and rectangles set into dark panels typify Baltimore treatment. Each glass cabinet of the Sister's Cylinder Bookcase is reverse painted using the technique of *verre églomisé*. Gilt foliage and a female allegorical figure surrounded by a triangular border are the types of representational motifs that Baltimore consumers preferred.

OTHER CASE FORMS

SIDEBOARD

The sideboard was the most revolutionary case piece. It was born out of advances that permitted the gluing together of thin layers of veneers. The sideboard was a low-profile, horizontally arranged cabinet that stood against a wall or sat in an alcove of a room dedicated to dining. Rooms became increasingly specialized, replacing the notion of one room serving multiple purposes that characterized living arrangements in colonial homes. Consequently, sideboards were designed to hold bottles, linens, and serving pieces, and most of these dining-room pieces stood on six legs arranged with four legs at the corners and two inner or front legs.

Sideboard cabinets took several shapes—flat, serpentine, D-shape, and concave—and were designed to stand on straight, tapered, or turned and reeded legs. Boston sideboards were built with a conservative demeanor. Broad and flat surfaces and flame-mahogany veneer were typical. Large color-field differences were absent, and contrasting veneers were subtle. Selective placement of minute inlays were decorative enough for conservative Bostonians.

The sideboard, to be used in the dining room, was an innovation of the Federal period. The half-round pilasters on the case that join the legs and the lunette stringing across the bottom of the case suggest the hand of John and/or Thomas Seymour, Boston, circa 1810.

New York, Philadelphia, Baltimore, and the South, by contrast, used representational inlay and angled corners. In New York, examples boasted light-colored quarter-fan inlay, paterae, fans, swags, and pendant husks inset in boldly figured mahogany. A select group of New

Related to a sideboard, this long, horizontally arranged table with a shallow apron is called a hunt board. It was the preferred form in Maryland and the South.

York area sideboards with cantered corners are distinct with eight legs, four of which appear in front. Diagonally set inner legs that flow with the cantered corners are another New York *tour de force*. Of the group, New York models were the largest, often six feet long, and two feet six inches wide. Philadelphia sideboards were in general a foot shorter. The hunt board, a sideboard lacking drawers or with a single row of drawers under the top, was an option in households in Maryland and the South.

SEATING

Side chairs were made in predominately three shapes: shield back, square back, and oval back. All three were popular through the first decade of the nineteenth century. The argument can be made that of all Federal forms, chairs were the embodiment of classical ornament applied to contemporary form. By 1805, select chairs were beginning to acquire some of the features that signaled the approach of archeological accuracy.

Federal chairs were notably light, and in some cases, their delicacy exceeded that of European manufacture. Seat frames were generally square, and some had gently bowed rails. The technique of overupholstery, or bringing the covering over the rails, gained momentum. Brass tacks secured the fabric in the symmetrical manner associated with Neoclassical rules. Regionalism in chair design was not as overt as it was in the Chippendale era, although some trends were apparent.

NEW ENGLAND

In New England, the shield-back chair prevailed. A "vase back" was the term used if the bottom of the shield was pointed, and an "urn back" label applied if the bottom of the shield was rounded. Only in New England did stretchers continue to connect legs, many of which were tapered. Strings of light-colored inlay were often the only ornament. On the other hand, spade feet, trowel-like terminals somewhat wider than the tapered legs to which they are attached, are usually limited to the front legs on the highest style Salem chairs, in tandem with carving and *appliqués* of exotic woods. Stretchers and inlays are absent. Salem chairs often have rear legs that incline inward. In accord with these changes, most seats are wider in front than in back. The aesthete Elias Hasket Derby is again linked with the most sophisticated chairs fitting these parameters.

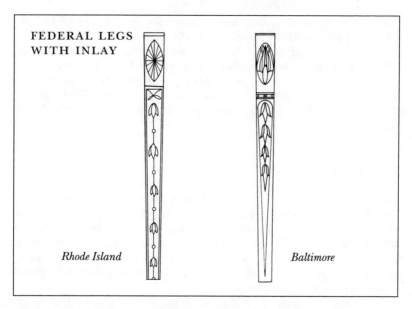

FEDERAL LEGS WITH INLAY

Rhode Island

Baltimore

While leg shape itself was generally similar throughout the regions, inlay patterns were interpreted locally. A bellflower inlay in Baltimore, for example, has an elongated central petal while the same bellflower in Rhode Island tends to be shorter and rounder.

RHODE ISLAND

Rhode Island households preferred a chair with a pedestal or modified square back whose outline and splat suggest those of a Chippendale chair. A central splat rests on a pedestal or shoe, another throwback to the older style. The legs are tapered and connected by H-shaped stretchers. The seat is large and overupholstered. A *kylix*, a flattened urn with extruded drapery, is the focal point. Large pendant bellflowers extend down from the bottom of the urn, suggesting a provincial taste as the designer focused on the linear aspect of the rendering at the expense of the overall design.

CONNECTICUT

Connecticut chairs showed an affinity for Chippendale-style silhouettes and Marlborough legs. These features were merged with flat Adam-inspired urns and swag-studded upholstery. Square-back chairs were more popular in New York and Portsmouth than in Massachusetts. Portsmouth chairs had square, reeded backs with rosettes at the corners of the crest, tapered front legs, and curved rear legs connected by stretchers.

The flattened urn, or kylix, *on this chair back was a popular choice in Rhode Island and illustrates how Federal-period Neoclassical ornament was applied to then-contemporary forms.*

Duncan Phyfe of New York turned out some of the finest examples of the scroll-back chair. This shape prefigured the arrival of the klismos *form in the subsequent Empire style.*

NEW YORK

New York artists supplied three varieties of shield-back chairs. One type has backs with banisters of three splats centering a fan; the second type is adorned with Prince of Wales feathers and drapery; and the third variety has backs made with four vertical ribs. A sunburst tablet at the top of the New York square-back chair is integral to the back design, and New York chairs with square backs were often paired with center banisters and an elongated urn, feathers, and drapery. Colonettes flanked these details, and on some models, the colonettes merged with Gothic arches at the top. New York armchairs organized in this manner with flared-out arm supports are sometimes punctuated with carved rosettes at the junction with the arm. Due to a larger component of labor, armchairs captured a premium.

PHILADELPHIA

In Federal furniture, one of the closest renditions of the French Neo-classical perspective found in America can be seen in a small number of painted and gilded armchairs from Philadelphia. Given their overtly French quality, it is probable that imported French prototypes of Louis XVI lineage may have contributed to the stately appearance of this limited American type. Many enterprising American merchants were in Paris at an opportune time in the 1790s to ship French furniture that had been confiscated and sold from fashionable households after the demise of the *Ancien Régime*.

Painted white and gold, these square chairs had upholstered backs and partially upholstered arm supports. The applied composition ornament and carving were masterful, and it is a certainty that chairs of this caliber inhabited the best parlors. Sheraton called this type a drawing-room chair while Hepplewhite noted them as cabriole chairs. In Philadelphia, where French furnishings served as inspiration for American-made furniture as well, cabinetmakers Ephraim Haines and Henry Connelly are known for high-rising arms dubbed "French elbows" after those found on French Louis XVI chairs. And on Philadelphia square-back chairs with a tablet top, the tablet simply rests on the top of the crest. Turned legs with bulb or round spade feet also suggest Philadelphia workmanship.

CHARLESTON

The shield-back chair was common in Charleston, and was occasionally supplemented with drapery carving reminiscent of treatments on

New York and Massachusetts chairs. Charleston imported more do-
mestically made pieces at this time, making such similarities logical.

BALTIMORE

The shield, heart, and oval back were the preferred forms in Balti-
more, with the oval-back chair uncommon outside this city. English-
man Adam is credited with introducing the oval-back shape to
England, where it was favored for twenty years beginning in the 1760s.
Another Baltimore preference was the modified shield-back chair with
a balloon shape incorporated into the back. The balloon resembles
the head of a tennis racket, after examples in Sheraton's *Drawing Book.*
This feature joins partially overupholstered seats, H-shaped stretchers,
stringing on the seat rail, and light-wood bands or cuffs on tapered
legs in defining Baltimore origins. Carrot-shaped inlays were another
Baltimore specialty.

In addition to *verre églomisé* and inlay, another treatment swept Balti-
more. John and Hugh Finlay stirred interest in polychrome painted
chairs. These fancy chairs were essentially Sheraton (square) forms
with icicle-shaped splats. One interpretation called for the mahogany-
and-maple body to be painted black with gilt and multicolored pictor-
ial details. This chair later served as the inspiration for less expensive
versions, including the mass-produced, painted and stenciled Hitch-
cock chair. The Hitchcock chair, a turning point in American furni-
ture retailing, sold for $1.50 and introduced a certain degree of style
to middle-class homes.

OTHER CHAIR FORMS

EASY CHAIR
As opposed to eighteenth-century examples, Federal easy chairs were
defined by a thin body. Vertically rolled arms and straight legs were
preferred in New England while New Yorkers sat in models with soft C-
scroll arms and cylindrical legs. Philadelphia examples often had
reeded legs, bulb feet, deep wings, and circular, rounded backs. Down-
ward sloping arms were a Baltimore preference.

SCROLL-BACK CHAIR
A new form, the scroll-back chair, made its debut about 1805, prefig-
uring the reappearance of the graceful *klismos,* a Greek chair born in
antiquity. The *klismos* became the pre-eminent form in the following
Empire period. Duncan Phyfe was especially taken with the scroll-
back chair, and his one-hundred-person shop turned out countless

numbers that appealed to those with a taste for carving and reeding.

For many, the ancient Greek *klismos*, with its splayed back and saber legs, represents a design pinnacle; its simple, graceful outline has never been surpassed by any other seating form. Additional nineteenth-century enhancements that possibly signal the Phyfe workshop include backs with zigzag bands and rosettes, reeding on the front legs, and a carved bow-knot motif on the crest. Seats were slightly rounded or bell shaped and often overupholstered. Eventually, the form transmuted to the lyre- and harp-back types that dominated Empire designs.

The Boston version has a scrolled back and splayed legs. The chair is topped by a small horizontal roller with a tablet on top. One noteworthy group of this type is attributed to the shop of John and Thomas Seymour, based on the superlative carving and veneering elements. This form is remarkable for contrasts in wood, alternating plain and carved areas, and for backs of squares, half and quarter ellipses, rectangles, and diamonds.

LOLLING CHAIR

The lolling chair was a new type of upholstered armchair with exposed arms based on earlier English and French models. The term *lolling* was a period label for any indulgent, leisurely pursuit. This type is alternately known as a Martha Washington chair, a term that came later to describe the American adaptation of a European form. The form was a product of New England shops, and Massachusetts makers turned out the greatest number with tall backs and thin, tapered arms and legs.

A great number of armchairs of this type, called lolling or Martha Washington chairs, were produced almost exclusively by Massachusetts shops. The front legs on this model terminate in spade feet.

Many sofas made in New York or Philadelphia in the early 1800s have a paneled crest with drapery swags and tassels.

SOFA

The Federal sofa joined other seating forms in a trend toward delicacy. Variations included serpentine backs topped with wood and bowed or "sweeped" backs. Baltimore "sweep" backs were called cabriole sofas. Other options included the square sofa with turned arm supports and exposed arms, which were a novelty. Most Federal sofas were silhouetted with mahogany embellished by veneer, reeding, or carving. Front legs were square, turned, or tapered.

TABLES

Two new categories of tables emerged. The small sewing or work table with cloth pouch hanging beneath the case and between the legs was exclusively associated with women and used to store sewing implements and work in progress, whether of the plain or fancy kind; ordinary sewing made up plain work while samplers and silk embroidery were the hallmarks of ladies who practiced fancy needlework.

Dining tables were three-part assemblages with two half-round ends or aprons that could be split into separate service. Four square, tapered legs provided the support; later D-shaped models had six legs. Brass clips hold the sections together. These drop-leaf dining tables were subject to fatigue when their long expanses of leaves opened and put pressure on a thin frame. Surviving examples, therefore, are less abundant than other Federal forms. A regional variation, as interpreted by Duncan Phyfe, was characterized by three separate mahogany sections with the two end sections slightly rounded at the top

Light-colored "book" inlay on the apron of this multipurpose Pembroke table resembles the fronts of vertically stacked books. Together with the graduated horizontal bands on the front legs, these are Newport characteristics of the Federal style.

edges. Each section was supported by a four-column platform that in turn rests on outswept legs and paw feet. When set up, this arrangement created enough dining space for approximately ten people, which must have seemed luxurious compared to the more confined space provided by gateleg and drop-leaf tables used prior to the Federal period.

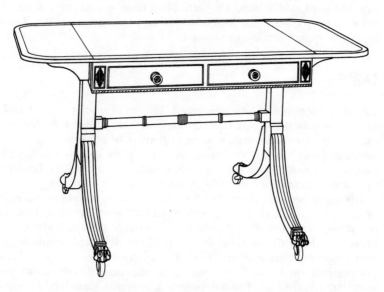

Leaves at either end and two drawers in the apron define the Federal sofa table. Fluted legs and brass animal-paw feet help date this example as early nineteenth century.

WORKTABLE

The superlatives that once applied to Philadelphia Chippendale high chests were reborn in the kidney-shaped worktable, a biomorphic shape unique to Philadelphia. Other shapes included the oval and as-tragal-end shapes. Astragal-end tops have a protruding front and back that interrupt an otherwise oval shape. As in other Philadelphia case work, lighter colored woods served to emphasize panels and drawers. Mahogany and satinwood were the primary woods, and on satinwood versions, dark rosewood or ebony banding and stringing highlight panels and drawers. In Baltimore, oval and square mahogany work-tables with light-wood accents predominated. New York worktables were generally larger in scale with a solid, richly figured mahogany surface; light-wood contrasts were less fashionable there. Canted cor-ners and astragal ends were common, as were splayed saber legs.

Square, tapered, or round legs, some with elongated bulbous feet and ring turnings at the top of the legs, were some of the many choices available in New England. Canted corners were appealing in the region, and Salem examples were perhaps the most delicate frames produced anywhere. Many New England worktables were pro-duced by the confluence of contrasting veneers accentuated by string-ing. Rare examples survive with delicately painted floral motifs, a fleeting fad in the Boston area at the beginning of the nineteenth cen-tury.

CARD TABLE

Card tables from the years 1790 to 1815 were square, round, tripod, and pedestal, and many were built in pairs to compliment the symmet-rical arrangement of the room's other furnishings. Satinwood and birch veneers and a centered oval panel on the front apron was one New England standard. This treatment promoted the illusion of three distinct sections across the front, with obvious light and dark contrasts.

In separate treatments, Boston and Salem card tables were distin-guished by serpentine, elliptic, or bowed fronts. By 1800, ovolo cor-ners that conformed to the shape of the turned front legs appeared on serpentine card tables. Newport card tables are occasionally identi-fied by light-colored book inlays (after their resemblance to horizon-tally stacked books) and by flared bellflower husks with black-veined lines.

Baltimore card tables were some of the most ornamental to be found, thanks to a regional inlay profession that blossomed in this newly prosperous city. Part of the decorative menu included wide stretches of ovals, shading, teardrop panels, three-part husks on legs

with long center petals, flower, vase, carrot, stylized tassel, and urn in-lays. Instead of light and dark contrasts, dark, highly figured ma-hogany was standard fare.

Églomisé, the decorative painting found mostly in Baltimore pieces, less frequently adorned New York tables and looking glasses. Urbane New York was second only to Philadelphia in expressing interest in French design resulting from Charles-Honoré Lannuier's influence. Lannuier's early tables follow the format of the French *Directoire* style, namely conservative square forms adorned simply with Neoclassical motifs that were metaphors for the French Revolution; the wreath was one such motif.

A card-table form once attributed exclusively to Duncan Phyfe but often the product of several New York cabinetmaking enterprises was a pedestal table with a five-lobed or double-elliptic folding top and carved tripod base. Appearing about 1810, the form is referenced in *The New York Revised Prices for Manufacturing Cabinet and Chair Work*. Dark-flame mahogany and stylized leaf carving on the base are joined by legs that end in paw feet covered with brass or carved from solid wood.

Philadelphia card tables were initially constructed of two formats. One type, a circular card table debuting about 1790, has the heavier scale associated with Chippendale pieces. Knees brackets and fluted Marlborough legs are adjuncts of the older style. By 1810, the card table assumed the delicate dimensions that brought it closer to the Federal ideal.

Related to the five-lobed pedestal-base card table from New York, a Philadelphia version rests on four colonettes that substitute for a sin-gle pedestal. Four molded legs with leaf carving contrast with only three on the New York version, and the Philadelphia base is measur-ably rounded and convex. These tables were the foundation for a form that swelled under the weight of heavy, archeologically correct orna-ment in the next stage of Neoclassicism, the Empire.

*S*UMMARY OF STYLE

Dates: 1790–1815
Distinguishing Features: fine scale; straight lines; geometric partitioning; inlay; contrasts of light and dark; symmetry; églomisé; painted surfaces; low-relief carving
Materials: mahogany, satinwood, birch, maple, ebony

COLLECTOR'S TIPS

1. *Look for (good example):* geometry in wood; delicate scale; contrasts of light and dark; well-balanced presentation; successful use of inlay
2. *Look for (outstanding example):* elaborate inlay such as that practiced by the Seymours in the Boston area; carving designs by Samuel McIntire; pieces by Duncan Phyfe; delicate painted pieces; églomisé panels
3. *Problems/what to watch out for:* replaced inlay and veneers; aggressive finishing of surface that reduces contrast of light and dark woods
4. *Conservation issues:* inlay, especially of stringing or banding type, subject to loss as a result of warping and buckling; églomisé panels prone to paint/gilt loss and are difficult to repair. Due to multiple materials used, repair can be costly.
5. *Cabinetmakers/firms important to style:* Duncan Phyfe, John and Hugh Finlay, John and Thomas Seymour, William Lemon, Stephen Badlam, Michael Allison, Ephraim Haines, Henry Connelly, John Shaw
6. *Where public can see best examples:* Metropolitan Museum of Art, New York, New York; Museum of the City of New York; Winterthur Museum, Wilmington, Delaware; Baltimore Museum of Art; Society for the Preservation of New England Antiquities, Boston, Massachusetts; and various locations throughout New England
7. *Department expert wish list:* Seymour piece with elaborate inlay; lolling chair with successful proportions, high back, and unaltered legs
8. *Miscellaneous:* Since pattern books were so important in disseminating Federal style, look for pieces that closely follow pattern books such as those by Hepplewhite and Sheraton. Reprints of these pattern books are commonly available.

CHAPTER 6

*E*MPIRE FURNITURE (1815–1840)

The same archeological investigations that began in the late eighteenth century and influenced the Federal style also brought about the American Empire style, the second phase of the Neoclassical period in furniture making. Greco-Roman is another label affixed to this second stage of Neoclassicism. In contrast to the Federal era, in which Neoclassical ornament was simply a decorative treatment superimposed on spare contemporary forms, the Empire period spawned an intensely literal or archeological spirit in both matters of dress and design. White clapboard houses (in imitation of Greek temples), allegorical painting and sculpture, and women clad in high-waisted dresses reminiscent of the chiton dress of antiquity, are just several manifestations of the archeological trend that Empire furniture followed.

The delicate Hepplewhite- and Sheraton-inspired furniture of the first decade of the nineteenth century was replaced with solid, large-scale chairs and case work that looked as if they had been cut from stone. Bas-relief and vase paintings were studied for inspiration and to ensure the accuracy of Empire designs. Plasticity, boldness, and heavy ornament replaced their respective opposites of flatness, delicacy, and subdued ornament. From about 1815 to 1825, proponents of the Empire style were consumed with replicating archeologically correct forms and ornament. However, by 1825, some forms were debased, swelling to such an extent as to earn the nickname "fat classical." Overly broad proportions and extra-large-scale carving define this swelling, noted foremost in certain Empire sofas.

The French influence on American furniture design that began in the Federal period continued, and the term *Empire* refers to the years from 1804 to 1815, a period in French history when Napoleon exercised control. The ancient civilizations of Greece and Rome held appeal for Napoleon, setting up parallels between his lofty military philosophy and that of Western antiquity. Designers Charles Percier

and Pierre Fontaine traveled with Napoleon on his campaigns, making scale drawings of the furnishings that were to inspire *le style antique*. More than just a patron of the arts, Napoleon was intent on the belief that luxury was a prerequisite for a healthy economy, and he took a fastidious interest in the furnishing of his living quarters at Malmaison, the Tuileries, and other royal residences. Some of the grandiose designs, including a dressing table and mirror with decorative bronze mounts and a washbasin on a stand modeled after an antique incense burner, appealed to Napoleon's vanity and served to link him with the great cultures of the ancient world. Pieces were endowed with military swords and shields, winged caryatid figures, lion's-paw feet, and the monopodium leg. The monopodium leg combined an animal head and paw in a single unit, a form prevalent in ancient furniture.

Percier and Fontaine published many of these illustrations in *Recueil des décorations intérieures* in 1801 and again in 1812. On a popular level, these pretentious designs were standardized and turned into affordable ones by Pierre de la Mésangère, a scholar, designer, and author, in much the same way that Hepplewhite and Sheraton popularized Adam's work, making them suitable for residences rather than palaces. Mésangère's *Collection des meubles et objets de goût* was published continually until 1835.

The Empire style was an international one: In England, Thomas Hope recorded the designs of antiquity in his scholarly 1807 work, *Household Furniture and Interior Decoration*. It presented furniture bred of the same archeological intensity that monopolized the French Empire style. In England, this design philosophy was known as the Regency style, dating roughly from 1800 to 1838, the period when George, Prince of Wales, acted as Regent for his ailing father, George III.

The additive style that earmarks American Empire furniture was borrowed from French and English sources. Pillars, brass-paw feet, and casters, as well as waterleaf carving and dolphins, found a precedent in English Regency work while the French relished gilt mounts, swags, military symbols, and Egyptian details. That American artisans could adapt from multiple sources sat well with their patrons. Americans had little patience for the imperial style of Napoleon with its military references ornately cast, or for the English version, which was an outgrowth of ostentatious Adamesque design geared to large English country estates.

In addition to changing motifs came changes in scale. Compared to those of Federal forms, which are noted for delicacy in scale and a highly linear quality, Empire legs, feet, and ornamental motifs swelled and became quite sculptural. Along with a trend toward boldness, case pieces lost decorative geometric partitioning, recapturing instead some of the architectural components that marked earlier Queen

Anne and Chippendale cases. Unlike previous pieces that only incorporated a pediment, Empire case work has a massive presence, recalling the entire temple facade. Carving reappeared, assuming a sculptural, three-dimensional, and highly permanent quality that tended to make Empire furniture look as if it had been carved from huge slabs of marble.

In most instances, stenciling, the painting of large-scale floral arrangements or tight, geometric motifs, replaced inlay—primarily a straight surface technique—on curved Empire bodies. Brushed on in gilt and occasionally in black or polychrome, it was an ingenious answer to the look of French *ormolu* (the decorative bronze mounts that often grace French furniture) without the cost. The only inlay technique to appear on Empire forms came in a type of brass inlay known also as boulle work, which was a rebirth of the process espoused by André-Charles Boulle that implants decorative elements into wood. Brass inlay appears on Empire work in limited quantity on straight or flat-textured surfaces such as drawer fronts or table-top edges, usually in conjunction with the highest quality materials and workmanship.

Mahogany endured in Empire designs, but rosewood was especially prized for its highly figured surface. This was important since the light and dark color contrasts of Federal forms were passed over in favor of plain, dark veneers with gilding or stenciling. Select pieces were grain-painted in imitation of more expensive woods. Brasses swelled in proportion to the heftier cases, the lion's head with circular pull worked well with sculptural animal-paw feet and monopodium legs. This marked a change from Federal hardware, which offered flat, geometric shapes mostly in the form of ovals.

CASE WORK

Compared to Federal case work, Empire case pieces were monumental in size and ornament. Solidity of form displaced delicacy of scale so that the configurations of drawers and cabinets that prevailed in Federal sideboards looked new under the weight of the ambitious Empire form. Empire sideboards took shape from either a simple square case or a series of smaller cases joined to a square top. Gone were the long, thin tapered legs of Federal design that created large voids between the case and its legs. On Empire examples, storage space was increased since larger cases came to rest on short, thick animal-paw feet. Finishing details might include a carved backboard, a brass gallery or rail around the rear of the top and at the sides, or a pair of knife boxes sometimes mimicking the design of the sideboard in miniature. Brass inlay was usually reserved for costlier models.

Perhaps the most bombastic American Empire case design is a sec-

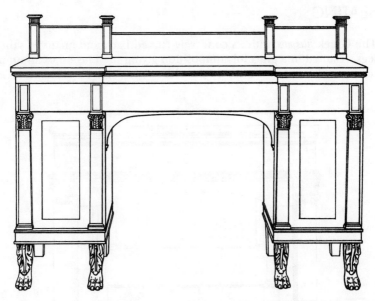

The monumentality of this sideboard from New York demonstrates the solidity of form inherent in Empire case work. As distinguished from their Federal antecedents, Empire sideboards usually rest on rectilinear cases that stand close to the ground, often on short, thick paw feet.

retary-bookcase attributed to Joseph Meeks & Sons of New York (Metropolitan Museum of Art). Made about 1825, the massive case stands more than eight feet tall. Large columns and an oversized cornice mimic those of a temple facade. Huge animal-paw feet serve to join the lower case with gilded cornucopia brackets. The ebonized mahogany body is a smorgasbord of painting, stenciling, carving, and gilding. Paint created the look of ebony while gold leaf and stenciling were ingenious alternatives to expensive brass mounts attached to French Empire examples.

The *secrétaire à abattant* was a square, large-scale cabinet with a fall-front writing compartment. This Continental form was favored in the major style centers of New York, Philadelphia, and, infrequently, Boston at a time when regional variations in general were beginning to reduce in intensity. An essentially simple form with expanses of mahogany, most relied on *ormolu,* or gilt, to make a decorative statement. The *secrétaire à abattant* is notable in that it is only one of several forms that made its way to America directly from France without English interpretation, although American models with tabernacle tops are thought to carry a Germanic influence.

SEATING

The Greek *klismos,* with its concavely curved back and incurved saber legs, resulted in a graceful composition giving the illusion of an uninterrupted line from the top of the chair to its legs. This ancient form

The secrétaire à abattant, *or desk with fall-front writing surface, was based on a Continental form and appealed to consumers in the major style centers of New York, Philadelphia, and, infrequently, Boston.*

Derived from the ancient Greek klismos, this Empire side chair has an uninterrupted line from the back to the front leg. These simple yet elegant lines are considered by many to be one of the most successful compositions ever conceived.

differs from modern chairs that are composed and analyzed in terms of distinct parts—back, seat, legs, and feet. In its original ancient configuration, the *klismos* was often associated with women; the Romans modified the scale to accommodate the male figure, thereby reducing the original delicacy of the form. Mahogany and rosewood—and surfaces painted to resemble them—were favored. Regional preferences were beginning to wane after having been so strong in past decades, and the *klismos* form became the undisputed prototype for the majority of Empire chairs. With its splayed legs supporting the form, the *klismos* was an engineering achievement as well as a consummate statement of fashion.

MASSACHUSETTS

In Boston, chairs were built with a carved swag and scrolled splat. Some Boston models have twisted, reeded, and carved front rails.

NEW YORK

Simple scroll backs, minimal carving, and plain saber legs typified New York chairs. Often attributed to Phyfe but probably the output of a larger, similarly skilled group, another New York variant was a chair with reeded stiles and legs and carved, gilded animal-paw feet. Choices for the back included lyre, harp, cornucopia, or eagle motifs.

PHILADELPHIA

Philadelphia *klismos* chairs are often heavier in scale; some recall the illustrations of Englishman Thomas Hope, whose *Household Furniture and Interior Decoration* was published in America and may have played a role in the loftier stance of Philadelphia chairs. Many chair makers dis-

pensed with the illusion of an uninterrupted line from the stiles to the front legs that marked ancient designs and that appeared again in Boston and New York versions. Following a trend established in case work, Philadelphia chairs revived the decorative art of boulle work using brass inlays. Chairs were beginning to display some of the fullness that they would achieve by the end of the Empire period.

BALTIMORE

In Baltimore, the heavier proportions indicative of English design are associated with John and Hugh Finlay. Round, tapering front legs and a generally larger scale, as well as maple painted with polychrome paint in the strong earthen colors of Pompeii, typify these chairs. The Baltimore rendition is a skillful compromise between the delicate proportions of ancient Greek models and a more masculine Roman version.

OTHER CHAIR FORMS

SLING-SEAT CHAIR

A new Empire chair, the sling-seat armchair, was another variant of an ancient form. Simply joined clean lines and lack of ornate detail lend an air of modernity. The chair rests on a *curule,* or X-shaped base. Ancient Egyptians used this form consisting of a sling seat over an X-shaped stretcher, and the Romans converted it to seating for magistrates, adding more curve to the stretcher. The form progressed through the centuries, with seventeenth-century crafters adding turned stretchers, curved arms, and leather upholstery. In its nineteenth-century incarnation, this permutation was known as a campeachy chair, offering appeal for potentates including Thomas Jefferson.

SOFA

Seating forms with full backs were called sofas, and those with partial or no backs were usually called couches. Many were made in pairs to flank doorways or to fit into niches. Couches filled a void left by the demise of the daybed form and were meant for repose during the day. Adding to the confusion, innumerable pattern books alluded to these seating forms with a variety of terms: *chaise longues,* Grecian couches or *squabs,* and the Roman *triclinium* were just some of the historical references.

In contrast to Federal antecedents that were largely rectangular, Empire sofas were often a blending of sweeping curves and textural ornament. Nowhere was this trait expressed more strongly than in New York. One high-style Grecian sofa, known as the dolphin sofa (Metropolitan Museum of Art) for its dolphin-shaped arms and legs, is the

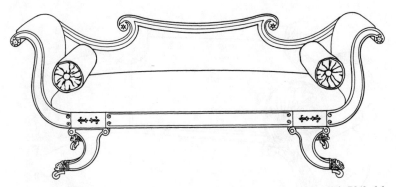

Sweeping curves and brass inlaid mahogany are characteristic of this sofa's Philadelphia origins, circa 1820.

best example of this type. It was inspired by the 1802 edition of *The London Chair-Makers' and Carvers' Book of Prices for Workmanship*. Part of the multifarious ornament includes a front rail inset with a brass key or fret, a classical pattern of square-hooked forms that repeat to form a band. Brass rosettes succinctly accentuate the scrolled ends of the back, and carved and gilded-leaf sprays act as brackets unifying form, texture, and ornament. To further suggest an alliance with objects of antiquity, the dolphin scales were highlighted with *verd antique,* a green-based paint process that simulates ancient bronze. As a point of connoisseurship, many high-style Empire pieces were originally decorated with *verd antique,* but the combination of time and overzealous refinishing have stripped some objects of this ornament. Competent restorers can, however, uncover the original painted surface or re-apply the treatment to create the look of bronze.

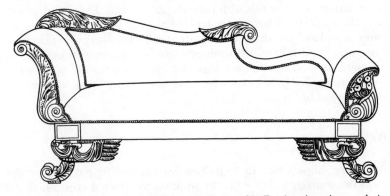

Following the trend toward archeological accuracy, this Empire récamier made in Boston might have been called a Grecian couch or squab or a Roman triclinium.

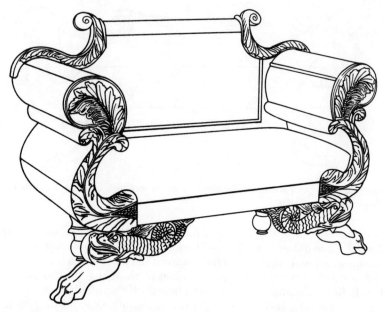

By 1835, many seating forms swelled to such an extent as to earn the nickname "fat classical." Ornament and forms of classical antiquity had become somewhat debased, and archeological exactitude ceased to be as important as it was in the beginning of the Empire period.

NEW YORK

Other less presumptuous New York sofas employed wider, scrolled arms and animal-paw feet with cornucopia brackets. Expanded to sofa size, the *curule* form was a popular design from Duncan Phyfe's workshop as well as from those independent cabinetmakers who may have once trained with him. A Boston example is sometimes recognized by a square base on thick fluted legs with brass casters. The addition of loose, overstuffed pillows was a reaction to the tight, linear appearance of Federal upholstery.

BALTIMORE

Baltimore shops joined those in New York in turning out some of the most decoratively lavish sofas. In addition to scrolled crest rails with rosettes, cornucopia, and animal-paw feet, rounded seat rails were also Baltimore subtleties. Carving tends to be broad yet flat, and some base

woods were originally painted to resemble costlier materials such as rosewood, although few painted examples remain in this state of preservation today.

PHILADELPHIA

A Philadelphia example opted for less ostentatious scrolled ends, pairing them instead with scroll legs and more emphatic *ormolu*. By 1825, archeological accuracy was dissolving regionally in favor of extremely broad proportions and large-scale carving. The heftiest examples of this later type are dubbed "fat classical."

TABLES

A whole new group of table forms emerged in the Empire period. Center, sofa, and pier tables joined work, card, and drop-leaf tables in making up room arrangements that were becoming plentiful. Tables, like cases and chairs, drew inspiration from antiquity.

CENTER TABLE

The center table was adapted from pedestal tables discovered in Rome. On these tables, the tops were supported by columns, modern-

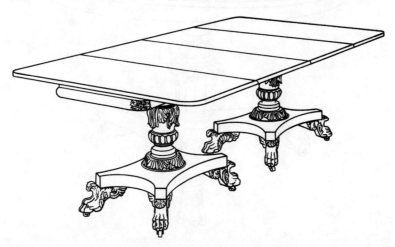

The columns on which this Empire dining table rest were likely derived from pedestal tables found on archeological digs in ancient Rome.

ized into wood from their original bronze format to suit modern nineteenth-century living. A center-table form built with three pillars connecting the base to a round top appears in the marketplace sufficiently enough today to suggest that it was a popular form in the Empire era.

In addition to a notable swelling in underlying form, ornament affixed to broad areas such as the apron or legs and feet ranged from singular applications of robust carving to complete decorative orgies consisting of carving, gilt, and *ormolu.*

SOFA TABLE

As its name suggests, the sofa table was developed as a companion piece to the "dress sofa," or a formal seating piece suitable for the best parlor and described in periodicals such as Ackerman's *Repository of Arts, Literature, Fashions, etc.* Many sofa tables were standardized at five to six feet in length, with leaves at each end and two drawers that divide the frame in half. Following the lead of card tables, bases include leaf-carved colonettes and eagle supports resting on animal-paw feet and touches of *ormolu.* Sofa tables proliferated in Philadelphia and

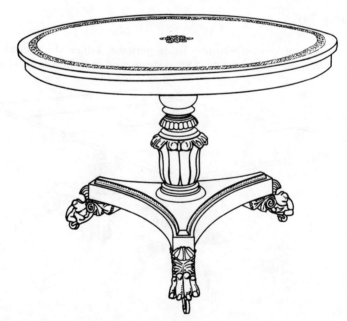

This tilt-top center table with leaf-stenciled borders and ormolu *rings in the pedestal is attributed to Philadelphia cabinetmaker Antoine-Gabriel Quervelle, circa 1830.*

New York. The lyre shape was long thought to indicate Phyfe authorship, but increased scholarship has clarified that the lyre motif was more widespread among cabinetmakers. It reached Philadelphia, Boston, and Baltimore, and in some cases it may have been brought to these locales courtesy of journeymen or traveling artisans who were once in Phyfe's employ.

PIER TABLE

A long-enduring form in Europe, the pier table was introduced to America in the late eighteenth century, but it didn't become a design *tour de force* until the Empire era. Its original design called for the table to be placed against the pier or wall between two windows or doors. The format for most Empire pier tables consisted of a square top supported by pillars, usually on a free-standing base with a horizontal platform between the legs close to the floor. Many tables had mirrored backs on the bottom between the pillars that provided some degree of space enhancement in a room. Over the years, most pier tables have lost their original mirrored backs, and many that exist today either rely on replacements or lack glass entirely. A large "pier glass" separate from the table was often suspended above the table to provide continuity of design. Richly veined marble and gilt tops were the predilection of Philadelphia makers while large expanses of mahogany veneers with conservatively rendered *ormolu* and carved lotus flowers on pedestal bases typify Boston tables. A typical Baltimore pier table often had four free-standing legs with no platform base, and a variant offered a low rectangular base with projecting blocks of wood at the juncture of the pillar and base. These legs had heavy reeding terminating in block-and-ball feet, a combination of a square and round terminus on a leg. X-shaped bases are sometimes found on fancy painted examples from Baltimore.

CARD TABLE

A Baltimore card table is noted for both a thick shaft connecting the top to a base of multiple turnings and an X-shaped pedestal base with painted or gilded scrolls. Some of the finest card tables in the fully developed New York Empire style were the output of Charles-Honoré Lannuier. With only about a dozen extant, these tables are the closest approximation of French Empire refinement as spelled out by Pierre de la Mésangère in his *Collection des meubles et objets de goût*. The focal point of these tables is a carved and gilded caryatid winged figure that supports the top. *Verd antique* animal paws with leafy hocks, *ormolu*, and

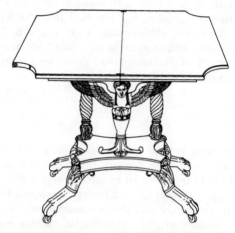

The gilded winged figure and carved animal paws with leafy hocks were touches that master ébéniste Charles-Honoré Lannuier adapted from French Empire designs for his American patrons in New York. It is believed that fewer than one dozen tables of this type are extant today.

inlaid borders are cumulative features all executed in the highest standards associated with a master *ébéniste*. Following the tradition established in European furniture making, many of these examples are stamped or labeled. Tables following this format, but not by the hand of a master, incorporate many of these attributes but lack the *élan* inherent in Lannuier's creations. Gold leaf and stenciling, while ingenious substitutes, lack the impact of *ormolu*.

SUMMARY OF STYLE

Dates: 1815–1840
Distinguishing Features: heavy forms; archeological emphasis; *ormolu* mounts; *klismos* chair; military symbols; plain, dark veneers; gilding; animal-paw feet and heads; sculptural carving
Materials: mahogany, rosewood, *ormolu*, *verd antique*, gilt

COLLECTOR'S TIPS

1. *Look for (good example):* high-quality veneers; successful proportions
2. *Look for (outstanding example):* pieces by Charles-Honoré Lannuier and Duncan Phyfe
3. *Problems/what to watch out for:* Because it is a recently popular collecting area, there are fewer fakes, which is good news for collectors. Since these pieces are so labor intensive, there is less potential forgery compared to earlier American styles. The gilded areas on Empire pieces are the most frequently replaced or repaired area. Watch out for re-veneering; small repairs or patches are acceptable, but total replacement is not.
4. *Conservation issues:* Due to multiple materials, restoration or repair can be expensive.
5. *Cabinetmakers/firms important to style:* Charles-Honoré Lannuier, Duncan Phyfe, Joseph Meeks & Sons, John and Hugh Finlay, Joseph Barry
6. *Where public can see best examples:* Metropolitan Museum of Art, New York, New York; Albany Institute of Art; Museum of the City of New York; Maryland Historical Society, Baltimore, Maryland; Baltimore Museum of Art
7. *Department expert wish list:* Lannuier card or pier table with winged figure; Finlay painted chairs; Baltimore center table
8. *Miscellaneous:* Nice area to collect since it is a young field. Recent exhibitions have increased the public's interest.

RESTAURATION AND PILLAR AND SCROLL FURNITURE (1830–1840)

Restauration refers to the French style associated with the Bourbon Restoration after the fall of Napoleon in 1815. As the political climate ultimately moved from Empire to Republic, a rising French middle class called for a kind of furniture suiting a lifestyle far simpler than the exalted one Napoleon led. Consequently, while Restauration furniture retained some of the architectural slavishness that dictated Empire designs, ornament became minimal, even non-existent. The combination of exotic materials, *appliqués* of military references as well as Napoleon's own highly indulgent "N" motif, were eliminated in favor of native woods, some in pale colors called *bois clair*, resulting in furniture in which the overall appearance was one of outright plainness. Contrast came in the form of ebony trim; *appliqués*, if used at all, were limited to impersonal brass and pewter motifs in contrast to the pretentious gilt or bronze decorations found on Empire forms. Since ornament was subjugated to form in the Restauration milieu, furniture lost some of the luster that marked the Napoleonic era.

Along with changes in the political climate that mandated that all vestiges of imperial taste be wrung out of furniture design, advances in furniture-making techniques were happening simultaneously in France and all other developed countries. One result of these advances was standardized furniture components. With the help of machinery, manufacturers aimed to execute their work more rapidly; steam power, for example, helped reduce labor costs and permitted the

precise sawing of boards or slicing of thin veneers. Uniform boards were cut into pillar shapes as well as into C- and S-curves known as scrolls, upon which thin veneers were then applied. The interchangeable term *Pillar and Scroll* is an alternate and more descriptive term for the Restauration style, isolating its primary, albeit limited, elements. This third stage of Neoclassicism was brief, impacting American design in the 1830s and 1840s, overlapping with some late Empire designs. Other infrequently used terms for furniture fitting this description are *late Empire, ogee,* or *early Victorian.*

Whether one uses the historical name Restauration or the more descriptive Pillar and Scroll, the impact on American furniture was the same. Objects reverted to simple geometric and architectonic shapes large in scale, which some scholars consider austere for their lack of applied ornament. The scrolls, composed of C- and S-curves forming supports or legs on case pieces, were thick and notably square to compliment the bulky framework they supported. If anything, Restauration pieces became even thicker than their Empire antecedents. The removal of animal forms such as the eagle eliminated an element of the grotesque that some patrons found distasteful. Mahogany or rosewood veneers supplied the dark surfaces for which American work is noted. Those of French origin, *bois clair* or pale-wood veneers, were not favored in American Restauration designs, which probably reflects the short-lived craze of light woods in France that died before the style migrated to America. Almost without exception, carving, gilding, and *ormolu* disappeared, and the archeological underpinnings of Empire forms dissolved in favor of unadorned geometric pieces that disseminated style in a less labor-intensive, and consequently less costly, manner to a larger buying audience. The lower price point of Restauration furniture, versus "bespoke" or custom-made pieces of a decade earlier, contributed enormously to its popularity.

The Pillar and Scroll style was the pivotal bridge between the hand-finished furniture of the past and the machine-made objects that began to emerge after 1840. With the advent of this style, regional differences became less important. Up to 1830, in the universe of cabinetmaking, designers working under the auspices of royalty or the affluent were the style setters in furniture design. By the beginning of the third decade of the nineteenth century, however, improvements in technology helped to introduce a wide range of products, including furniture, to a burgeoning middle class. Annual fairs and exhibits—not the individual cabinetmaker—became the vehicles that influenced popular consumption. Retailers or middlemen, some of whom offered their wares through catalogues, changed the long-standing rapport between the cabinetmaker and client. In other instances, furniture manufacturers crossed over into the home furnishings marketplace, offering such items as feathers and mattresses. The maintenance of ad-

equate inventories and the know-how to market them took precedence over design subtleties.

Whereas precious few individuals were capable of executing masterpieces in the manner of Charles-Honoré Lannuier in the Empire period, a plethora of firms across America turned out furniture in the Restauration style using a stereotyped format of broad, plain surfaces, scrolls, and pillars. The apprenticeship system, in which young craftsmen learned their trade under the supervision of a master craftsman who took them from abstraction to product, was eclipsed by the shop or factory method. Instead, workers learned to operate machines, which resulted in the impersonalization of furniture making by separating a finished product from its original conception. Although historians who focused on the separation of the artist from his craft would disagree, the factory or shop method was not always a detriment to furniture making. Duncan Phyfe, for example, was already working in a variant of the factory method in previous Federal and Empire fashions by employing more than a hundred craftsmen, all of whom had separate responsibilities for carving, turning, upholstery, and assembly; the design and execution of these pieces has long been regarded as excellent. Consequently, when assessing furniture of the Restauration, it is more important to be able to spot Pillar and Scroll forms than it is to identify the hand of a specific cabinetmaker or regional school. John Hall's *The Cabinet Maker's Assistant* of 1840 was one of the first pattern books of American origin to spread this style. Like the multitude of design mavericks who espoused the rudiments of previous styles, draftsman Hall codified the Pillar and Scroll style, citing the elliptical curve as the most beautiful of all design elements. America at long last assumed a leadership role in producing pattern books, and many antiquarians feel that this was symbolic of America's self-direction in the arts.

While the Pillar and Scroll edict spread quickly across the country, New York and the Midwest were leading centers for production. New York firms were instrumental in embracing the plain surfaces, scroll supports, and columns inherent in this style. Duncan Phyfe, long a leader in Federal and Empire furniture of the highest style and quality, was sensitive to changes in taste and technology. He made a well-timed transition to the new style. In 1833, the firm of Joseph Meeks & Sons, one of Phyfe's competitors, produced a broadside, or one-page advertisement, that illustrated more than forty pieces in the new format. Cabinetmaking transmuted into a marketing enterprise, and agents assigned in other cities helped to augment sales even further. Boston manufacturer Samuel Beal offered countless pieces following Restauration imperatives. Additionally, Charleston was replaced by New Orleans as a design transfer point in the South, a position that would solidify in the Victorian era. New Orleans assumed such an important

role at this point due in part to the building and furnishing of many cavernous antebellum mansions in that region. So many Pillar and Scroll pieces were made using a standardized format that it is difficult without the aid of labels or strong provenances to attribute furniture of this genre to a region or specific maker with any degree of certainty. Consequently, the more abbreviated discussion that follows focuses less on regional variations and more on the characteristics of the universal forms themselves.

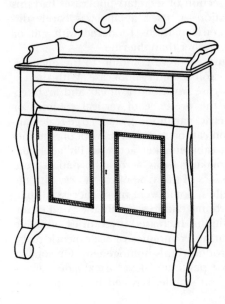

Beading around the inset panels on this Pillar and Scroll commode add emphasis to an otherwise plain form. (Courtesy Margaret Woodbury Strong Museum, Rochester, New York.)

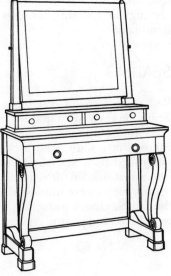

Dressing tables with attached mirrors became popular as the mid-nineteenth century approached. The scroll supports on this example identify it as a late classical design in the Pillar and Scroll style.

CASE WORK

In case work, balanced arrangements superseded superfluous ornament. While *ormolu* and gilding disappeared, projecting columns and massive architectural cornices were remainders of the classical imperative. C- and S-scrolls were common in the lower case, and these plain surfaces looked even more massive since there was little in the way of competing ornament to visually break up the surface; the installation of glass cabinets on the upper section of secretary-bookcases had this desired effect. Applied decoration—if used at all—was barely discernible shapes of tight, geometric patterns rendered with gilt or brass, and this was the exception rather than the rule.

Broad panels of veneered surfaces were common to the gigantic, often nine-foot-tall Pillar and Scroll secretary-bookcase. With the exception of scroll supports, this case work had a linear and architectonic character due largely to the presence of vertical columns or capitals at the corners. Geometric partitioning and large-scale fan-shaped relief in the lower section can be seen in the work of Antoine-Gabriel Quervelle, a Paris-born cabinetmaker active in Philadelphia, although hundreds of cabinetmaking firms across the nation were now capable of executing the basics of this type of case work, with details similar to those of Quervelle's. Some were more successful than others, and good overall proportions tend to separate the good examples from the more banal renditions. Increased inventories, available for the copying and manufacturing economies of scale provided by the steam-powered band saw, produced this homogeneity. On smaller case forms such as the server—a petite and less formal sideboard—rectangular legs with turnings and simple, scrolled backboards predominated.

SEATING

Restauration chairs were based on the French chair *en gondole,* which gently curves to surround the back. Out-flared and downward curving stiles form supports for the arms, and the open back is partially eclipsed by a wide, solid back splat. An upholstered armchair with a tall, rolled back was labeled a Voltaire chair after the popular poet, who was associated with a chair of this description. In the period, many seating forms were upholstered with large, symmetrical patterns, but the largest change came in the volume of upholstery: Seating forms were becoming plump, especially as mid-century approached.

The boat-shaped back of this Restauration form earned it the name chair en gondole. *Its balanced arrangement takes precedence over any superfluous ornament.*

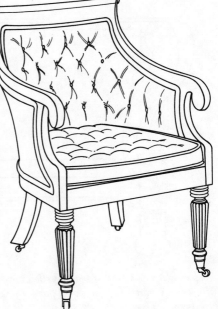

The plump tufting on this tub arm- chair portends the growing emphasis on volumetric upholstery that began in the 1840s.

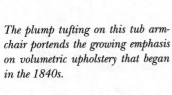

149

SOFA

The sofa took on plain, contoured surfaces and scroll supports; the back was high and scrolled, often with a single expanse of mahogany for the crest rail. Other features include scrolled arms, a swollen front rail or horizontal member, and large S-scroll supports for legs.

REST BED OR MÉRIDIENNE

The sofa was joined by the *méridienne,* a short sofa with one arm higher than the other. The raised pillow-like end places this seating piece in the same category with daybeds, or "rest beds."

TABLES

Heavy proportions characterize Restauration tables, which were combinations of square or round tops on thick pillars with scrolls at the

Simple scroll supports on a square section are the focal point of this Pillar and Scroll pier table. A marble slab top would provide contrast with the plain mahogany or rosewood-veneered body.

base in the shape of C- and S-curves. Thinly applied mahogany or rosewood veneers were serene compared to heavily ornamented Empire versions. Marble tops and pressed glass drawer pulls are admixtures suggestive of this late Neoclassical style. Regardless of size and the function they served—dining, gaming, or work—tables endlessly adhered to this format.

*S*UMMARY OF STYLE

Dates: 1830–1840
Distinguishing Features: simple geometric shapes; C- and S-curves square in section; broad expanses of plain veneers; very little applied ornament
Materials: mahogany, rosewood

COLLECTOR'S TIPS

1. *Look for (good example):* good proportions; nicely figured wood
2. *Look for (outstanding example):* a secretary-bookcase by Antoine-Gabriel Quervelle; any piece with stenciling or inlay that suggests higher quality work
3. *Problems/what to watch out for:* lifting of veneer; excessive repairs to same
4. *Conservation issues:* consistent environment that avoids large swings in temperature and humidity is essential to preservation
5. *Cabinetmakers/firms important to style:* Duncan Phyfe, Joseph Meeks & Sons, John Hall, J. W. Netterville
6. *Where public can see best examples:* Metropolitan Museum of Art, New York, New York; Philadelphia Museum of Art; Sleepy Holly Restorations, Tarrytown, New York; Lyman Allyn Museum, New London, Connecticut
7. *Department expert wish list:* secretary-bookcase

\mathcal{G}OTHIC/ELIZABETHAN REVIVAL FURNITURE (1830–1865)

With regard to furniture styles, Queen Victoria's long reign (1837 to 1901) witnessed multiple revivals that looked beyond classical principles to other historical sources for inspiration. The early Victorian period was strongly influenced by two peculiarly English revivals—Gothic and Elizabethan—that developed more or less concurrently, making it practical to examine both styles together. Many objects were fanciful combinations using both historical references.

The Gothic Revival style was spawned in England, where Gothic elements had long been intermittent design standards from the Middle Ages to the Chippendale era. Unlike Continental societies, where women often exerted great influence in matters of decor, England gravitated to the Gothic style that was widely perceived to be a masculine one and that suited the religious and intellectual pursuits of its society, which was dominated by men. The English architect and designer Augustus W. N. Pugin emphasized the appropriateness of Gothic design in his controversial book *Contrasts*. He labeled Gothic design the embodiment of Christian thinking and cited classical design as pagan. Setting up such contrasts was part of a romantic nineteenth-century philosophy, and these contrasts were never more evident than in the curious mixture of classical and medieval design that sometimes vied for space in Victorian households.

As part of this romantic phase, an interesting contradiction emerged. In Western society, the concept of "movement forward" or improvement was at odds with ornamental sources that looked backward. The Industrial Revolution focused on mechanized processes

rather than on the agricultural base that had been the norm up to the nineteenth century. For furniture, what it advanced in terms of technology and machine-assembled bodies was seemingly refuted by the Gothic Revival style of archaic ornament dating from the twelfth through the sixteenth centuries. Nicknames for Gothic furniture fitting this description include medieval or Norman to account for the lengthy time span from which many motifs were borrowed, although these labels are rarely used today. Exact copies this furniture was not; adjustments were made for comfort, especially in seating forms. Gothic Revival stylists merged any feature suggestive of medieval design—pointed and lancet arches, trefoil and quatrefoil rosettes, finials, tracery, spirals, and crockets—with essentially contemporary objects. The forms and usage of these nineteenth-century designs were incongruous with medieval life, creating pieces that were suggestive rather than literal. Horace Walpole's house and furnishings at Strawberry Hill in England, for example, recalled that country's strong medieval heritage, but in an overtly idealized, nineteenth-century way.

It was common in the nineteenth century to furnish individual rooms in separate styles appropriate to their use. Because it was a style with strong religious and intellectual associations, the Gothic Revival style—as well as its historical antecedents—has traditionally been associated with men. Consequently, Victorian tastemakers advocated Gothic Revival pieces for the typically masculine domain of the library or its adjacent hallway as a way to suggest a romantic parallel between the intellectual activities that may have transpired in the nineteenth-century library and in those of generations past. Because of its historically religious overtones, the Gothic Revival style never reached the zenith in America that it did in England, and when the style appeared in America, it was primarily due to the efforts of architects who designed pieces for specific buildings, mainly churches and schools. In contrast to the mid- and late-Victorian styles that followed and which were more widely produced, Gothic Revival furniture tended to be very costly. Alexander Jackson Davis, a prominent American architect, was the foremost proponent of the style. His design of the New York Gothic Revival villa Lyndhurst near Tarrytown and its furnishings remain the most important example of the style in America.

In order to understand the limited appeal of the Gothic Revival vogue, it is important to recognize some of the influences impacting furniture styles at the time. Prior to the 1830s, there was a strict formality to interior decoration and furniture design. It helps to recall that there existed specific guidelines for usage; early in the previous century, for example, chairs were a luxury reserved for the male head of household. By the third quarter of the nineteenth century, however, the concept of formality in placement gave way to furniture that

moved into the center of the room. This replaced the routine that prevailed since the earliest days of interior design—furniture being lined up around the walls, then moved for use, then placed back around the perimeter. Historians have labeled this phenomenon the "devaluation of space." Many factors brought this later devaluation about, including the gradual disappearance of aristocratic societies, the rise of the middle class, and the introduction of the feminine influence. Feminization of the interior accounted for the introduction of plants and flowers into living areas, the notion of comfort, as well as the explosion of small objects and bric-a-brac. Even popular periodicals supported this change and were aimed at women and their efforts to make household decisions. It is no wonder that the duration of the Gothic Revival style as espoused by male architects was limited in terms of audience and duration.

Separately, Victorian aesthetics often contrasted strongly masculine and architecturally oriented forms with delicate and curvaceous feminine ones. Such was the contrast between the "masculine" Gothic Revival style and the more "feminine" Elizabethan Revival style that developed concurrently. It is a misnomer of the twentieth century that Victorians repressed any notion of sexual distinction. That design elements of each style can be found on a singular piece strengthens the idea that masculine and feminine symbolism permeated popular objects, including furniture. The term *Elizabethan,* a broadly appropriated label, is inaccurate; in fact, details were borrowed from several periods, including the eras of Charles I and Charles II. Some of these traits include Baroque-inspired spiral-and-ball turnings and lighter proportions than those found on heavier Gothic Revival pieces. Between the two styles, shared traits included contrasts of solid and void and materials such as mahogany, rosewood, or walnut. Generally, dark woods—or those varnished to simulate dark wood—prevailed. Gilding was an infrequently used option. Visual excitement came in the form of carved or turned elements. Applied decoration was not ordinarily used. Besides differences in scale and shape of elements in Gothic and Elizabethan Revival styles—architectural versus purely ornamental, respectively—perhaps the biggest difference was found in the way each style was produced and marketed.

While the Gothic Revival style was predominantly the specialty of architects, the Elizabethan Revival style was equated foremost with mass-produced wares, especially a type known as cottage furniture. Due to manufacturing advances resulting in components that were often interchangeable, regional variations were rarely if ever important. Cottage furniture grew out of a type of simple and economical furniture used for centuries in Europe that was conceived for function rather than display and is equated with more provincial designs that rely on a

combination of local skills, materials, and preferences. Victorian furniture of this type is routinely available in the marketplace, and references to nineteenth-century cottage furniture relate to moderately priced, factory-made furniture on which elaborate spirals such as those on higher style Elizabethan pieces were reduced to simple, less volumetric ball turnings. It was suitable for such public spaces as upstairs bedrooms or summer cottages (hence the label "cottage"). Combined with less costly softwoods that were gaily painted with a variety of fruit, floral, or vine motifs to cover cheap materials and/or workmanship, this furniture brought a certain degree of style to both working and middle-class homes. While some cottage pieces have been passed over by collectors as uninspired, other examples have a certain degree of idiosyncratic charm.

CASE WORK

The New York firm of J. and J. W. Meeks advanced the Gothic Revival style as well. A secretary-bookcase (Metropolitan Museum of Art) made from rosewood was fashioned from a squared case whose severity was relieved by a pointed arch and quatrefoil tracery on the glass doors of the upper case. Gothic cusps projecting from the intersection of two curves are the sole ornament on the rosewood panels of the lower case. A contrasting satinwood interior was a finishing touch used by the best firms. The overall effect of this secretary-bookcase and of the form in general is a decidedly masculine one, owing to its large proportions, simple, clean lines, and subdued ornament. It was perfectly suited to the masculine environment of the library, in which it undoubtedly would have been placed.

Other case pieces were more overtly architectural. Even though Gothic Revival furniture designed for use outside the library was infrequently found, certain objects, including a chest of drawers form with a looking glass attached, might house a mirror frame made up of finials shaped to resemble church spires. The influence of the architect's hand alone accounted for this building-like configuration, and there was little effort on the part of the general public to understand the whole concept of Gothic structures. This seems incongruous today, considering that select elements were found in public buildings, including those designated as churches and schools.

NEW CASE FORMS

A new form, the *étagère*, emerged in the early Victorian era of the Gothic and Elizabethan revivals. A French term for a "whatnot," the

Throughout history, Gothic elements have traditionally been associated with religious and intellectual pursuits. Consequently, this Gothic Revival secretary by J. and J. W. Meeks, New York, circa 1840, would likely have been placed in the library, where nineteenth-century aesthetes deemed it appropriate.

freestanding tiered shelving was perfectly suited to the Victorians' dual love of ornament and display and relates to the feminization of the interior. Meant to house small objects, these pieces were the focal points in the best parlors, entrusted with the same status-confirming duty that the high chest once performed. Many were outfitted with mirrors behind the shelves to augment the displays. No singular format applied: Some models had shelves that were graduated in size from top to bottom while other models relied on equally sized shelves. A Gothic Revival version was likely to have an enclosed mirrored bottom with an open work top reminiscent of tracery.

SEATING

Chairs were the forms most frequently produced in the Gothic and Elizabethan Revival aesthetic since chair backs and crest rails, the basic components of the form, were easily manipulated with the new vocabulary. Due to their strong vertical emphasis, side chairs were the perfect form to showcase the exaggerated points and arches of Gothic ornament or to display the spirals reminiscent of elaborate "twist turn'd" chairs of earlier Baroque compositions found on Elizabethan Revival examples. Many chairs exhibited both elements simultaneously: Examples exist on which a tall back rises to a pointed arch and crest full of tracery while the spiral-twisted legs and rear stiles suggest an Elizabethan sensibility. A chair following this format would be readily distinguished from any seventeenth-century antecedent by its ample proportions and emphasis on its plumped-up upholstery. While carrying traits of both styles, many of these chairs were simply dubbed "Gothic."

A small but select group of furnishings from Lyndhurst are the most important examples of Gothic Revival furniture designed by an architect. A side chair made by cabinetmakers Richard Byrne or Ambrose Wright, circa 1842, follows a drawing laid out by Davis. Made from darkly varnished oak, this wheel-shaped chair-back design was a novelty that underscored the link be-

Pointed arches and quatrefoils conclusively place this armchair in the Gothic Revival style. (Courtesy Lee B. Anderson.)

In addition to the arches and the rose-patterned back suggestive of the Gothic Revival style, this chair also has features of the Elizabethan Revival style in its spool-turned stiles and legs, although in the 1840s, this chair was probably labeled "Gothic."

tween architecture and the decorative arts. Though not as intensely architectural as the work of English Gothic Revivalist Pugin, the wheel-shaped back recalls a rose window, one type of colorful medieval glass design used extensively in the construction of Gothic cathedrals. A rare form, this chair is the standard by which all Gothic chairs should be evaluated, based on its strong architectural composition and its quality of workmanship.

There were far fewer couches, sofas, and easy chairs made in the Gothic Revival format since Gothic details were overlaid primarily on side chairs and secretary-bookcases destined to be placed in the library; couches and easy chairs, which were less popular forms for the library during this period, rarely received this treatment. However, they turn up occasionally and were probably originally intended as furnishings for many Gothic-style cottages, where the entire design of the building as well as those of its furnishings was interpreted in the Gothic mode (there are rare Gothic Revival bedsteads, for example). Of the limited number of easy chairs made in the Gothic mode, most were endowed with tufted upholstery, an innovation of the mid-nineteenth century that saw buttons sewed through the upholstery to secure it. The angular patterns this plump tufting assumed resembled the pointed and rounded arches found in other mediums (in furniture these shapes were found in wood; in architecture such curves were noted in stone) in a most creative and voluminous way. On the couch form in which one end was enclosed, artisans made good use of the end with the high back: Pierced stiles and finials, and crockets, or architectural moldings terminating in a curve, formed a medley of Gothic motifs from the stiles to the crest. Elizabethan examples followed the same basic format as those of Gothic Revival couches, substituting tall, spool-turned backs for those of Gothic design that were pierced and adorned with crockets or finials. With the exception of pieces that were admixtures of both styles, all traces of architectural components were weeded out. Legs were turned in simple

spool shapes, or in the more volumetric twist-turn'd arrangement that often signals a more expensive version of the Elizabethan Revival.

TABLES

Gothic and Elizabethan Revival tables adhered essentially to one format. Following design tendencies established through the centuries, the advanced ornament of the time—in this case, Gothic or Elizabethan Revival—was applied to an older, conservative form, usually a Restauration or late classical body. Specifically, a pedestal table—a classical form—would receive Gothic ornament at the base in the form of tracery and arches. Another classical form, a trestle table with a flattop resting on legs stabilized with stretchers or crossbars, incorporates Gothic ornament in the guise of quatrefoils cut through the skirt or apron. This was an appropriate design for gaming tables. Gothic Revival elements are not usually found on dining tables. More often than not, Elizabethan Revival tables were of the trestle variety, in which a combination of spool-turned legs and stretchers supported a square top. Blatant intermixing among countless forms and decorative philosophies endured for many decades and marked the entire Victo-

It was common practice in the Gothic Revival style to impose Gothic detail on a classical pedestal form. This example, stamped "J. and J. W. Meeks," has a marble top resting on a mahogany body. (Courtesy Lee B. Anderson.)

The spires rising from the base of this tilt-top table recall similar architectural details on medieval cathedrals. (Courtesy Lee B. Anderson.)

rian era. On any given piece, such combinations include the mixing of two different stylistic modalities—Gothic and Elizabethan Revival, for example—or the mixing of a classical form with what was considered fashionable ornament—Gothic Revival ornament overlaid on a pedestal or trestle table.

\mathcal{S}UMMARY OF STYLE

Dates: 1830–1865
Distinguishing Features: medieval elements including pointed arches, tracery, spirals; spiral ball turnings
Materials: mahogany, rosewood, walnut, or oak varnished to simulate dark wood; painted floral motifs on cottage furniture

COLLECTOR'S TIPS

1. *Look for (good example):* rosewood; quality of materials and workmanship. On Gothic Revival pieces, look for architectural elements in proportion to the object they adorn; on Elizabethan Revival pieces, look for elaborate turnings.
2. *Look for (outstanding example):* architect-designed pieces in the Gothic Revival format; elaborate, volumetric turnings on Elizabethan Revival pieces preferred over simple spool turnings found on less costly cottage furniture; unusual designs
3. *Problems/what to watch out for:* No widespread problems are noted, but the market for Gothic Revival furniture is small. Elizabethan Revival forms appear commonly, but some cottage furniture of this type lacks aesthetic merit.
4. *Conservation issues:* Oak and rosewood are generally very durable materials, but spirals and tracery are more fragile components, especially where there are large areas of voids or open space.
5. *Cabinetmakers/firms important to style:* A. J. Davis, J. and J. W. Meeks, Richard Byrne, Ambrose Wright
6. *Where public can see best examples:* Metropolitan Museum of Art, New York, New York
7. *Department expert wish list:* side chair with Gothic and/or Elizabethan details. This could include a tall-back chair with a pointed arch and crest rail with tracery (Gothic details) and spiral-twisted legs (Elizabethan detail).
8. *Miscellaneous:* Gothic Revival furniture appears frequently in the marketplace; it is not widely collected and hence pieces can be hard to locate. Many pieces are hybrids incorporating details of both Gothic and Elizabethan revivals.

\mathscr{R}OCOCO REVIVAL FURNITURE (1840–1870)

Inspired by sensual Rococo designs of the eighteenth century, the Rococo Revival style became the most popular design of the mid-Victorian era. By 1840, cabriole legs, scroll feet, sculptural contours, and intricate S- and C-scrolls returned to furniture crafting. Following the lead of other revival styles, the Rococo Revival style as envisioned by Victorian America was evocative, not literal. Whereas French makers of the 1840s utilized many of the same tools and techniques found on historic examples, resulting in pieces that can be confused with French pieces made one hundred years earlier, American craftsmen were not bound by the tradition of the *ébéniste*. American stylists working in the Rococo Revival vogue often went beyond the tenets of eighteenth-century design to create excessively ornate forms, many with an extravagant naturalism. Alternate labels include French antique, Louis Quatorze, or Louis Quinze. This toplofty style was especially popular in the French-speaking locales of New Orleans, New York, and Baltimore, all centers that experienced increased French immigration after the start of the Second Republic in 1848.

Beyond cabriole legs, sculptural contours, and S- and C-scrolls, there was an emphasis on carved clusters of fruit and flowers that surpassed any eighteenth-century rendering. Most of this radically organic and representational carving took the form of grapes and oak and rose leaves, an outgrowth of the mid-nineteenth-century passion for nature that influenced all mediums. Several differences separate this type of carved detail from its eighteenth-century antecedent. Rococo Revival carving is grandiose in scale, and the lace-like pattern of this meandering carving was a feat brought about by technological advances that made it possible to bend and press wood into new curved

shapes and to manufacture carving by machine, which heretofore had been mostly a labor-intensive process accomplished by hand.

Solid wood was not particularly amenable to the grandiose and detailed nature of Rococo Revival carving; the lamination process consequently changed both the way furniture was constructed and the way it was ornamented. John Henry Belter, a German immigrant, was the leading promoter of Rococo Revival design using laminated wood, and it was largely skilled German craftsmen working in his manufactory who helped popularize the technique.

The lamination procedure, a precursor of plywood production, involved gluing together lengthy strips of rosewood veneer. Belter's lamination method resulted in strips that were approximately one-inch thick. The minimum number of layers was six; extremely complex forms required as many as eighteen layers. These strips were then steamed, compressed, and shaped into various forms using molds. Not only did this process allow for the creation of highly sculptural forms, but it also imbued these forms with enough flexibility to accept the intricately carved and pierced ornament that is its hallmark.

Belter moved ahead of some of the leading cabinetmakers—Duncan Phyfe among them—to become New York's arbiter of fashion, and much of the large-scale, ornate furniture produced in this manner was credited to Belter, whether or not his firm produced it. Belter was responsible for the highest quality Rococo Revival pieces, but versions were available at all price points as his patents were the subject of infringement in the era. Imitations were regularly made from walnut and lack the attention to detail that annotates Belter's work. International fairs, including New York's Crystal Palace Exhibit of 1853, showcased the products of this technology, thereby subjugating the role of the elite as sole style setters.

The mechanized processes of the Industrial Revolution facilitated this type of furniture manufacture, including the carving, which could now be performed by machine. Lush, intricate vines, leaves, and bunches of grapes were associated with Belter, as was a carved cornucopia. Cheap and simple "finger-rolled carving," an unadorned rounded molding that decoratively outlines a shape, was often practiced by imitators, although some higher quality pieces used it as well.

Rococo Revival furniture was sold *en suite,* and there was an inordinate amount of attention given to each object and where it was placed in a room. Part of this attention arose out of the permanence that now dominated room arrangements. By the nineteenth century, furniture had lost some measure of the portability that had characterized it in centuries past. As was discussed in the earlier colonial styles, furniture forms were not as plentiful in the seventeenth and eighteenth centuries, and pieces were moved from room to room, often serving more than one function. An eighteenth-century drop-leaf table, for exam-

ple, utilized as a writing surface or as a dining table, was moved about to make best use of daylight, a heat source, or some private space if it could be found. By the Victorian era, room arrangements were more plentiful, and separate forms were designated for each purpose. Generally, if furniture moved at all it was usually to accommodate the rearrangement within the room itself—not because it was to perform double duty in another room. Brass casters attached to Victorian furniture made this limited movement possible. Rococo Revival parlor and bedroom suites were typical. Parlor suites were often some combination of a sofa or *méridienne,* armchairs, side chairs, center tables, firescreens, and whatnots. Printed matter often referred to pieces with dual French and English titles: a *tête-à-tête* and a sofa, or an *étagère* and a whatnot, for example.

The practice of labeling objects was common in the Victorian era, providing important clues to the prevailing aesthetics of different firms, even if they varied little in the machine age. Many Belter pieces are die-stamped "J. H. Belter & Co." in black on the frame, or a printed label supplying this information was attached. John Henry Belter produced furniture under his own name until 1863, the year in which his brother-in-law took over the firm, and the successor firm operated under the name Springmeier Brothers until its demise in 1867. While technology instituted a certain degree of uniformity in Victorian furniture design, regional preferences existed occasionally, and on the best pieces, hand carving was still employed.

While Belter is usually regarded as the pre-eminent Rococo Revival stylist to arrive on these shores, a continual influx of skilled craftsmen was lured to this country, fueling America's fascination with European fashion. America was thriving economically, and fashion historically follows wealth. Charles Baudouine, Alexander Roux, Prudent Mallard, and Leon Marcotte were among the artisans who worked successfully in the Rococo Revival style. In addition, the firm of Joseph Meeks & Sons, previously active in the Empire and Pillar and Scroll styles, proved to be one of Belter's main competitors in New York. These names are linked to the most successful Rococo Revival designs in terms of quality of form, materials, and workmanship, and are highly sought after today by those collectors attracted to its curvaceous outline and organic ornament. In the marketplace for Rococo Revival furniture, pieces by these makers command the highest prices. This discriminating group of cabinetmakers inspired hundreds of firms across the nation to produce the Rococo Revival look at lower prices for the working class, but the resulting designs are today considered inferior, in terms of design and workmanship, to those of Belter and the select group mentioned above.

CASE WORK

The *étagère* or whatnot reached a pinnacle in the Rococo Revival era—the consummate showpiece of the best parlor—and its status was on a par with the high chest of generations past. Namely, it was a repository for objects of all sorts, from the trivial oddity to the most coveted *objets d'art*. The more ornate the piece, the better the *étagère* served as an index of social prominence. Cabinetmakers were willing partners in this conspiracy, investing the greatest design effort on the one object that served the least utilitarian purpose. Some *étagères* were comprised solely of shelves while other versions united open shelves with a cabinet below. Due primarily to the standardization of components that was a byproduct of technological advances, regional preferences were largely absent on Rococo Revival pieces, but they are occasionally found in case work. Philadelphia and New York patrons showed an attraction for extremely curvilinear forms. After 1848, both cities witnessed increasing numbers of French-born aesthetes who were conversant with the curved eighteenth-century forms on which the Rococo Revival was based. Compared to these patrons, Bostonians favored less curvaceous examples.

In New York, French-born and -trained Alexander Roux used his knowledge of earlier Rococo designs to create an *étagère* that was a close approximation of eighteenth-century models using opposing C- and S-scrolls (Metropolitan Museum of Art). An extremely open and curvilinear arrangement supporting shelves, this form captures in a nineteenth-century object the illusion of movement that earmarked eighteenth-century French designs. While skillfully executed, the exuberant application of large-scale, naturalistic ornament in the shape of garlands and floral bouquets, however, reflected the nineteenth-century impulse to capture nature in carved detail. The choice of rosewood, not favored in eighteenth-century designs, further places this piece in the category of nineteenth-century Victorian design.

Dressing Bureau

Frequently, chests of drawers came with attached mirrors, and this form was referred to as a dressing bureau. In the Belter process, the serpentine front and sides of the cabinet are constructed from single pieces of laminated wood shaped in hot cauls and joined with glue in the back. The front and sides of the chest were made of a single wide sheet and sawed apart to create the drawers. This single laminated sheet eliminated dust boards and stretchers between drawers that had been part of cabinetmaking since the eighteenth century, and had the effect of reducing labor costs by doing away with two now-redundant

parts. Overlays of Rococo Revival carving adorn the crest holding the mirror, the drawer pulls, and the columnar corners, juxtaposing a technology-driven form with what was sometimes called French antique carving, a nineteenth-century nickname for the highly naturalistic ornament found on all Rococo Revival furniture.

Chests of drawers with attached mirrors were called dressing bureaus. The serpentine front and sides of this Rococo Revival cabinet are constructed from single pieces of laminated rosewood shaped in hot cauls or molds to create their curved appearance.

SEATING

BALLOON-BACK CHAIR

One of the most common seating forms was the balloon-back chair, which received its name based on the back's close resemblance to the shape of a hot-air balloon. It is recognized by a crest with a swollen, rounded shape that narrows at its juncture with the seat. The form differs from earlier balloon-type chairs, especially those of the Queen Anne aesthetic, in which the seat was the only balloon-shaped element. The rear legs on a Rococo Revival chair are usually chamfered or beveled off at the base, and the front cabriole legs—the standard used on most Rococo chairs—are less curvaceous than those on an eighteenth-century chair. A design standard, the Victorian balloon-back chair often mixed several Victorian ornamental overlays; undulating Rococo lines were capriciously punctuated with Gothic ornament, and examples appeared at all price points.

This small récamier *has the flowing curves, scroll feet, and large-scale French antique ornament that identify it as Rococo Revival.*

SOFA

The sweeping silhouette of the balloon-back chair served as the inspiration for the triple-crested sofa, an innovation that surfaced in the mid-nineteenth century. Deep, undulating lines typify this combination of two tall sections and a smaller profile section in the middle, or the reverse—two short profile crests flanking a taller mid-section. Some triple-crested sofas were upholstered all the way up the back while others, especially those turned out in the Belter style, were partially upholstered on the back. The remaining area of the triple crests consisted of the ornate, high-relief carving for which some of these pieces are notable. These sofas rest on short, cabriole legs, and upholstery was stretched over the wooden frame of the seats and any part of the back that was not carved. In general, there was an emphasis on comfort as the profile of upholstery swelled. Coiled springs, tufting, and ample horsehair and cotton batting made up seating substructures. Many seating forms were designed with casters for ease of movement within a room. Given their height and weight, which made them awkward to handle, most Rococo Revival pieces would have been immobile without them.

SIDE AND ARMCHAIRS

Side and armchairs with extremely tall backs and extravagantly conceived carving are often attributed to the Belter school. The lofty proportions of these high-back chairs probably had roots in Baroque work, especially in Belter's native Germany where the Baroque edict never totally passed from favor. The ornament, on the other hand, is a uniquely nineteenth-century adulteration of eighteenth-century French Rococo detail. Nowhere was the Victorian

Technological advances of the mid-nineteenth century made possible the laminated lacy arabesques on the Rococo Revival chair back, which was bent and pressed into shape by machine. The finest examples of high-backed chairs in the Rococo Revival format were turned out by John Henry Belter.

love of embellishment better manifested than in the deeply pierced, lacy arabesques that made up the back or crest. Arabesques are made up of floral or geometric scrolls cut out by jigsaw machines that create open patterns out of solid material. Jigsaws were commonly operated by treadle or foot pedals until the nineteenth century, when power jigsaws then became synonymous with the cutout patterns gracing Victorian architecture and furniture. When compared to the delicate carving found on eighteenth-century archetypes, Rococo Revival chairs illustrate the incredible strength of steamed and pressed laminated wood.

TABLES

CENTER TABLE

The technology that enabled Belter to saw the arabesques on seating forms was easily transferred to table forms. Most tables following the Rococo Revival format were sold *en suite* with seating pieces and case work, have characteristically undulating lines, and stand on cabriole legs, some of which were formed from opposing C-scrolls. Heavy garlands and bouquets of flowers merged to form an apron under a round or rectangular top or were grouped together where stretchers meet the base. Many of these rosewood tables were topped with a marble slab, an effective contrast to the pervasively dark surface below. Tables of this description are classified as center tables, a form that was meant to dominate a room arrangement.

As with other Rococo Revival forms, rare tables exist that passed up the heavy Belter-type ornament in favor of good proportion and the simplicity of alternating scrolls. French *émigré* Charles Baudouine was one cabinetmaker working in this manner on a card-table form, turning relatively plain, curved surfaces of the top and apron and long and short opposing scrolls that defined the legs into a workable, rhythmic composition. This form contrasts with the standard Rococo Revival blueprint that called for a round or rectangular top on cabriole legs with heavily rendered organic ornament seemingly stuck on as an afterthought.

\mathcal{J}UMMARY OF STYLE

Dates: 1840–1870
Distinguishing Features: laminated woods; sculptural contours; C- and S-scrolls; intricate, organic carving; large proportions
Materials: rosewood, mahogany, walnut

COLLECTOR'S TIPS

1. *Look for (good example):* laminated rosewood; walnut veneers are less favored; sculptural contours in proportion to overall object; finger-rolled carving
2. *Look for (outstanding example):* very elaborate arabesques; naturally rendered foliage; designs by Belter, Baudouine, and Marcotte
3. *Problems/what to watch out for:* On some designs the tacking that secures the carving pierces through the laminated layers
4. *Conservation issues:* Laminated layers can blister when exposed to wide variations in temperature.
5. *Cabinetmakers/firms important to style:* John Henry Belter, Charles Baudouine, Prudent Mallard, Leon Marcotte, Joseph Meeks & Sons or J. and J. W. Meeks
6. *Where public can see best examples:* Metropolitan Museum of Art, New York, New York; Brooklyn Museum; Philadelphia Museum of Art; High Museum of Art, Atlanta, Georgia
7. *Department expert wish list:* Belter-designed settee with cornucopia decoration and high back

RENAISSANCE, NEO-GREC, AND EGYPTIAN REVIVAL FURNITURE (1860–1885)

By the second half of the nineteenth century virtually every historical period had been harvested for inspiration to satisfy the Victorian penchant for novelty. The countless revivals and reactions to revivals that characterize the majority of Victorian furniture reached their zenith in the years following the Civil War (1861–1865), and many examples are imaginative hybrids of several stylistic influences. For this reason, Renaissance, Neo-Grec, and Egyptian revivals are often grouped together in an analysis of furniture of this epoch. Each of the three influences rarely exists in its unadulterated strain.

Nearly every piece of furniture made until the end of the century was often arbitrarily labeled Renaissance, regardless of its design source. The term "eclectic" is far more appropriate for the curious marriage of nostalgia and exotica that characterized the furniture produced during the late Victorian era. It is important to distinguish the revival styles of the Victorian period from the earlier revivals of the Neoclassical era, especially those of the Empire period. It is helpful to recall that Empire designs were, as much as possible, conceived under the guiding principle of historical accuracy based heavily on archeological digs.

The Victorian revivals, of which the Renaissance, Neo-Grec, and Egyptian were part, were romantic, idealized portrayals of a remote

past, one that helped soften some of the more disturbing realities of the Industrial Revolution, including workers relegated to performing endless repetitive tasks in a piecemeal manner. Historical accuracy was passed over in favor of a freely adapted improvisation of large proportions and exaggeration. Scholars have suggested that the term *Renaissance* is aligned more closely with the creative influences that were at work in the nineteenth-century artistic community rather than having any association with sixteenth-century art; the heightened interest in sculpture was one example of this influence. The Académie des Beaux-Arts in Paris was one center of intellectual activity that fostered a renaissance in fields such as painting, sculpture, and the decorative arts, drawing artisans from across Europe and America.

RENAISSANCE REVIVAL

While many pieces of Renaissance Revival furniture exhibited hybrid personalities, some standards did prevail. The shapes of Renaissance Revival furniture are architectural and massive, with squares and rectangles predominating. This was probably due to the *Italianate* style of architecture, which exerted influence on the decorative arts; its more ordered design dogma eschewed the free-form designs for interiors that characterized Rococo Revival furnishings. *Italianate* refers to Renaissance details imposed on architecture and its related decorative arts anytime after the sixteenth century. The guiding principles of symmetry and proportion found in the square and rectangle shapes, as well as modifying details such as medallions, cartouches, and broken pediments, were certain references to a Renaissance aesthetic. While all forms were subjected to this treatment, it was on the larger case forms—cabinets and secretary-bookcases—that the Renaissance Revival style found its best expression. The indiscriminate borrowing on the part of Victorian designers in reality surpassed Renaissance sources and crossed numerous stylistic intervals from Europe dating from the fifteenth to the eighteenth centuries. American furniture of the Renaissance, Neo-Grec, and Egyptian persuasions is regarded as being less aligned with its styles of origin than its European counterparts, and any restatement of earlier, historic forms was unsuccessful. Further, since many objects from this late Victorian era may combine more than one stylistic influence, the preferred method for dealing with such multiple influences is to identify the piece by its most dominant feature, with notations made of all secondary influences.

Due to multiple design sources, several variations prevailed. Earlier pieces of the 1860s tend to be somewhat jagged in overall shape, and were made of walnut or mahogany, with rosewood and ebony prevalent as well. Pine as found in cottage furniture was reserved for the

least expensive examples and destined for less affluent households. Animal and human figures were also popular decorative motifs, whether carved in wood or applied as porcelain plaques. Marquetry, or decorative inlays of wood, ivory, or other materials, was another frequently found treatment. A hallmark of the best Renaissance Revival furniture is the abstract pattern often formed with contrasting materials, creating specific borders for a large area, such as the panels on a cabinet. Inlays set up optical illusions so that a one-dimensional pattern seemed to project out of the plane in much the same way that a skillfully executed painting might create the illusion of depth.

NEO-GREC

By about 1870, shapes were severely linear, merging the square backs, straight stiles, and turned legs of Louis XVI forms with the architecturally massive Renaissance bodies and their medallions, cartouches, and pediments. Flat surfaces and angular corners predominated. In case work, applied burled walnut panels and porcelain plaques were common, as was inscribed linear decoration infilled with gold leaf. Incising was an inexpensive, technology-driven decoration that was made to seem more glamorous than it was by the addition of gold leaf. In order to create the inscribed linear decoration, rotary-powered chisels were first moved across a flat wood surface to chisel or cut in the shallow lines. This was followed by another step that implanted gold leaf in the inscriptions as a highlight. Incised-line ornament was especially prevalent in the 1870s. This merger of Louis XVI and Renaissance Revival styles is often referred to as the Neo-Grec style. It was introduced by the firm of Ronguet, Le Prince, & Marcotte, a firm operating in both Paris and New York, and by French and German cabinetmakers who established businesses in New York. An alternate and admittedly more confusing name for American furniture in the Neo-Grec style, Victorian Renaissance, was given to distinguish it from the original style that flourished in sixteenth-century Europe. That the label Victorian Renaissance existed at the same time as the separate term *Renaissance Revival* underscores just how truly confusing this eclectic period was and continues to be to twentieth-century observers.

EGYPTIAN REVIVAL

Paralleling developments in the Renaissance Revival and Neo-Grec styles, several events conspired to bring about a renewed interest in Egyptian decoration, which got its start following Napoleon's Egyptian campaign which ended in 1799. The Egyptian motif was far-reaching:

One of the first collections of Egyptian artifacts was exhibited in New York in 1852. In 1862 there was an exhibition of Egyptian antiquities in London, and in 1869, the Suez Canal was completed, prompting the commission of Verdi's *Aïda* to celebrate its opening. In 1881, an obelisk, Cleopatra's Needle, was installed in New York's Central Park, further solidifying this highly decorative theme, and all across America the Egyptian craze was observed. The Mississippi River was nicknamed "the American Nile," and towns were christened with such Egyptian names as Cairo and Memphis.

The principal design components of the Egyptian Revival style were primarily decorative, superimposed on an underlying Renaissance Revival body. These components include palmettes, sphinx heads, lotus capitals, zigzag lines, and geometric patterns, as well as animal-paw feet. Eye-catching combinations of materials often characterize this revival, including interplay of gilt, marble, bronze, mother-of-pearl, and wood. Contrasts of light and dark were also important to this scheme, including ebony juxtaposed with lighter woods.

It is a misnomer that all furniture produced during the Victorian era was mass produced and inexpensively made. The highly documented loss of the artisan-designer occurred mainly in heavily commercialized, mechanized enterprises where output was targeted to mass consumption. The larger cities still catered to the upscale market and continued to lure designer-craftsmen who operated in small to mid-sized shops and orchestrated refined designs for the affluent, using a "formula" of a Renaissance Revival body often incorporating overlays of Neo-Grec or Egyptian details. Regional variations were largely lost, but this loss is not meant to suggest that quality declined or that pieces were mirror images of one another. European immigrant craftsmen turned out extremely sophisticated cabinetwork for American patrons. At the 1876 Philadelphia Centennial Exhibit, for example, furniture was displayed that competed with the finest French work; an elaborate cabinet was more expensive than a modest house. Wealthy customers could select from the finest examples of goods obviously not intended for mass markets. In 1878, French-trained Leon Marcotte was awarded a gold medal for an ebony cabinet he showcased at the Paris Universal Exhibit.

In addition to Marcotte, some of the leading craftsmen working with the highly eclectic Renaissance, Neo-Grec, and Egyptian revivals included Alexander Roux, John Jeliff, Daniel Pabst, and Thomas Brooks. Herter Brothers, founded by two German immigrant brothers, got its start in New York by turning out revivalist designs and ultimately rose to become a top-tier purveyor of custom-designed aesthetic pieces in the Anglo-Japanese flavor of the 1880s. Another New York firm, Pottier and Stymus, produced many high-style Renaissance Revival pieces, especially those with a strong Egyptian slant. Furniture fabricated for

the middle and lower end of the market, on the other hand, originated out of Grand Rapids, Michigan, and other points in the Midwest, an area that was a regional manufacturing center. Berkey & Gay was one firm making middle-market furniture, and the gigantic, overbearing bedroom suites shaped in this manufactory were only as restrained as the dimensions of the interiors they occupied. Other midwestern firms catering to the middle market included Mitchell & Rammelsberg of Cincinnati and Phoenix Furniture Company, and Nelson Matters & Company, both of Michigan.

CASE WORK

CABINET OR CREDENZA

Following a tradition in American case pieces, Victorian cabinetry continued to be a harbinger of fashion and wealth. Much cabinetwork of the post–Civil War period was based on the credenza, a horizontally configured cabinet of Italian origin commonly found in Renaissance design. For the leading cabinetmakers of the day, a credenza offered ample space upon which to exhibit their technical and decorative virtuosity; for the patron, the elaborately conceived credenza affirmed its owner's wealth and good taste. While in underlying structure most cabinets or credenzas were inspired by precisely defined Renaissance forms raised off the floor with paired doors, the ornament was decidedly eclectic. Many of these credenzas were finished with Louis XVI, Neo-Grec, and Egyptian details, some incorporating two or more of these influences in a single cabinet. Used in the best drawing room, these pieces were frequently dubbed "French cabinets" and served an overtly ornamental purpose. Geometrically partitioned panels of rosewood, cherry, mahogany, and fruitwood were often adorned with burled woods, ebony, or other exotic materials, as well as with incised lines.

WOOTON OR PATENT DESK

Even functional furniture was conceived using a "fashionable" philosophy. The patent desk fit this category. William S. Wooton of Indianapolis designed, patented, and manufactured a desk for businessmen that became the consummate status symbol for men who had "arrived"— railway magnates and other late nineteenth-century entrepreneurs who were beginning to experience the complexities of managing a diverse enterprise and its attendant paperwork. On the outside, many of these desks differed little from other case pieces. They were marvels of

ornament that included bodies of walnut with exotic veneers and panels with carved and incised detailing. Bodies were held together with bronze hinges and hardware. What made this form so unique was that it was actually a series of separate, moveable cabinets that folded onto

Together with the pedimented top and large-scale carving, the symmetrical architectural presence of this massive secretary-bookcase owes a debt to the Italianate *style of architecture.*

When closed, this stately form known as a Wooton desk after its maker, William S. Wooton, had all the trappings of a Renaissance Revival case piece, including a body of walnut and inset panels. Disguised behind the hinged doors, however, were ample storage compartments. Made for businessmen, this moveable arrangement permitted the user to keep all important papers within easy reach.

one another through a series of hinges. When open, however, these desks revealed "a place for everything and everything in its place," where information about a gentleman's entire operation was instantly before him. Many interiors contained more than one hundred compartments, providing an important measure of organization concealed behind a decorative exterior when closed. Wooton patent desks fulfilled the Victorian penchant for gadgetry and were commonly available in four grades: Ordinary, Standard, Extra Grade, and Superior Grade. Prices ranged from $90 to $750.

SIDEBOARD

In the more traditional pieces, many cabinetmakers were still judged by the sideboard form, which in the revival styles was a vehicle for intense competition among rival manufacturers. Moving from the ground up, the standard organization consisted of an overblown bottom case or cabinet with doors and a set-back or recessed top with open shelves. Marble was often the choice for the top of the cabinet

and shelves, and walnut was likely for the body. Like other case work of the period, the shape that these components took was loosely based on the Renaissance cabinet or credenza partitioned into panels by columnar supports. The sideboard took on an even more massive quality

The lower case on this massive sideboard resembles a Renaissance credenza, which was a low-slung cabinet, often with doors. Sideboards like this Philadelphia example made by Daniel Pabst were often essentially status objects overflowing with decorative detail. (Courtesy Philadelphia Museum of Art.)

with the addition of a scrolled pediment. Ornament consisted of carved leaves and flowers rendered in the large and excessively naturalistic manner for which the Victorians were noted. In some instances carved ornament such as dripping game was so indiscriminately combined with flowers and scrollwork that it was difficult to determine the designer's original inspiration or intention on these bombastic pieces.

SEATING

Diversity of design was equally applied to seating forms. Materials were as multifarious as ornament, which was usually applied in a symmetrical or repetitive manner. Walnut, maple, rosewood, and ebonized surfaces prevailed. Characteristic of the age, the combinations of these materials varied so wildly that generalizations are difficult. On those forms that carry a strong Renaissance Revival flavor, trumpet-turned legs (similar to those found on early eighteenth-century pieces) and pendant drops (downward-pointing finials from the shoulders of the crest) were standard fare, as was an architectural cresting piece. Acorn finials, medallions, and ring or circular pendants were alternatives on some chair crests. The overall shape tended to be somewhat geometric in seating forms of this time frame. Incised designs, or shallow, border-like patterns sometimes infilled with gold leaf characterize chairs of the Neo-Grec Revival, a combination of Renaissance and Louis XVI elements. Caryatid or figural arm supports, palmettes, and hooved feet are indicative of an Egyptian Revival vocabulary. Some of the finest seating pieces were the creative effort of Leon Marcotte, who chose such exotic treatments as mother-of-pearl inlays on his Louis XVI–inspired designs. Pottier and Stymus and Herter Brothers also had a strong following for their sophisticated, expensive seating designs of the finest materials and craftsmanship.

At the lower end of the market, certain Renaissance Revival details were

Usually made from walnut, Renaissance Revival side chairs are often recognized by their trumpet-turned legs and an architectural crest topped with a medallion or cartouche.

Attributed to the New York firm Herter Brothers, this piece mixes Renaissance Revival details, including the trumpet-turned legs with Louis XVI features, an inset medallion, and linear incising, to create a Neo-Grec chair, circa 1865. (Courtesy Metropolitan Museum of Art, Gift of James Graham and Sons, 1965.)

worked into less expensive bodies. An architectural crest might be superimposed on a simple turned frame. Many of these less costly seating forms are recognized by their spare proportions and such banal features as simple caned seats—another cost-saving component.

Armchairs and sofas were especially plump, with tufting securing the upholstery. Such deep, linear tufting over ample fillings lent yet another layer of geometry to an already geometric shape. Legs were short and trumpet-turned, and arms were a combination of wood surface and padding. In contrast to sofa frames of the early and mid-Victorian period that were often a focal point of the form, Renaissance, Neo-Grec, and Egyptian frames were more subdued. Fully upholstered sofa backs with architectural crests or medallions were far more solid and angled than the tall, lacy arabesques of asymmetrical demeanor found on frames of the Rococo Revival variety.

Linear incising decoration inset with gilt across the front seat rail was a standard machine-performed procedure on Renaissance Revival furniture.

TABLES

Tables continued to be made *en suite* or as companion pieces to case work, chairs, and sofas. The greatest number of tables in the eclectic repertoire that made up the Renaissance, Neo-Grec, and Egyptian Revivals followed a design mandate that favored angular, flat elements for the major components—top, apron, and legs. This contrasts with the heavy emphasis on a three-dimensional quality inherent in the Rococo Revival style with its cabriole legs, and heavy, "stuck on" organic ornament. The big exception to this trend appeared in some primarily Egyptian Revival tables, where strongly rendered sphinx heads break free of the plane of the legs and top to lend these tables a sculptural effect.

Tables fall into two major categories. One group looks to the classically inspired pedestal form, with a top resting on a pedestal base. The second group relies on a form termed the trestle table after permanent models found in original Renaissance designs. These tables consist of a long slab resting on some arrangement of posts and feet. Massive library tables often followed this blueprint. Designers, as well

as mass marketers, employed the exhaustive collection of revival ornament from Renaissance, Neo-Grec, and Egyptian sources, all with varying degrees of success. As applies to all other furniture forms produced in this period, many tables incorporate disparate details from all three strains, blurring the distinction between Renaissance, Neo-Grec, and Egyptian influences. Manipulated together, these elements might take the shape of a trestle (Renaissance) form, upon which shallow, incised, and gilt-filled borders across the apron prevail (primarily a Neo-Grec detail), with legs composed of sphinx heads (Egyptian detail). A marble slab top would contrast with rich rosewood and walnut woods below. Just how integrated this design would register is the key to a successful orchestration, as compared to one that is simply confused.

Egyptian motifs became popular following Napoleon's campaign of 1799 and remained a decorative influence in the mid- to late nineteenth century. The New York firm of Pottier and Stymus crafted objects in the Egyptian Revival format using eyecatching details as zigzag or geometric borders, patinated-gilt bronze, and hooved feet.

SUMMARY OF STYLE

Dates: 1860–1885

Distinguishing Features: large proportions and exaggerated detail; architectural components including medallions and pediments; inscribed linear decoration; Egyptian motifs including sphinx heads, animal paws, and exotic inlays

Materials: rosewood, mahogany, walnut, exotic materials such as mother-of-pearl, porcelain plaques

COLLECTOR'S TIPS

1. *Look for (good example):* large, successful proportions; inlay; architectural forms; shallow, linear decoration
2. *Look for (outstanding example):* exotic inlays; inset panels; quality materials and workmanship; on forms with multiple influences, integration of decorative details; pieces by Herter Brothers and Pottier and Stymus
3. *Problems/what to watch out for:* New tops or replaced panels can devalue a piece significantly; form that was originally a larger sideboard now cut down to cabinet size to fit today's smaller dwellings.
4. *Conservation issues:* The use of multiple materials such as inlay, porcelain, mother-of-pearl, and gilt can make repairs or restoration expensive.
5. *Cabinetmakers/firms important to style:* Alexander Roux, Leon Marcotte, John Jeliff, Daniel Pabst, Thomas Brooks, Herter Brothers, Pottier and Stymus, Berkey & Gay
6. *Where public can see best examples:* Brooklyn Museum; High Museum of Art, Atlanta, Georgia; Metropolitan Museum of Art, New York, New York; Los Angeles County Museum of Art; The Newark Museum, Newark, New Jersey
7. *Department expert wish list:* Renaissance Revival side chair; large sideboard by Daniel Pabst
8. *Miscellaneous:* The majority of Renaissance, Neo-Grec, and Egyptian Revival pieces held in public museums are of the highest quality and some of the best examples of this very eclectic and sometimes confusing period in American furniture. Novices should view these examples in order to fully grasp the styles. This will help distinguish the better examples in the marketplace today from what can often be an inordinate amount of mass-produced forms with little aesthetic merit.

\mathscr{I}NNOVATIVE FURNITURE (1850–1900)

Throughout the nineteenth century, Innovative furniture forms appeared that differed from the formalized styles of the period. The history of furniture is usually viewed along a continuum where one style gently transitions into another. Perhaps the best example of this progression can be seen in the gentle S-curve of the cabriole leg and pad foot on Queen Anne designs that transformed into the full-blown angular leg and claw-and-ball foot in subsequent Chippendale designs. Moving forward to the realm of Innovative furniture, however, other forces were at work—technology in particular—that altered such stylistic continuity. Innovative furniture of the Victorian period is defined as objects that:

- relied on advances in technology, such as those permitting steam bending of wood;
- were dependent on mechanical contrivance, including convertible or folding types; and
- incorporated new and/or exotic materials not heretofore found in furniture.

It is important for those new to the study of the decorative arts to grasp the notion that Innovative furniture was as much a part of the genre of Victorian furniture as were the Rococo, Renaissance, Neo-Grec, and Egyptian revivals with which it was contemporaneous. Where those influences looked romantically back in time, creating loosely based pastiches of earlier styles, the class of furniture known as Innovative forged ahead, creating techniques, forms, and materials in-

cluding bentwood, collapsible pieces, *papier-mâché,* and metal that were at once revolutionary and evolutionary.

In America, the impetus for Innovative furniture began early in the century when individuals such as Samuel Gragg of Boston designed a *klismos-*type chair whose unbroken curves were formed entirely from steamed and bent wood. The year was 1810. Some forty years later, John Henry Belter would refine this wood-bending technique in his Rococo Revival designs with the addition of laminated rosewood strips that proved far stronger than the designs Gragg envisioned. Belter's wood-bending and lamination technique deserves to be included in a discussion of Innovative furniture. However, because Belter's designs are indelibly wed stylistically to the Rococo Revival theme and its curvaceous, organic compositions, historians have traditionally relegated them to the analysis of revival furniture (see Rococo Revival furniture).

While imaginative forms such as Gragg's chair fashioned entirely from bentwood appeared early in the nineteenth century, it was in the second half of the century that they flourished. Fueled by the advanced machinery of the Industrial Revolution and the quest for experimentation, newly developed techniques and materials joined to bring diversity to the decorative art of furniture making. While the status of the furniture designer was sometimes uncertain in these years, thanks to the separation of artist and finished product, that of the inventor was assured as he worked to convert a patented idea to a workable model. Such innovation often followed one of two pathways—technical manufacturing improvements or mechanical contrivance. In an age when technology was the driving force, innumerable patents were issued for furniture whose newfangled assembly processes often overshadowed its decorative appeal. A combination of objects, both real and those that were destined never to make it past their ambitious plans, demonstrated the Victorian predilection for gadgetry. Most of this furniture falls into a category labeled "patent furniture," for which thousands of patents were issued by the United States Patent Office from the 1860s until the end of the century. Collapsible furniture, folding chairs, hide-a-beds that tucked into such odd devices as pianos, tables, or bookcases, as well as swivel chairs and therapeutic recliners, fit this broad category of mechanical contrivance. Although folding furniture was a recurring theme since antiquity, nineteenth-century designers were influenced less by old ideals of portability and more by a constant need to experiment and invent. In the 1860s, George Hunzinger of New York, a German-trained furniture maker, received patents for a number of folding chairs, ultimately prompting firms such as the Boston Furniture Company to turn out similar versions in cities around the country.

In addition to mechanically assisted pieces, Innovative furniture includes those pieces constructed using technological advances such as

the laminated bentwood technique, which is attributed to Michael Thonet. Working in Austria and Germany, Thonet experimented with lamination and steam shaping of birch by attaching the wood to metal strips with clamps, bending both the strip and wood. Several days later, the metal strip and clamps were removed and the wood held its shape. Thonet perfected his process by 1850 at the same time that Belter was perfecting his method of shaping wood in America by combining thin, laminated strips together that were then shaped in molds. On an aesthetic level, Thonet and Belter's designs were opposites: Thonet produced mainly spare-looking chair forms with no applied ornament while Belter's designs were the epitome of ostentatious Victorian display in many forms. Whatever the technique, both designers were indebted to Gragg, who appears to have been the only forward-thinking designer of his day working at testing the tensile strength of wood. And while the *klismos* form Gragg created proved too fragile to endure, it foreshadowed an entire class of Innovative furniture that reached its peak at the eclipse of the nineteenth century.

One advantage of bentwood furniture to nineteenth-century commerce was that it could be shipped in parts to be assembled later for retail distribution. In the case of Thonet's furniture, its importation to this country prompted a host of American-made copies, although many are regarded as generally below the integrity of Thonet's originals.

Constant experimentation with materials was another feature of Innovative furniture: Metal, *papier-mâché*, and unusual treatments of natural materials all fit the broad definition of pieces labeled "inventive." This differs substantially from the "age of walnut" (William and Mary) or the "age of mahogany" (Chippendale) that marks much American furniture prior to the mid-nineteenth century.

Metal furniture was another recurring type dating to antiquity, popular in the objects made by metalworkers in the Middle Ages and the Renaissance, as well as in the decorative mounts known as *ormolu* found on eighteenth and early nineteenth-century objects, especially those of French manufacture. In late Victorian designs, metal was lauded not for its ability to be hand-worked but for its ability to conform to inexpensive machine production, notably bodies shaped by molds. The iron industry entered an era of great expansion; as early as 1851, cast-iron beds were shown at the Crystal Palace Exhibition and became a welcome, hygienic alternative to the mostly wooden bedsteads that were often plagued by bugs even in the cleanest and most moneyed households since the colonial days. Additionally, highly ornate cast-iron furniture, which was made by screwing together individually cast sections, was used in interior and exterior settings especially in the last quarter of the nineteenth century. As a preservation measure, most cast-iron furniture was painted in the period. Exterior cast-iron furniture, known as garden furniture and made in the nineteenth century, is highly sought

after today as an icon for the American interest in the outdoors that flourished beginning in the 1850s. As a point of connoisseurship, in the refinishing processes to which some objects have been subjected, additional coats of paint may have been applied, blurring or flattening the original casting, and many collectors have mistakenly attributed this flattening to poor casting, when in reality overzealous repainting may be the culprit. These pieces command less in the marketplace than those that have more clearly delineated casting.

An adjunct to metal furniture, wire furniture was often manufactured by the same firms engaged in the making of weightier iron objects. Separate wire-making machines were responsible for forming intricate, mass-produced pieces, particularly chairs and small tables, out of malleable wire, many in free-form shapes recalling Rococo Revival influences. Metal chairs fit this category best and are recognized by fanciful backs or seats that have a "spun" quality suggestive of spider webs. Due to its lightweight nature, however, the long-term survival of wire furniture has been less assured than that of cast-iron pieces.

Papier-mâché furniture took life from what would seem unlikely materials for furniture crafting—ground paper pulp and glue—and combined and pressed them into desired shapes by machine. While the manufacturing possibilities of the industrial age made possible the machinery to create the underlying form, the decoration of these compounded objects utilized an ornamental process based loosely on the centuries-old technique of Oriental lacquer work called japanning in the West. Japanning held fascination for Westerners ever since its introduction in Baroque England. In the nineteenth-century process, Victorians achieved the highly lustrous and decorative look of japanning using dark paint on the molded-paper compound to create a background upon which polychrome floral or landscape scenes were painted and varnished. Gilt selectively placed on borders or as an accent to the polychrome scenes made for successful contrasts with the dark backgrounds.

As was the case with many Victorian styles, the London Crystal Palace Exhibition of 1851 stirred mainstream interest, and the opening of Japan to foreign trade in 1854 helped popularize Japanese artifacts even further. Japanned *papier-mâché* was yet one more example of Victorian attempts to romanticize their environment in an era of rampant industrialization. Additionally, select *papier-mâché* pieces are exotically decorated with mother-of-pearl and ivory inlays, considered a subset of the Moorish influence, which in the 1880s co-existed with other revival styles. The Moorish style, also known as the Turkish, Saracenic, or Arab style, was loosely based on a Near Eastern vocabulary that included Moorish arches, patterned walls suggestive of Persian tile, and brilliantly colored, plump seating pieces. It was often reserved for masculine rooms, particularly those devoted to smoking

and billiards. John D. Rockefeller's sitting room in his New York City residence (now installed at the Brooklyn Museum) made a definitive statement about the Moorish style. This taste was one in which over-stuffed chairs, couches, pillows, and Oriental rugs tucked into "Turk-ish corners" often under a tent-like canopy—and Innovative in their own right—reflected the dual concern for comfort and informality that had become commonplace in the American domestic interior. A. A. Vantine and Company of New York specialized in decor with a Moorish accent. The English firm of Jennens and Bettridge was the foremost purveyor of *papier-mâché* furniture, and most of the com-pounded paper objects found in American homes were of English manufacture. Of the few locales engaged in the process in the United States, Litchfield, Connecticut, was a regional center for such opera-tions as the Litchfield Manufacturing Company, although American versions rarely turn up today.

Separately, some Innovative furniture made from organic materials sought to substitute for traditional woods and was still assembled by hand because its highly irregular forms would have been difficult to as-semble by machines dependent on largely standardized parts. These objects are remembered today for their unique configuration of mate-rials over technological advancements. Included in this group are "rus-tic" items such as furniture made from tree branches (also called bent twig and Adirondack) rather than from the thin, shaved veneers that prevailed in traditional furniture forms. In objects of this type, the nat-ural qualities of the material were preserved and provided quirky ap-peal. Another related type is exotic furniture fashioned from animal horns in which using a chair as an example, the entire form—seat, back, and legs—was shaped out of steer horn. The popularity of this type of furniture in general coincided with the exploration of the West and, to a minor degree, the desire on the part of regional centers to supply some of their furniture needs closer to home. Horn furni-ture was transported for sale to the East, where it was used in billiard rooms, libraries, or summer camps, and where its boorish look enter-tained images of the Old West.

Other types of purely organic material did fit the framework of ma-chine assembly, and woven furniture suits this category best. The circu-lar loom brought woven furniture into the realm of the affordable, providing stylistic curlicues, beadwork, and spider-web motifs woven from imported cane, rattan, or similar fibrous material at reasonable cost. Many of these pieces had a distinctly Far East flavor. In usage, wo-ven furniture was well suited to leisure-time activities; removable up-holstered cushions, for example, made for ease of maintenance in indoor or outdoor settings. Although many pieces of woven furniture were painted, just as many were left in a natural state that required lit-tle maintenance. Additionally, furnishings designed for public use,

such as those destined to become seating for rail cars, often relied on wicker.

During the last quarter of the nineteenth century, a craze for things Japanese influenced domestic furnishings made from bamboo; it also influenced inexpensive cottage-type furnishings that used turned-wood simulations to create the bamboo effect. The resulting fanciful designs, replete with scrolling bamboo fretwork, satisfied several needs, including the Victorian penchant for things suggestive of distant, romantic locales—even if they were conjured up by American craftsmen in forms alien to Japanese material culture. Bamboo furniture also answered a demand for imported objects from the Orient that began in the earliest days of America's far-flung mercantile activities.

CASE WORK

In the last quarter of the nineteenth century, Innovative case forms served as an adjunct to the more traditional case work being made at the same time and in the many different styles formerly discussed, including the highly eclectic revival styles. The ensuing discussion focuses exclusively on the offbeat case forms labeled Innovative and their portrayal of the Victorian quest for novel, technologically advanced furniture, albeit at the expense of pragmatic design. One of the most curious nineteenth-century case pieces labeled Innovative was the piano-bed, perhaps the single most idiosyncratic example of convertible furniture. Regardless of how quixotic it appears by present-day standards, the form indeed made it from the drawing board to the drawing room. The exterior cabinet was constructed to resemble a piano. On some cases, the top would lift, the front would fall, and the bed would extend downward from its attached position at the back of the case. On other models, a trundle bed would slide out from under the case.

Beds were also designed to retreat or fold upright into a bookcase, and when open, some loosely recall the concept of a "room inside a room" suggested by wood enclosures or textiles that dominated sleeping forms until the early nineteenth century. The fact that so few of these types are today extant is indicative of both their short-lived fadishness and of the high failure rate of the mechanisms on poorly conceived designs.

SEATING

By far, seating forms were both the most technologically driven and the most exotically composed experimental furniture forms, and it is

in this genre that so many imaginative creations took hold. Bentwood, hollow tubular frames, mechanical contraption, *papier-mâché*, centripetal springs, and animal horns were just several manifestations of this trend. The designs of Michael Thonet, who experimented with lamination and steam shaping of birch, reflect a simply designed curvilinear form suggestive of a Rococo Revival temperament. At the same time, however, the unadorned surfaces and general light-handed proportion serve as a prognosticator of the modern designs that would follow in the twentieth century. Chairs following the Thonet prototypes are still being made today.

Following a tradition established in Europe in the 1840s and 1850s, American designers began making chairs with hollow tubular frames. Tubular rockers in which two separate metal tubes formed the entire frame of the chair undoubtedly influenced the designs of American industrialist and philanthropist Peter Cooper. His rocker substituted flattened metal components for the hollow tubes, and the resultant design was one in which the frame was the basis for the integral back and seat. The spring-like resiliency of metal that was advocated in Cooper's design would be refined and exploited decades later in the 1920s through the work of Ludwig Miës van der Rohe and Marcel Breuer, as well as in contemporary applications that persist today.

Mechanical contrivances were particularly abundant in chairs. One type of armchair with an especially therapeutic appeal was considered a forerunner of today's wheelchair. This chair was outfitted with adjustable arms and a folding footrest that permitted the user to move from a sitting position to a supine one with little effort; construction called for lightweight materials, often a metal frame, and casters for ease of movement. The Marks Adjustable Folding Chair Company of New York produced chairs in this mode with a ratchet mechanism for raising and lowering the arms, back, and footrest. Although heralded as a therapeutic device, this chair was just as likely to be called a *chaise longue*. Its ability to fold was not promoted as a space-saving device with the "form follows function" pragmatism with which an eighteenth-century folding table would have been advertised. Rather, it was promoted foremost as a byproduct of nineteenth-century ingenuity. The ingenuity associated with therapeutic chairs was adapted to fit other everyday uses, such as reclining deck furniture on cruise ships. American interest in collapsible or folding furniture was also related to the early development of long-distance rail travel in which stays of several days and nights were common.

George Hunzinger of New York was responsible for a variety of patent chairs. A German *émigré* from a family with a proven furniture-making talent, he was fascinated with chairs that could fold or had the appearance of folding. The chair form he patented, which today is called a Hunzinger chair, was a folding chair made of thin, turned

Creative thinkers such as George Hunzinger were fascinated by objects that could fold or had the appearance of folding. This Innovative chair was just one of the many that Hunzinger patented.

members, and a cantilevered seat. This form also has a modern presence owing to spare proportions, and, on some models, the use of woven-steel bands that form the back and seat. Hunzinger's chairs are unique for their turned members that resemble machine parts in motion —complicated shafts, cogs, and wheels. The Boston Furniture Company was one maker working in the Hunzinger mode, substituting upholstery for woven-steel bands and simple carved detail for intricate turnings. These were concessions the mass market was willing to accept, all of which could be managed in a cost-effective manner in a large-scale factory setting. Some folding armchairs were predecessors of the contemporary "director's chair," in which the seat rests on a folding X-shaped base. Chairs meant to be used in libraries were occasionally equipped with compartments that would convert the chair into library steps by extending the steps out from underneath the seat.

Another form, the centripetal-spring chair, had a large spring under the seat that allowed the chair to recline backward with pressure from the sitter's back, as well as to turn and swivel and snap back into place. A forebear to what is commonly called a secretary chair, this form had a base of heavy cast iron and an exuberantly ballooned metal frame back that was painted and varnished. The front of the chair is upholstered. This form, shown at the Crystal Palace Exhibition of 1851, was popular through the 1860s. The American Chair Company of Troy, New York, was a leading supplier of these chairs.

Additional experimentation with metal resulted in heavier cast-iron chairs with organic motifs suitable for indoor or outdoor use, although today the appeal of these assembled chairs rests with their use as garden furniture. This type frequently captured in cast iron the scrolling vines and grape leaves so integral to John Henry Belter's laminated wood designs. Another variant of cast-iron furniture was seating that

Made by the American Chair Company of Troy, New York, this chair was a precursor to the modern secretary chair. The metal support under the seat, a centripetal spring, allows this chair to flex. (Courtesy Metropolitan Museum of Art, Gift of Elinor Merrell, 1977.)

substituted wooden slats for seats in those forms likely to be used in a public setting.

Lightweight metal versions of the rounded bentwood shape introduced in wood by Thonet, as well as intricately spiraled wire chairs produced by wire-bending machinery, were regarded as inexpensive cafe-type chairs apropos for public establishments. They are also nicknamed "ice-cream parlor chairs," as their low price point and portability made them a favorite in these locales. The airy lightness of the thin metal strips or of the whimsically spun wire ultimately proved unsuitable for heavy use, and consequently few examples survive.

The fully upholstered chairs and couches often associated with the Moorish or Turkish influence evolved from metal-coil springs. These helical or spiral springs were secured to the frame by string, enabling the structure of a seating piece to be concealed, and it was possible for the upholsterer to build massive seating forms using tufting and heavy fringe to cover the entire form. Hard, non-splitting woods such as birch were the best choice for use with tied springs as they were better able to handle the tension inherent in the design. This combination of springs and multiple-layered padding produced a more comfortable product than the eighteenth-century easy chair that relied on padding alone. Springing was perfected so that wire-shaped support frames could be screwed onto a wooden frame that, in turn, was fully submerged beneath fabric bulk. Upholstered furniture of this type is referred to as employing "Turkish frame construction." The wooden parts, the only components that were not upholstered, were four small legs and a connecting member.

Papier-mâché chairs of this time frame are recognized by their characteristically Victorian shape—the balloon back. Chairs are the largest surviving examples of this decorative treatment; large papier-mâché furniture is exceedingly rare. Typical decoration called for a black or sim-

Materials that heretofore were not used in furniture became ripe for experimentation in Innovative designs. On this chair, interlacing horns join a leather seat to create a wildly organic chair.

ilarly dark background. Elaborate painted and gilded floral sprays were especially popular, occasionally with landscape and commemorative scenes. Cane seats were frequently used.

As a point of scholarship, the condition of the *papier-mâché* is a critical component in assessing its value. Large changes in temperature and humidity can be devastating, altering an object's solidity if the compounded paper is exposed to dampness. The process calls for multiple coats of lacquer followed by gilt and polychrome paint; hence restoration is exceedingly difficult, and sometimes impossible, to perform satisfactorily.

Probably some of the most exotic and eclectic seating forms were those assembled from organic materials. Horns or antlers, for example, were studied to determine how their inherent shapes could best accommodate the human body. The resulting chairs, especially those made from antlers, have a grotesque quality due to the highly asymmetric nature of the material.

TABLES

Many Victorian tables were meant to finish a set of coordinated furniture. Tables that fall into the category of Innovative sometimes belie this rule; many were one-of-a-kind creations that did not yield to machine production and, due to the highly organic quality of their parts, did not replicate well. Nature had more to say than designers did about the shape that tables took when constructed from tree roots. As larger groupings of *papier-mâché* tables were generally impractical due to their fragility, they were often incidental pieces. Primarily a decorative treatment, *papier-mâché* in general was better suited to smaller objects, such

as tables, trays, chairs, small boxes, and fans. A popular treatment for *papier-mâché* tables (and related trays) called for elaborate floral and landscape scenes, exotic birds, and ornate outlines often accentuated with gilt edging. Inlays of ivory and mother-of-pearl were also popular, probably reflecting the Moorish influence of the 1880s.

Whereas most late Victorian tables—especially those associated with the revival styles that prevailed after the Civil War—were derived from the pedestal or trestle form, Innovative forms are more likely to assume an amorphous or non-specific shape. Rustic tables formed from tree roots and unprocessed wood fit this category best. A large component of their design was dependent on manipulating the material to conform to the outline of a table form. Unlike traditionally made tables that can be neatly classified by a specific shape, Innovative tables challenge the rule. On these tables, textural quality outweighs form.

Other tables with ornate cast-iron bases were assembled from individually cast sections held together with screws and occasionally topped with marble slabs that made them suitable for indoor or outdoor use. In the specialty field of woven material, Heywood Brothers and Wakefield Company of Wakefield, Massachusetts, was the largest manufacturer of wicker furniture, including tables. The firm assembled elaborate tables with curlicue and web motifs.

The appeal of this table was in its quirky, naturalistic arrangement of tree roots. In an era of widespread mechanization, these tables were an exception because the organic material was not always suited to machine assembly.

\intUMMARY OF STYLE

Dates: 1850–1900
Distinguishing Features: forms relying on mechanical contrivance; bent-
wood; *papier-mâché;* exotic organic materials including animal horn
Materials: metal; iron; woven materials; horn

COLLECTOR'S TIPS

1. *Look for (good example):* crisp, good castings on metal furniture;
 hinges and levers that function on mechanical pieces
2. *Look for (outstanding example):* design that is both functional and
 aesthetically pleasing; examples by Michael Thonet and George
 Hunzinger
3. *Problems/what to watch out for:* mechanical components that are
 missing or fail; excessively re-painted cast iron that blurs the crisp-
 ness of the casting
4. *Conservation issues: Papier-mâché* objects require a constant tempera-
 ture and must avoid exposure to dampness so the compounded pa-
 per is not damaged.
5. *Cabinetmakers/firms important to style:* John Henry Belter, Michael
 Thonet, George Hunzinger, Jennens and Bettridge, Marks Adjust-
 able Folding Chair Company, Boston Furniture Company, Heywood
 Brothers and Wakefield Company, American Chair Company
6. *Where public can see best examples:* Brooklyn Museum; Metropolitan
 Museum of Art, New York, New York; Henry Ford Museum, Dear-
 born, Michigan
7. *Department expert wish list:* horn furniture; *papier-mâché;* quality cast-
 iron garden furniture
8. *Miscellaneous:* Many Innovative materials are still used in furniture
 being made today. Use care when selecting pieces purporting to be
 nineteenth-century Innovative to be sure they are truly of the pe-
 riod. Bentwood is an example of a material still employed today. Be
 sure the form shows the wear suggestive of its age. Wicker is another
 category in which reproductions masquerade as period objects.

\mathscr{D}ESIGN REFORM FURNITURE (1870–1915)

In art history, one recurring theme holds that as one aesthetic is explored very explicitly over approximately thirty years, priorities then shift so that a new stylistic temperament begins to prevail. Following this dialectic, if the advent of Victorian design occurred in the 1840s, it is reasonable that by the 1870s, a movement was afoot that criticized the mid-nineteenth-century separation of art and craftsmanship. So-called design reformers assailed furniture that bore tasteless and indiscriminate pastiches of historical periods, was poorly designed, or relied entirely too heavily on machine production at the expense of the individual craftsman. That this notion held sway concurrently with one that equated ornament with affluence—as was the case in a host of revival styles—illustrates how truly divergent design standards were in the late nineteenth century. An important point to keep in mind regarding Design Reform furniture is that regardless of how protomodern some of the furniture appears, it was still a product of the Victorian era. In late nineteenth-century England, Design Reform furniture followed two major pathways: (1) art or Japanese-inspired designs of the aesthetic movement and (2) reformed or modern Gothic imperatives, otherwise referred to as the Arts and Crafts style.

In the American decorative arts, no singular style is regarded as the archetype of Design Reform furniture. Like its English counterpart, American reform furniture is a combination of several influences, notably the aesthetic movement, in which art- or Japanese-inspired creations predominated, and the Arts and Crafts movement. Of these converging styles, the Arts and Crafts observance proved more influential, and it was an important bridge between Victorian revivalism and twentieth-century modernism. Some scholars also include in the

category of Design Reform the Art Nouveau and other European design persuasions including Bauhaus, but these styles will not be included here. This chapter concludes with designs that began no later than the Victorian period and that had direct impact on American furniture forms. Art Nouveau was primarily a European design phenomenon, and so few pieces of furniture were made by American artisans that it is difficult to analyze the category thoroughly, based on the exceedingly limited American-made examples that do exist. Collectors interested in this movement either collect French-made examples or focus their attention on other mediums—ceramics, glass, and metalware—in which American objects of great distinction abound in the Art Nouveau format by such prestigious makers as Louis Comfort Tiffany. Separately, the Bauhaus movement, named for a school of design that flourished in Germany after World War I, is not a style that got its start in the Victorian era, and any discussion of this movement is better suited to one about the streamlined designs that mark the beginnings of what is popularly referred to as the age of modern furniture.

ART- OR JAPANESE-INSPIRED FURNITURE

Art- or Japanese-inspired furniture of the 1880s was widely perceived by late-nineteenth-century Victorian aesthetes as the antithesis of the vulgar, overblown, and eclectic revival styles that preceded it or that held sway about the same time. With its clean lines and low-profile ornament based on Asian sources, including popular Japanese woodblock art, a new simplicity was championed in cabinetmaking that was part of the larger aesthetic movement. Furniture fitting this description is alternately labeled "aesthetic" or "Anglo-Japanese." This movement permeated not only furniture design but also facets of everyday life that included matters of dress and symbolic reference. With Japanese art steeply rooted in symbolism, it was the perfect course for artisans to follow in their quest for lucent, unencumbered designs mirroring a new simplicity. A precursor to the Arts and Crafts movement, art- or Japanese-inspired furniture was the largest component of the aesthetic movement that began to stress a return to harmony of form and function in design and decoration. This philosophy was manifested in furniture that is recognized by:

- simply outlined and generally delicate rectilinear forms;
- ebonized wood; and
- decoration restricted to limited areas taken from Japanese architecture, motifs, or artwork with inlays of light woods, mother-of-pearl, ebony, gilt, ivory, and brass.

In England, the pre-eminent advocate of this style was the architect E. W. Godwin, whose designs were executed by a number of cabinet-makers, including William Watt. When art- or Japanese-inspired designs were executed by American makers they were almost exclusively ebonized wood items produced by the top-tier New York firm Herter Brothers for a privileged constituency. Herter Brothers incorporated in its work the same simplicity of line and integrity of ornament that prevailed on English models. Butterflies and Japan's national flower, the stylized chrysanthemum, were often inlaid in their case pieces and side chairs. The extensive use of floral motifs, especially stylized flower heads, suggests the overriding Japanese influence inherent in this work. Art or Anglo-Japanese furniture of the aesthetic movement eventually lost favor in the 1890s to furniture born of the Arts and Crafts movement, a style for which it had laid important groundwork.

THE BEGINNING
OF THE ARTS AND CRAFTS MOVEMENT

Originating in English circles, which had a history of reform-minded thinkers such as Augustus W. N. Pugin, Owen Jones, and Henry Cole (who under the pseudonym Felix Summerly founded Summerly's Art Manufacturers), the group of designers calling for additional reforms was initially small. The guiding principle of both Cole's Summerly firm, and those of his colleagues, was "to revive the good old practice of connecting the best art with familiar objects in daily use." This view was recanted by other critics who also lamented the rise of Victorian furniture that had become synonymous with ornament that out-stripped its utility and was therefore not "the best art." John Ruskin, William Morris, and Charles Locke Eastlake were three popular figures within this artistic community who called for reforms that included:

- the return to handcrafting;
- integrity and honesty of material and function in the practice of furniture making that would replace elaborate surface decoration; and
- a return to solid wood in rectangular forms that stressed horizontal and vertical planes.

The principles laid out by these critics won a wide audience in Europe and were soon to impact the decorative arts in America. Englishman William Morris, an architect and designer, was part of a group of artists known as the Pre-Raphaelites, which also included John Ruskin. The ideals espoused by this group included a strong interest in forms

found in nature as well as in the spiritual elements of medieval hand-craftmanship. Applied to the business of furniture making, it was believed that some of the social and creative problems that emerged in the Industrial Revolution could be solved by returning to the honest, plank-type construction born of the individual craftsman that prevailed in the Middle Ages. The overriding mantra of the reformist Arts and Crafts movement was that society could be redeemed or saved through art. This perspective was bolstered in the Arts and Crafts Exhibition Society, which was founded in London in 1888.

Arts and Crafts furniture borrowed only those elements from the past that could be worked into objects of contemporary usage, particularly those idealizing or glorifying the perceived superiority of hand-craftmanship and mortise-and-tenon joinery in twentieth-century objects. Translated into its components, this new style was a mix of simple shapes with no hidden seams or braces and the contained flat, panel-type elements of Gothic furniture.

THE EASTLAKE INFLUENCE IN ENGLAND

The transition to this simpler type of furniture first began with Englishman Charles Locke Eastlake through what is today labeled the "Eastlake" or "reformed" Gothic style. The term *Reform Gothic* was coined to differentiate it from the Gothic Revival style of the 1840s. Eastlake applied the concepts espoused by Morris and his circle to mass-produced products made of oak. Eastlake's *Hints on Household Taste,* published first in London in 1868, advocated rectilinear forms with shallow incised linear, geometric, and floral patterns along with the decorative elements of grooving and spindles, all of which could be performed by machine. Some antiquarians describe furniture in this format as a less volumetric version of Renaissance Revival forms with elements mixed in from the Gothic.

THE FULLY DEVELOPED
ARTS AND CRAFTS STYLE IN ENGLAND

In spite of Eastlake's contributions, as the Arts and Crafts movement gained strength, a new streamlined profile emerged that left behind any vestiges of Victorian eclecticism and excessive mechanization. What emerged were the fully blown Arts and Crafts characteristics of a generally flat and rectilinear shape and heavy structural features with projecting tenons and exposed dowel-pin construction, all components of hand-made furniture. Hardware, if it existed at all, consisted

of forged or hammered metal reminiscent of the strapwork on medieval case work. Oak was by far the favored wood—fumed or stained to give the appearance of age and to bring out the natural qualities of the grain—typically "quarter sawn." When a log is initially cut into quarters and then sawed into boards at approximately right angles to its concentric rings, it is termed quarter sawn.

THE ARTS AND CRAFTS STYLE IN AMERICA

For purposes of this discussion, American Arts and Crafts furniture is defined as:

- forms produced in the late-nineteenth or early-twentieth century;
- employing handcraftsmanship to as great an extent as possible;
- made using solid, visibly forthright construction methods, including exposed tenons;
- being in harmony with its domestic environment;
- displaying justifiable ornament taken from nature and not in conflict with either the form or its function; and
- being an artistic, creative endeavor.

In these objectives, the American Arts and Crafts movement aligned with its English heritage. Where the American strain differed was in its approach to technology and machine production. While in theory, if not always in practice, English reformers mandated a total anti-industrialist paradigm that validated complete handcrafting as the "true and honest" approach to furniture making. This outlook is especially understandable in England, where the sometimes harsh realities of the Industrial Revolution were even more demoralizing to the working class than they were elsewhere. On the other hand, American adherents placed less emphasis on total handcraftsmanship, discreetly employing machinery as long as it did not compromise the quality of the finished product. As was pointed out earlier in this text, throughout the history of American furniture, many makers understood the pragmatic element of their craft, modifying their designs to suit American patrons. Like the early colonial turners who utilized cheaper wood painted black in place of costly ebony, American artisans working in the Arts and Crafts milieu continued their pragmatic practice of using machinery when necessary. This decision may have come from the realization that, for all its aspirations, the Arts and Crafts movement in England sometimes fell short of its objective of social reform through art since the final cost of handcrafted furniture was prohibitive to the middle and working classes.

Like its British antecedent, the American Arts and Crafts movement reacted against the mechanized processes that turned out highly ornamental furniture, some of it of dubious quality and lacking integrity of design. In addition to furniture, which heretofore had been regarded as a minor art, other decorative arts including metalwork, glass, ceramics, and textiles were elevated by the craft tradition to the status of art—as marked by the return of the artisan and handcrafting. Following this rationale, it was argued that both the craftsman and consumer would prosper. In short, the Arts and Crafts dictum was heralded as a solution for such diverse nineteenth-century conundrums as the exploitation of labor under the factory system.

Many late nineteenth-century Victorians held steadfast to the belief that art was a compulsory component to the home environment, and handcrafting became the vehicle of this artistic expression for households ranging from working class to affluent. It was from the Arts and Crafts movement that interior decoration changed from the ostentatious display of large-scale furnishings, overstuffed upholstery, and voluminous drapery to arrangements that resulted in lighter, more smoothly flowing spaces. Whereas earlier Victorian designs of the mid-nineteenth century often relied on ornament at the expense of sound design, Design Reform furniture born of the Arts and Crafts temperament achieved its sense of beauty from an organic approach that stressed good proportion and honesty of construction and material. The progression to honest material, construction performed mainly by hand, and solid wood in rectangular forms was, as it had been in England, gradual.

THE EASTLAKE INFLUENCE IN AMERICA

American furniture following the Eastlake influence was loosely adapted from his concepts and what prevailed in English examples. Machines continued to produce much of the linear decoration, which was often a combination of highly geometric or floral designs as well as spindles, inset panels, and grooving. While Eastlake favored oak, American makers often produced forms in cherry, maple, or walnut, and low-end, mass-produced pieces liberally termed Eastlake often combined with some Victorian revival styles as well. Charles Locke Eastlake's message grew stronger, however, thanks mainly to his *Hints on Household Taste,* which, when published in Boston, went through eight editions from 1872 through 1890. A new simplicity emerged, and pieces began to adopt rectangular forms with simpler or low-relief carving and straightforward construction.

THE COLONIAL INFLUENCE

At the end of the nineteenth century, Arts and Crafts societies took root in most American cities. In Deerfield, Massachusetts, once a region that figured prominently in colonial designs, the return to honest construction took the form of a distinctly colonial revival that was reawakened by America's centennial in 1876. Even though the displays represented a romanticized re-creation of the past through such gimmicks as open hearths and spinning wheels, they marked the beginning of what was to become a strong interest in the young nation's historic past, accompanied by the advent of antique collecting in America. American artisans turned to the designs of the seventeenth century, incorporating into their furniture details such as stretchers, gatelegs, trestle bases, and brass-tacked leather, all elements with strong roots in colonial design.

THE FULLY DEVELOPED
ARTS AND CRAFTS STYLE IN AMERICA

POPULAR DESIGNS BY GUSTAV STICKLEY AND HIS FOLLOWERS

By 1900, the transition from the colonial revival mode to the Arts and Crafts movement was complete. Gustav Stickley, born in Wisconsin in 1858 to German immigrant parents, was one of the leading promoters of the Arts and Crafts movement in America, having been introduced to it on a trip to England in the late 1890s. In 1901, he began publication of *The Craftsman,* a monthly periodical that became the bible of the American movement, replete with philosophical and practical dissertations on the meaning and fulfillment of the Arts and Crafts lifestyle for the American middle class. Suggestions were offered for Craftsman house plans and Craftsman furnishings, all in a characteristically forthright manner, thereby promoting the popular American style that grew from his concerted marketing efforts.

The Craftsman Workshops, a firm Stickley established in New York in 1904 from an existing operation, turned out oak furniture as well as metalwork and textiles by artisans charged with creating designs that "shall justify their own creation; which shall serve some important end in the household . . ." In other words, in the Arts and Crafts philosophy, objects had a specific mission or function in the household. Consequently, there are frequent references to Arts and Crafts furniture as "mission oak." Separately, some scholars suggest that this term was borrowed from the unadorned structural oak forms like the rectangular oak chairs with rush seats modeled after Spanish mission pieces of the

Southwest. Whatever the label's origin, it is shorthand for furniture born of the Arts and Crafts vision.

Furniture turned out by Gustav Stickley and his Craftsman Workshops was initially strong, extremely rectilinear, and overconstructed with exposed tenons. In 1903, Stickley hired the itinerant architect-designer Harvey Ellis to produce furniture and house plans for *The Craftsman*. While maintaining the integrity of Stickley's structural forms, Ellis introduced subtle changes such as arched curves—which reduced the extreme rectilinearity of the earlier format—overhanging tops, and minimal or no hardware. Ellis also experimented with delicate, abstracted inlay, which was introduced in slightly more attenuated forms than that found on pieces made before 1903. The combination of Ellis's untimely death in 1904 and the higher production costs associated with inlay work made this a short-lived but much-admired treatment.

In keeping with guild-like methods and a pervasive pride in craftsmanship, Arts and Crafts furniture was often stamped or labeled to identify the maker. Perhaps the most famous was Gustav Stickley's shopmark, a joiner's compass (a tool used in cabinetmaking) combined with the Flemish words "Als ik kan," translated loosely as "As best I can," a philosophical incantation to the dedicated workmanship that went into each piece. The shopmark was sometimes supplemented with a paper label. In combination with object-specific evidence, the shopmarks and labels can help pinpoint a date of manufacture. Gustav Stickley and the Craftsman Workshops used a series of four different shopmarks featuring the joiner's compass from 1902 to 1916, when the firm ceased operations. Separately, three paper labels were used during the years from 1905 to 1916. A few words of caution. It is important to authenticate not only the object but also the label or shopmark brand. Never use a shopmark or label as sole proof of authenticity. Publications listed in the bibliography reproduce many of the commonly used shopmarks and labels used by Arts and Crafts manufacturers, and reproductions of period Arts and Crafts catalogues are easy to obtain in libraries or bookstores. These can be an invaluable tool in developing connoisseurship and authentication skills.

Gustav Stickley's shopmark shows up repeatedly in certain locations on his furniture. Seating forms such as side chairs and settles often have one on the inside or outside of the rear stretchers. Armchairs and large leisure seating pieces such as the Morris chair may have a decal underneath either arm or on a rear stretcher. Desks and tables may have a red decal inside the drawer or a brand on the outside of the drawer. Large case pieces often have a red decal placed near the top of the back and may also have a large rectangular paper label. Occasionally labels can be found on the bottoms of seats and tables, but, like many of the red decals, they have been lost to refinishing or reupholstering.

Other firms working in the Arts and Crafts style for the middle-class clientele include The Roycroft Shops, The Shop of the Crafters, The Tobey Furniture Company as well as Charles Stickley and Stickley and Brandt, and L. & J. G. Stickley Furniture Company. All of the Stickleys were related, which occasionally creates some confusion in the identification of Arts and Crafts furniture with a Stickley origin. As a general rule, however, in today's marketplace, Gustav Stickley's designs are preferred over those of his relatives. Be mindful of attributions to Gustav Stickley based on incomplete labels for they may be remnants of labels used by other Stickleys.

At the low end of the market, some makers took shortcuts that appeared to provide some of the attributes of the Arts and Crafts style without the corresponding expensive handcrafting or finishing. While these pieces may have inherited the overall rectilinear shapes of their more expensive relatives, they lack the integrity of construction, materials, or proportions that connote mid-level or high-end designs. Some of these shortcuts include plain sawn lumber or thin veneers, exposed screws or heads, clumsy proportions, fake tenons, thin components, and, at the very worst, mixed attributes from other periods that thwart the Arts and Crafts mandate for honest, unencumbered designs.

CUSTOM-DESIGNED FURNITURE BY ARCHITECTS

In addition to popular designs repetitively turned out by firms working in the Arts and Crafts style, there existed a high-end market for custom-made or commissioned pieces marketed to the wealthy. As this exclusive body of work was overwhelmingly the output of architects, many—while adhering to the Arts and Crafts doctrine of honest and forthright construction—were more concerned with designing furniture to suit the setting of the interiors they envisioned than with the personalized nature of handcrafting. The most influential practitioners in this mode were Frank Lloyd Wright and the brothers Charles Sumner Greene and Henry Mather Greene.

Wright, whose designs would span nearly seven decades before his death in 1959, was the foremost spokesman for the Prairie school of architecture that flourished in Chicago and the plains of the Midwest at the turn of the nineteenth century. The Prairie school shared the Arts and Crafts ideology that argued for natural materials and furniture that existed in unison with the setting it occupied. Where Wright differed from the Arts and Crafts purists, however, was in his omission of pegged joints, hammered hardware, and exposed tenons. Wright's furniture exhibited even stronger architectonic tones and contrasts of planes than did middle-of-the-road Arts and Crafts examples. Wright's commissions reflect Japanese horizontal timber-frame construction in

many of his pieces, advanced by Prairie architecture's emphasis on Japanese art. While a red square that denotes his name can often be found on his architectural drawings, Frank Lloyd Wright demanded no shopmark on the furniture that was made to his specifications, some of it assembled by the John W. Ayers Company of Illinois. Owing to the highly individualized nature of his work, however, and to well-documented commissions, pieces made under his discerning eye can be authenticated fairly easily.

Trained as architects, Charles Sumner Greene and Henry Mather Greene eventually settled in Pasadena, California, where they opened their own architectural business. In the first decade of the twentieth century, they built a wealthy clientele and were renowned for their "ultimate bungalows," large-scale houses in which the Greenes dictated the architecture, furnishings, and landscape. While influenced by the English Arts and Crafts practitioners, the largest impact on their work came from their closeness to the Pacific Rim and their fascination with Oriental design. Unlike the strong, sharp contrasts of planes found in the work of Frank Lloyd Wright, their painstakingly crafted furniture is distinguished by a gently rounded treatment on the edges of the corners, discreet ebony inlays, mahogany, teak, and—rarely—carving arranged asymmetrically in the Japanese manner. Instead of mortise-and-tenon joinery in which a mortise or tongue is fitted into a hole and pegged, to secure joints, they relied on slotted screws, a specialty of Pasadena's Peter Hall Manufacturing Company, which was charged with executing these exacting designs. The branded script "Sumner Greene/His True Mark" is sometimes located in two or three places on the underside of Greene and Greene pieces, but because this furniture was never mass-marketed, the need to label each piece was not a high priority. While it can be said that *all* of the expensive, architect-designed furniture of the Arts and Crafts style is highly individualized, it was Greene and Greene who conceived some of the most imaginative and pleasing forms of this period.

As a point of scholarship, whether analyzing Arts and Crafts furniture made for the populace or custom pieces designed by architects, certain standards can be applied with regard to construction, finish, and repairs. Any example can be assessed for the genuine reliance on visible elements of construction, such as mortise-and-tenoned and pegged joinery. The appearance of these components are meant to demonstrate the craftsmanship inherent in the design. Low-end imitations used false tenons applied with nails or glue to suggest a quality that was, in fact, lacking in their designs. Another element to check for value and authenticity is an item's finish, which should ideally be original. Arts and Crafts collectors place a high premium on original-condition finish, which should be a dull sheen instead of shiny shellac. A finish with obvious distress due to age and normal wear and tear is pre-

ferred to one that has been stripped, sanded, or heavily lacquered so that the fumed or aged appearance is destroyed. Ranging from pale gold to deep black, many finishes have suffered from overzealous refinishing, resulting in a skinned appearance. The best advice is to seek quality construction, pleasing form, and original finish. Generally, Arts and Crafts pieces survive in better overall condition than eighteenth-century forms because of the durability of oak and the deliberate over-construction that went into Arts and Crafts objects, but keep in mind that repairs do alter the desirability of some examples. Obviously, surface refinishing should be evaluated, as should any changes to form or hardware. Hardware, for example, was patinated to complement the object on which it was placed. Leather surfaces that are missing or replaced with a different treatment serve to alter the intent of the maker. All of these factors are important to a style that relied heavily on the spirit and hand of the individual craftsman.

CASE WORK

ART- OR JAPANESE-INSPIRED CASE WORK

Although a guiding principle of Design Reform furniture was to improve the quality of furniture and related household objects used by ordinary people, paradoxically, this philosophy was most successfully carried out by the exclusive cabinetmaking enterprises patronized by a moneyed elite. Herter Brothers was one high-end firm working in the art- or Japanese-inspired style for such wealthy families as the Vanderbilts. Flat, rectilinear bodies of ebonized cherry with similarly flat ornaments of light-colored floral inlay are typical of their case pieces. Reflecting the influence of Japanese wood-block prints on the decorative arts, a common motif is a stylized marquetry rendering of the chrysanthemum, Japan's national flower, typically found on doors and drawers. Decorative drawer pulls and hardware are flat and thin and generally in keeping with the low-profile sentiment that began in the late-nineteenth-century designs of Eastlake; they were eventually eliminated in some pieces by his Design Reform successors.

ARTS AND CRAFTS CASE FORMS

The cabinet or bookcase and the fall-front desk were two of the most prevalent case forms, taking their shapes mainly from American white oak that was usually quarter sawn and fumed to give the appearance of old wood. Infrequent examples exist in mahogany and maple. In the cabinet type, the basic shape of the underlying form was extremely lin-

ear and non-sculptural, and there was a deliberate emphasis on solidity and endurance. Thanks to the durability of oak and panel-and-frame construction (a preindustrial technique that permitted expansion and shrinkage without significant damage to the assembled form), the longevity of this work was assured. While in the eighteenth century this sturdy construction technique was passed over in favor of the dovetail joint—which lent lightness and verticality to many forms—it was perfectly suited to the more rooted forms of Arts and Crafts lineage.

A bookcase was often the two-door type, with glass insets in the panels or structural-flanking flat pilasters that define the doors. Some models have leaded glass at the top of the panels, usually indicating an assembly date circa 1900. By the first decade of the twentieth century, however, most of the leaded glass was replaced with wooden muntins holding plain glass panels. A case of this description customarily rests on a short base with an arched apron, matched with similar cutout arches on the sides of the base. As a point of connoisseurship, these arches add a degree of lightness and sophistication to a form that might otherwise be considered plain and heavy. The top is thin and flat with a slight overhang. Arched aprons, overhanging tops, and lack of hardware are usually characteristic of Harvey Ellis, who designed for Gustav Stickley.

The fall-front variety of desk was a popular choice, given that it meshed with an Arts and Crafts ethos that looked as far back as the Middle Ages for inspiration. Recall that the earliest writing boxes of the Middle Ages eventually evolved into the fall-front form in the early colonial period and were equipped with a board that extends out of the case to create the writing surface. Similar to all pieces in the Arts and Crafts format, the fall-front desk was constructed of quarter-sawn oak in an extremely linear arrangement. Since glass of any kind is universally absent, one must rely on the interaction of components for any indica-

A thin overhanging top and an arched apron are hallmarks of Gustav Stickley's Craftsman furniture as designed by architect Harvey Ellis. Ellis's designs brought a lightness to Gustav Stickley's furniture, which tended to be extremely massive and overconstructed prior to 1903.

tion of pleasing design. Some of the Ellis-designed examples, which were well integrated and overtly vertical, became popular because they are far more compact than early eighteenth-century desks of the fall-front class.

Arts and Crafts models are recognized by a thin overhanging top resting directly on the case with a recessed, paneled fall-front board. The bottom of the case consists of some combination of shelving and drawers, and some interiors are outfitted with octagonal inkwells and pen trays. Hardware was usually made from hand-wrought copper in simple shapes, including the bail or U-shaped pull, ring, or butterfly hinge. Select examples received subtle decorative inlay in the recessed panels in the form of copper, pewter, and wood in a manner that made them appear radically different from the more representational inlays of decades past. Of delicate proportions, most of these inlay patterns were derived from organic, plant-like sources, but highly stylistic renderings make them difficult to identify with any specificity. While considered a direct legacy of the British Arts and Craft designers, including M. H. Baillie Scott, C. F. Vosey, and Charles Rennie Mackintosh, inlay—whether in case work or in other forms—did not find commercial success in America due to its expense. Consequently, when limited inlaid examples appear in the marketplace, however infrequently, they are keenly pursued by museums and private collectors alike.

The sideboard was arguably the most horizontally designed form in the Arts and Crafts style. With only minor variations, the format changed little from the standard of a boldly rectilinear mortise-and-

The wrought-iron strap hinges, pulls, and escutcheons on this Gustav Stickley oak sideboard demonstrate the handcrafting that went into each piece of Arts and Crafts furniture. The quality of the finish and the patination of the hardware are heavily weighted in a determination of value of any Arts and Crafts object.

tenon framework of quarter-sawn oak with exposed tenons flush with the surface and a gallery or plate rail running along the back and/or sides of the top. Occasionally this gallery was made up of batten boards, vertical strips of even-sized wood fitted together, or horizontal rails. Ornamental details were non-existent, save for the hardware—usually some combination of iron-strap hinges arranged loosely in the shape of horizontally pointed arrows and pulls that were circular or, infrequently, square faceted. The storage space of the sideboard was a grouping of cabinets and drawers; a typical arrangement consists of two chamfered-board cabinets flanking a center section of drawers. Although at first glance the sideboard form is decidedly horizontal, there is an obvious juxtaposition of horizontal and vertical elements achieved, depending on how the cabinet-drawer design was worked out (generally, the cabinet was more vertical and the drawer more horizontal). Also working to balance some of the horizontal mass are the squared legs, which help break up the surface vertically. Larger sideboards usually have eight: four across the front, of which two define the drawer area, and four in the rear. On smaller models, there are four legs, which are formed or sawn from the two oak planks that make up each side of the case.

At the high end of the market were the architect-designed pieces by Frank Lloyd Wright and Charles Sumner Greene and Henry Mather Greene, whose preference for furniture that coordinated with their interiors far outweighed any need to promote the Arts and Crafts ideal of handcrafting. In fact, many connoisseurs of Design Reform furniture would argue that the designs of Frank Lloyd Wright and Greene and Greene are testament to the cogency of technology and machinery when guided by sound design ideology. Wright, as well as the Greene brothers, produced forms intensely architectonic in character, many inspired by Japanese architecture with its exposed construction. Other details emphasize a strong Japanese undercurrent, including a homage to nature. This is evident in the low-slung nature of their cabinetwork, which keeps it firmly rooted to the ground and that is visible in the brackets, drawer pulls, and carvings.

Following the designs of Greene and Greene, a sideboard or cabinet made by Peter Hall Manufacturing Company, Pasadena (Los Angeles County Museum of Art), is the summation of custom-designed, high-end case work. Made in 1907 from teak with ebony accents, the essentially rectilinear case has a roundness that contrasts with the sharper designs that customarily define the Arts and Crafts genre. This is due to the gently rounded edges and carved panels on the two cabinet doors. Whereas the designs of Stickley and Wright projected strength through the sharp delineation of planes, the Greenes achieved their look with sculptural panels carved by Charles Greene in a highly asymmetrical manner indicative of Japanese fine art. In keep-

ing with the Arts and Crafts creed that decried superfluous application of ornament, the carved, gnarled tree roots function as drawer pulls for the two cabinet doors. The two center drawers have stepped, horizontal handles called cloud lifts, attached so that a larger bar is covered with a progressively smaller or stepped one. These handles, usually positioned to conceal brass screws, are accented with discreet ebony inlays, a technique some Arts and Crafts purists would have avoided. A carved Asian motif can be found at the bottom of the four straight legs.

SEATING

ART- OR JAPANESE-INSPIRED CHAIRS

A specialty of the Herter Brothers firm, chairs of this style, which happen to be the largest surviving type of art- or Japanese-inspired furniture, are relatively simple, more delicate, and shorter than those of the later Arts and Crafts mode. The overall shape of these chairs grew out of Westerners' fascination for the simple Asian objects found at various international exhibits, including Japan's display at the Centennial Exposition of 1876. Basically rectilinear, these chairs are marked by straight stiles, legs, and seat rails, with crest rails distinguished by inlays of a generally floral nature on an ebonized or dark-grained hardwood—all features employed by Herter Brothers in their entirety. Occasionally, lattice-like splats are incorporated into the back, and seats are often overupholstered. Herter look-alikes sometimes used cane seats and *faux* bamboo for the structure. Although highly prized by museums with Design Reform collections, the Herter examples rarely make their way to the market, which, of course, adds to their allure. Although rarely la-

Ebonized cherry and a stylized trellis-like back were features attributed to Herter Brothers. The stylized flowerhead inlay on the crest was favored for aesthetic movement furniture of Anglo-Japanese taste.

beled, these pieces are easily distinguished by their high quality materials and craftsmanship.

ARTS AND CRAFTS SEATING FORMS

The box settle, so named for its box-like appearance, was turned out by nearly every firm working in the Arts and Crafts blueprint. This form, also known as an even-arm settle because of the equal height of the arms and back, is considered a classic example of the form, available with either leather or canvas upholstery. Following a tradition established hundreds of years earlier mostly in seventeenth-century tables, some examples are known as knock-down settles since they can be partially dismantled. Leather pillows provide comfort against the back's rigid, unyielding surface. Like their counterparts in case work, they are extremely horizontal in stature. Since all models take their shape from a square frame with exposed mortise-and-tenon joinery and wide boards that form the seat and back rails, there are particular qualities that distinguish the best examples. These include a back height in proportion to the overall length, a comfortable seat depth, and well-spaced splats both on the sides and in the rear. These details are important not only for comfort reasons but also because this form acts as an informal room divider, much as its predecessor did in colonial times. It is therefore important that the form be balanced and well orchestrated from many angles. Some artisans turned out later, smaller models (of settee size) with a back taller than the sides and characterized by very thin, squared spindles, probably reflecting the influence of Frank Lloyd Wright, who preferred thinner and more attenuated elements in his designs. This trend was short-lived, however, and the high-back settee is less prevalent than the box-settle type.

In single-seating pieces, countless armchairs and rockers received inspiration from an adjustable-back design for leisurely sitting originally favored by English designer William Morris in the 1860s. Called a Morris chair, this form consists of a drop-arm configuration with exposed tenons and long, tapering quarter-sawn boards that slant toward the back to create the arms. Simple supporting brackets called corbels appear frequently on these chairs, underscoring the Arts and Crafts emphasis on honest construction over cumbersome applied ornament. High-quality Morris chairs with under-arm slats are generally preferred by collectors today to open-arm designs. A tall, square back with slats covered by a leather cushion adjusts to provide a measure of comfort for the sitter. The square seat with wide rail was customarily fitted with a drop-in leather cushion, and the chair rests on square legs with exposed tenons. Like the settle, these chairs are judged in today's

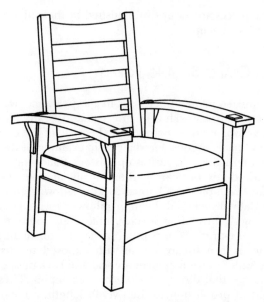

Called a Morris chair, this form is based on a design made popular by Englishman William Morris. Its distinguishing features include an adjustable back.

marketplace for sophistication of overall design, with proportion being the single most important criterion.

In side chairs made prior to about 1903, there was an emphasis on solid, square forms in oak not unlike those of earlier seventeenth-century design. This type characterizes the ubiquitous heavy and generous mission-style profile that was the hallmark of early Arts and Crafts furniture. Back stiles, seats, and legs were square, and stretchers were often arranged with one heavy front stretcher and two thinner stretchers on each side. Many have between three and five vertical splats and heavy, straight, or gently V-backed top rails. Seat rails were straight, and leather drop-in sets predominated. Occasionally rush seats and horizontally arranged slats altered this configuration, as did fully leather-upholstered backs and seats with brass tacks, evocative of the armless farthingale chair of the early colonial era.

By about 1903, another chair type emerged. This chair was taller and thinner than the first type yet it, too, was extremely linear. If the side chairs fashioned before 1903 are considered stylistically aligned with heavier seventeenth-century colonial chairs, then side chairs designed after 1903 show certain similarities with chairs of the William and Mary period, notably the tall, thin framework. Usually made from oak (infrequently from mahogany), many replaced the singular thick

crest rail with a double crest rail composed of thin horizontal members and three slim, vertical slats that joined the double crest with a bottom rail. Straight stretchers brace the legs. The addition of curvilinear features came courtesy of the arched seat aprons or—rarely—in the guise of gently arched crests, working in tandem to reduce the emphasis on the series of vertical lines that so dominated earlier Arts and Crafts models. The use of dark wood, copper, and pewter inlay also serves to distinguish this second type, with many designs attributed to Harvey Ellis.

Architect-inspired side chairs often followed the proportions of this second type; they were tall, thin, and light in scale yet offered enough substance to keep the chair firmly planted on the floor. Where the work of architect Frank Lloyd Wright can be distinguished from that of the major Arts and Crafts manufacturers is in Wright's purposeful omission of pegged joints, exposed tenons, and hand-wrought hardware. His chair designs were an outgrowth of the Prairie school of architecture (for which he was the major spokesman), reflecting a geometric, rectilinear style that emphasized unity between the exterior

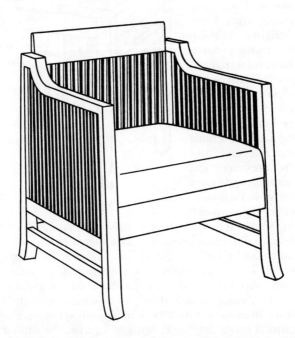

Architect Frank Lloyd Wright was one of the first artisans to incorporate thin spindles into his Arts and Crafts designs, and he devoted an inordinate amount of attention to this chair's final interior destination.

Frank Lloyd Wright designed tall-backed chairs such as this for the dining room, where its height symbolically provided a barrier against the outside world. Often built from dark-stained oak, this vertical chair provided contrast to the primarily horizontal configuration of his Prairie school architecture.

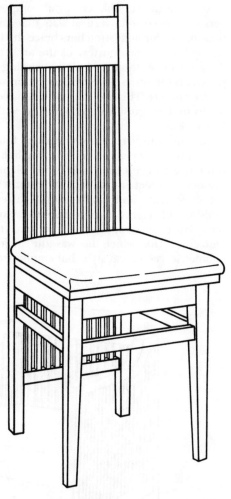

and interior, respect for natural material and Japanese art. Narrow slats and square spindles were characteristic of both the designs he executed for his own home and his early chair designs, circa 1900. While Wright's custom-designed furniture has a highly individual nature, some generalizations can nevertheless be made. These oak chairs are usually stained dark, and can be recognized foremost by their architectural and rectilinear presence and characteristically wide crest rail, often with thin spindles numbering as many as eleven, which terminate in the lower H-shaped stretcher. This unique feature differentiates these chairs from anything that came before, as splats and spindles regularly concluded at the junction of the rear seat rail. This extremely vertical composition measures approximately forty inches or more in height. Such tall backs functioned as screens in the dining room and helped offset the strongly horizontal nature of the interior architecture. Functionally speaking, the extreme rectilinearity is also a drawback, demanding from the sitter a fully upright back at all times. Drop-in leather seats were standard fare. This design, like so many others by Wright, produces a marked contrast of planes in which additional ornament was unnecessary.

TABLES

ART- OR JAPANESE-INSPIRED TABLES

The format of these aesthetic movement tables was generally in keeping with the linear, low-profile designs found on related case work and chairs. Herter Brothers, which produced the finest examples, favored a rectangular body of ebonized wood. The apron, running horizontally under the top, meets turned legs with a pierced and carved H-shaped stretcher and may house a drawer with thin handles shaped as brass drops. Ornament consists of stylized, small-scale inlay in interlacing patterns of floral sprays and a centered urn. These details were typically rendered in contrasting bone and tulipwood. Whereas these tables remained highly decorative, they were a well-conceived and progressive alternative to some of the overblown tables of the Victorian revival styles as well as precursors to the more subdued orchestrations that followed in the Arts and Crafts style.

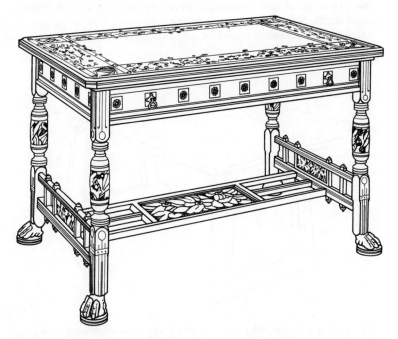

The linear, horizontal arrangement of this rosewood table is suggestive of aesthetic movement furniture. The highly stylized floral inlay taken from Japanese sources represents the single most influential decorative treatment on aesthetic pieces made by Herter Brothers.

ARTS AND CRAFTS FORMS

The small book or library table was a popular shape derived from the revolving bookcase, which was a standard nineteenth-century form. The Arts and Crafts model did not customarily rotate, but it served the same purpose of combining a table with an encyclopedia bookcase. These cube-like oak tables were a mixture of shelves and vertical slats with a square, often overhanging top and straight legs. Decorative effect was absent, except for what was provided naturally by the wood and the arrangement of the slats.

In larger library tables, an example designed by Frank Lloyd Wright for the Francis W. Little house in Minnesota (Metropolitan Museum of Art) illustrates the best of architect-designed furniture. Like the case pieces Wright envisioned, this table has an extremely horizontal quality. Typical of Wright's work after his return from Europe in 1911, it is constructed of naturally colored and waxed oak rather than the dark-stained oak of his earlier designs. The rectangular top and separate, smaller undertier—or second top—rest on four square legs that house a lower cabinet. There, four small apertures function as pulls on twin-hinged doors. Strongly suggestive of the architect's unique perspective is a heavy emphasis on uncomplicated planes. The cabinet appears to

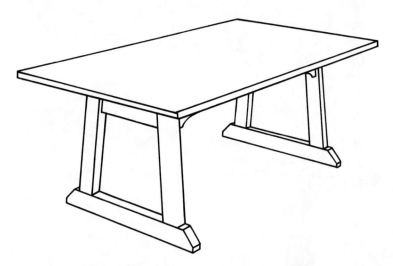

As part of Design Reform philosophy, Arts and Crafts furniture discarded the decoratively overrun objects of the late Victorian era in favor of pragmatic designs based on medieval craftsmanship. This simple oak trestle dining table by L. & J. G. Stickley, circa 1910, displays the same honest construction that its predecessors did hundreds of years earlier.

be suspended from the four square posts, lending spatial flow and lightness to an otherwise weighty arrangement.

Another large form, the trestle or director's table, referred to medieval English prototypes for its design. These horizontally spread tables were equipped with a thick overhanging top resting on a square apron, four straight legs with large, visible pegs at the juncture with the apron, and trestle feet. These massive tables ranged from about seventy-two inches in length to ninety-six inches for the larger models. Some served as dining tables.

The hexagonal shape, a popular choice for library and games tables, first appeared about 1900. A hexagonal-shaped top was placed on six heavy square legs with converging or cross stretchers and exposed tenon joinery. Those familiar with early colonial gateleg tables may see a likeness in the Arts and Crafts hexagonal-shaped table, thanks to its multiple legs, even if the materials and joinery are categorically early twentieth century. Original-condition models with leather tops, suggestive of the treatment found on seventeenth-century chairs, are considered highly collectible.

*S*UMMARY OF STYLE

Dates: 1870–1915

Distinguishing Features: aesthetic or art-inspired: simple outlines; low-profile rectilinear forms with Japanese motifs; Arts and Crafts: exposed construction methods such as tenons and pegs; emphasis on solid forms and overconstruction

Materials: aesthetic or art-inspired: ebonized wood; inlays of light woods; gilt; ivory; mother-of-pearl; Arts and Crafts: oak, hand-wrought metal hardware

COLLECTOR'S TIPS

1. *Look for (good example):* good proportions and evidence of some handcrafting in rectangular forms stressing horizontal and vertical planes. Art-inspired pieces should be free of or have only discreet ornament. Arts and Crafts furniture generally has no ornament besides what came from exposed construction methods or hardware.

2. *Look for (outstanding example):* architect-designed pieces using finest materials and workmanship. Outstanding examples are often in original or close-to-original condition. Rare examples of inlay should be of delicate, stylized nature.

3. *Problems/what to watch out for:* Arts and Crafts pieces that have had their surfaces skinned or sanded and are now heavily refinished. This destroys the value of the original design. Use care with labels, brands, or shopmarks; authenticate them as well as the object to which they are affixed.

4. *Conservation issues:* Any repairs or restoration should be reversible. It is possible to refume Arts and Crafts pieces with ammonia, but it is not always successful and is not usually advised. Original leather tops or upholstery should be preserved if at all possible.

5. *Cabinetmakers/firms important to style:* aesthetic or art-inspired: Herter Brothers, Kimbel and Cabus; Arts and Crafts: Gustav Stickley; Harvey Ellis; Elbert Hubbard; the architects Frank Lloyd Wright, Charles and Henry Greene, George Elmslie, Charles Rohlfs, Charles Limbert

6. *Where public can see best examples:* Metropolitan Museum of Art, New York, New York; Los Angeles County Museum of Art; Grove Park Inn, Ashville, North Carolina; Craftsman Farms, Morris Plains, New Jersey; Gamble House, Pasadena, California; Frank Lloyd Wright House, Oak Park, Illinois

7. *Department expert wish list:* Herter Brothers inlaid cabinet or side chair in Anglo-Japanese taste; Greene and Greene or Frank Lloyd Wright pieces

8. *Miscellaneous:* The Arts and Crafts period is a well-documented one, making it easier to research than early colonial styles.

WHAT IS CONNOISSEURSHIP?

HOW TO GET STARTED

Beginning collectors need to understand the workings of the market-place for American furniture. The finite universe of American furniture can be dangerous for the uninformed. The market is a complex one, where an intangible quality such as personal taste is sometimes judged to be as influential as historical importance or originality of design in the determination of value. How, then, is the novice to get a foothold in the emporium that is American period furniture? And how can one understand the difference between an object that sells for $100,000 and one that sells for $10,000? One answer to these questions comes through the development of skills in connoisseurship, authentication, and evaluation as well as in knowing how and where to purchase and care for these "objects of desire" collectively called American furniture.

The remainder of this text will be devoted to these issues with the hope of developing in novice collectors a level of confidence with which to enter this marketplace. Following are some general guidelines for getting started that have proven helpful to seasoned collectors, scholars, dealers, and others devoted to the American decorative arts in their quest to understand what makes a piece of American furniture a mediocre example or a truly outstanding one of its kind.

Connoisseurship is defined as the ability to pass critical judgment in the arts or in matters of taste. While long thought to be a talent associated with academic specialists, it can be cultivated by well-informed amateurs. There are many ways to develop connoisseurship skills. Begin by trying to determine a main or specific area of collecting or scholarly interest. This is accomplished by taking the time to discover what you like—and what you don't. Start with a gut reaction, and don't be intimidated into thinking that just because an object is an antique that has somehow survived for one hundred years or longer that it must be desirable: What is it about the object that is appealing to you? Is it the under-

lying form with strong contrasts of solid and void? Is it the color or turnings of the wood, or is it the carving or the shape of a leg? Fairly early on in this formative process, some patterns should emerge based on your initial reactions to different styles. Trust your own judgment about a particular style. Ultimately you will become confident and comfortable in stating your attraction to Philadelphia Chippendale furniture, or nineteenth-century Rococo Revival pieces made by John Henry Belter, for example.

Obviously, the easiest way to formulate opinions about a piece of furniture is to look at as many examples as you can. This can't be stated emphatically enough: The single most important step in developing connoisseurship skills is to LOOK, LOOK, LOOK, AND LOOK AGAIN! Look at furniture in museums, historical societies, antique shows, dealer shops, and auction houses. Chapter 19 is a regional listing where you will find specific locations for viewing the best examples of American furniture firsthand, some of it in appropriate period settings. Attend lectures and exhibits at museums and historical societies to pick up on new scholarship or learn valuable insights from individuals whose function it is to educate the public. Consult auction houses or dealers as sources of education; many offer free lectures or walk-throughs for upcoming sales, and some encourage novices by sponsoring special events for beginning or young collectors. The larger auction houses even have separate educational studies departments that conduct intensive courses on the topic of American furniture. An advantage of these programs is that they provide access to professionals and institutions that might not be available to a collector studying alone.

Along with developing your own aesthetic opinions, learn what it is about a particular style or a specific form that makes it desirable in the marketplace. Perhaps the guide that is most helpful to beginners is Albert Sack's *The New Fine Points of Furniture,* available through bookstores that specialize in the decorative arts. This comprehensive book is a bible for anyone wishing to develop connoisseurship skills as it compares hundreds of examples of American furniture—from good examples to museum quality masterpieces—in many styles. Study it and use it as a guide in looking at real objects. But don't rely exclusively on the images in this book or any other as a shorthand for viewing objects firsthand. Seasoned collectors differentiate themselves from mere devotees of American furniture by their insistence on viewing the object itself rather than the image of the object. It is imperative that a collector become a firsthand witness to the beauty of the materials and workmanship. While certain features, such as pleasing form or proportion, can be captured in a photograph, other details, such as painstakingly fine inlay or sculptural quality, cannot be transmitted on paper.

Additionally, there are periodicals and newspapers that cover the topic of American furniture. Some of these sources include *The Magazine*

Antiques, The Maine Antiques Digest, and *Antiques and the Arts Weekly.* While these sources do not deal exclusively with American furniture, they devote enough significant attention to the subject that they warrant special attention. Copies are available at your local library or by subscription, and you should read them regularly to keep informed about current issues and events. All of these publications keep abreast of developments in scholarship, and the latter two include coverage of auctions and shows, which helps keep readers apprised of the state of the market as well as the location and dates for many of these events.

Developing a focus will keep a collection coherent, whether one is building an entire collection or searching for a specific piece. Nevertheless, when first developing connoisseurship skills, avoid becoming too rigid in scope: Some of the best collections often mix objects from several regions or from slightly different stylistic intervals. This strategy mimics original purchase patterns in which furniture was much too valuable to be cast aside with each change in style. It also builds connoisseurship skills by allowing a collector to appreciate a successful design whenever it appears in the marketplace, even if it is slightly outside his or her main interest. This pragmatic approach also provides leeway should one's collecting interest change over time.

MACRO ANALYSIS OF A STYLE

One surefire way to become thoroughly educated about a style is to understand its macro features—those features associated with all furniture from a particular time frame or fitting the category of a specific style. The essential features of each style in this text are summarized at the end of every chapter, and you should refer to the style summaries repeatedly to help crystallize the information. These macro features can be broken down into several important components:

- dates during which the style predominated;
- underlying shape or form;
- components and scale; and
- materials and ornament, including hardware, carving, veneer, inlay, and paint.

Dates

Remember that style dates are approximate ranges during which the style predominated; many styles endured past these stated ranges, and there were often overlaps between styles.

FORM

Underlying shape or form is perhaps the single most important component in identifying a particular style, and therefore should be the starting point for identification. For example, by knowing that a style was dependent on straight lines, one can eliminate those styles that were dependent on curvilinear forms. If a novice was faced with an object he knew little about except that it was composed of straight lines, with his knowledge of the underlying forms for different styles he could eliminate obvious curvilinear styles such as Queen Anne, Chippendale, and Rococo Revival. Other stylistic features may help pinpoint the object even further. Separately, as was mentioned earlier in this text, the "squint test" should be employed when assessing underlying form. Squinting one's eyes—doing away with all superfluous detail and ornament—allows the underlying form to become the focal point. Connoisseurs of American furniture know that the squint test is an invaluable tool used by novices and experts alike in determining the success of the composition.

COMPONENTS

The components and scale of a piece have a lot to say about whether the overall design is successful. Think of components as body parts—legs, feet, arms, backs, and cases. The most skillfully executed carving and veneering can't hide cabriole legs that are too bulky or do not have well-formed ankles, nor can they mask proportions that may be out of sync between individual components (for example, an upper case that is too tall or wide for the base on which it rests). Further, in developing a flair for components and scale, it helps to know what components were common to a particular style and whether they were robust or attenuated. For example, both the Chippendale and Rococo Revival style relied on scrolls, but the Rococo Revival had a much more robust demeanor. Be prepared to compare elements in a similar manner. Get familiar with the parts of each style. Seasoned collectors know what components and combinations were used in any given style. Paintbrush and bunfeet, for example, were products of the early colonial period while spade feet are a clue to early nineteenth-century design.

MATERIALS AND ORNAMENT

Knowledge of period material and ornament is crucial to connoisseurship. Many of the highest style examples of American furniture are decided by these two factors. A standard for American furniture—

no matter its stylistic interval—is that the best examples employ the finest materials and ornament skillfully combined. Again, it is important to know what materials and ornament were popular in a specific period. Collectors should be able to identify the age of walnut as belonging to the William and Mary period, or the age of mahogany as belonging to the Queen Anne and Chippendale eras. Further, most pieces are analyzed in terms of their primary and secondary woods. Primary woods are visible when the object is fully assembled and are usually chosen for such aesthetic qualities as the color of the wood or the pattern established by the grain. Secondary woods are structural woods that are usually concealed (as in internal bracing) or visible only on the undersides or inside. They are selected for such engineering qualities as durability, low shrinkage component, or compatibility with the primary wood. The visual impact of a secondary wood is usually irrelevant since it is covered with the primary wood either solidly or in applications of thin veneers. Native species make up all secondary woods in American furniture.

Ornament is a broad category that covers carving, inlay, veneering, paint, and hardware. Novices should understand what decorative treatments were peculiar to a style: Carving, for example, was ubiquitous in the Chippendale style but not in the Federal style, in which inlay was the primary decorative treatment. Ornament should also be evaluated in terms of its integration with the whole object. The best examples of American furniture are recognized by a fine orchestration between the ornament and its underlying object. A balance is struck when an ornament complements the basic form, as when the viewer's attention is drawn to a sculptural contour on a cabriole leg. This is one reason why successful hand carving commands a larger premium than does machine carving. In lesser examples, carving appears "stuck on" as an afterthought or lacks the vitality inherent in premium examples. Learning to spot the difference is just one more element in developing connoisseurship skills. To some collectors these differences are obvious. To others, it takes a little more effort to train their eye. Don't be discouraged for the more you examine and compare, the easier it will be to distinguish fine ornamentation from mediocre renditions. As you are learning, don't be afraid to ask professionals—curators or tradespeople—what it is about the ornament or materials on a piece of furniture that qualify it as desirable.

MICRO ANALYSIS OF A STYLE

Once these macro concepts have been mastered, the next step in the development of connoisseurship skills is to get familiar with certain micro features—those peculiar to a more narrowly defined universe of American furniture. As an example, think of the cabriole leg. In a macro analysis, the cabriole leg is one component of the Chippendale style. However, a

cabriole leg with a terminus consisting of a sturdy claw grasping a flattened ball and flowing, naturalistically rendered carving on a rounded knee give further information that allows for more specific identification. In fact, such a leg would be a regional Philadelphia interpretation of the Chippendale style. Mastery of this type of analysis is what separates beginning from more advanced collectors. Micro details include:

- regional characteristics;
- artisans, cabinetmakers, and firms important to the style; and
- origins of the style.

REGIONAL CHARACTERISTICS

Regional characteristics are more important to some styles than others. For example, regional attributes were crucial in the development of American furniture up to 1830 and less important thereafter as standardization of parts during the Industrial Revolution became widespread. When machines replaced many of the heretofore handcrafted operations, including carving, many regional nuances disappeared. The disparate elements of construction and ornament can also vary by region. Recall, for example, that on a Chippendale chair, seat construction was handled differently in Philadelphia than in Massachusetts. And in carving treatment, Philadelphia forms are recognized by highly life-like foliage, whereas Massachusetts carving is often regarded as an antonym to Philadelphia work—somewhat flat and less animated. To understand the subtle distinctions in claw-and-ball feet among regions is the mark of a seasoned collector.

Regional preferences also influence the selection of materials. To know that mahogany was the favored wood of the Chippendale era falls within the domain of macro features noted above; however, to know that cypress was often used as a secondary wood in Charleston is a discerning piece of information that goes beyond macro knowledge of a style's features. It helps to know what primary and secondary woods were used in a particular region; except for imported woods (such as mahogany), which were always used as primary wood, cabinetmakers generally relied on locally supplied stock for secondary wood. Consequently, many pieces of American furniture can be traced directly to the region in which they were made. Recently, this information about primary and secondary woods has played a larger role in the identification of American furniture by helping to reclassify as American those pieces once thought to be English.

Names Important to Style

There are many reasons why collectors acquaint themselves with artisans, cabinetmakers, or firms associated with a particular style. In some styles, one simply can't avoid it. It would be difficult, for example, to be conversant with the Rococo Revival format without coming across the name John Henry Belter and the integral part this innovative cabinetmaker played in developing the curvaceous laminated forms associated with that style. In other instances, collectors know that the quality of workmanship and materials that some cabinetmakers employed impacts favorably the price their pieces fetch in the marketplace. For example, the precise dovetail joints that the esteemed Goddard-Townsend workshops incorporated in their case work, as well as their choice of the finest imported mahogany, are synonyms for quality and attention to detail, making their designs some of the most highly prized in American furniture.

Much of the ongoing work in the field today consists of identifying specific artisans or cabinetmakers previously unknown in American furniture. This is done by narrowing down regional attributions to individual cabinetmakers or shops, a time-consuming and challenging task that can prove daunting to even the most accomplished scholars, and often takes a decade or more of advanced research to complete. Learning the names of known cabinetmakers, artisans, and shops will not only promote scholarship regarding the finest aspects of American furniture, but it will also make the process of collecting more intimate and immediate for the collector.

Information about cabinetmakers and the styles with which they were associated is also important because some firms worked in more than one style. While one collector may be able to afford pieces in the Empire style made by Duncan Phyfe, a second collector may not. Nevertheless, this same collector, armed with knowledge about Phyfe's work, may be able to capture at a lower cost some of the quality that Phyfe is recognized for in his Restauration style pieces. Because Restauration furniture is less widely collected, it tends to be less costly than Empire forms. The identification of a specific cabinetmaker or firm also plays a crucial part in determining value, a lengthier discussion of which will follow.

Origins of the Style

Novices of American furniture often overlook another feature of connoisseurship—the origins of a style—focusing solely on the American-made pieces without regard for the English or Continental example that inspired it. This is a mistake. It is widely acknowledged that American furniture owes a debt to English and European sources for three rea-

sons: (1) imported objects from these locales were the basis for style transmission; (2) immigrant craftsmen, trained in the styles of their homelands, produced pieces surprisingly like those left behind; and (3) imported pattern books kept American patrons abreast of the latest English and European fashion. These occurrences are all reflected in the end products of American furniture makers. There are both differences and similarities between American furniture and its forebears, and by knowing a little about the origins of a given style, a collector is better equipped to judge whether the American version is a successful interpretation, a highly idiosyncratic one, or just a plain failure.

To cite just one example of the usefulness of the origins of a style, consider this: As the Rococo edict evolved in France, it affected underlying form as well as ornament, resulting in highly asymmetrical and curvaceous forms enhanced with organic adornment. As the same style spread to England and the colonies, it was less the careful orchestration of curvaceous, anti-classical form and organic ornament than the result of organic ornament applied to then-contemporary forms. The highly asymmetrical quality, which was inherent in French examples, was often lost in the translation. In light of this fact, it now appears more logical that on eighteenth-century American furniture of the Rococo persuasion, foliate ornament was superimposed on high chests that retained the straight quarter columns indicative of classical design. Knowing the origins and subsequent translations of the Rococo style helps explain what might otherwise seem like a stylistic omission—or a glitch in stylistic evolution. No matter what style you are analyzing, the importance of understanding its transmission from a major city or country, otherwise known as the style transfer point, is essential to understanding how the American version may follow or deviate from its forebear. Scholarly publications often scrutinize American pieces in relation to their English or European ancestors, and collectors should make comparisons as a point of connoisseurship.

*H*OW TO DETERMINE AUTHENTICITY: THE PITFALLS OF THE MARKETPLACE

Assuming that a collector knows what he is interested in acquiring, how can he be assured that what he is considering purchasing is indeed what it purports to be? The issue of authenticity (or genuine origin) in American furniture is an important one covering many concerns, the most important being the determination of fakes and frauds, and repair and restoration. Self-seeking miscreants wishing to fill the void left by an ever-narrowing cache of authentic period furniture have profited handsomely from deceptive activities. One of the best reference works on this topic is Myrna Kay's book *Fake, Fraud, or Genuine?* It spells out in great detail the pitfalls to avoid in collecting American furniture. Some of the most serious assaults on the marketplace include:

- complete fakes;
- new objects fashioned from old parts;
- remade antiques;
- enhanced objects or those that have had a "face-lift";
- married pieces;
- English or European objects being passed off as American; and
- reproductions masquerading as real period pieces.

FAKES

Complete fakes, or forgeries, are those pieces with no original antique parts. Fraudulent pieces, on the other hand, are genuine antiques that have experienced alteration or enhancement or have been misrepresented in terms of authorship, provenance, or any detail upon which a buyer might evaluate it. Fakes are less common today than they were earlier in the twentieth century. Collectors are better educated now and are able to spot them more readily, thanks to the efforts put forth by a number of sources, including historical associations, museums, and individual scholars.

Fakers follow the money trail, devoting their talents to copying genuine period pieces that command record-breaking prices. As some of the most coveted American forms are products of the Queen Anne and Chippendale periods, purchasing furniture from this time frame requires due diligence. Conversely, furniture of those styles that have yet to capture the public's fancy, or in which too many design variables are involved, spawn fewer fakes. Simple economics dictate that the Herculean effort needed to fake an Empire form from scratch, with its multiple materials—including veneer, gilt, *ormolu*, and paint—would not be adequately rewarded in the marketplace. In either case, however, a trained, informed eye is the best defense against fakes.

In some instances, fakes may even have passed through private and public institutions where they may have once been displayed as genuine. Some of the best repositories of American furniture, including the Metropolitan, Winterthur, and Yale University museums, have purposefully included fakes in their study collections (generally accessible to the public) to educate novices in the tricks of the forger. While becoming conversant in the macro and micro elements of a given style can aid one immensely in spotting fakes, the best way to educate oneself is to examine a genuine piece alongside a fake. The many institutions listed above, as well as those in "Sources," occasionally make these comparisons possible, and novices should make the effort to view these examples firsthand. The best starting point is to contact the larger public museums with extensive holdings in American furniture. Of those that do maintain study collections, access varies widely, so contact them directly for viewing times and availability.

FRAUDS

NEW OBJECTS FASHIONED FROM OLD PARTS

More prevalent than complete forgeries is the practice of passing off as genuine a new object fashioned from antique or old parts. Objects of

this type fall into the category of fraudulent antiques. Old or antique parts display "age," which was produced by such naturally occurring factors as oxidation and normal wear and tear, consequently making them appear more realistic than those pieces that were put together with "antiqued" parts that merely simulate age. Age can be simulated by chemicals or techniques as simple as distressing the surface with a hammer. A common practice is the fashioning of old, non-furniture forms into furniture. Floorboards, for example, may be resurrected as a tabletop, a facade, or a side for a case piece.

Occasionally, antique forms are also transformed into "rarer," costlier pieces. A red flag should be raised in a collector's mind when confronted with a "rare example" or "rare form." Case pieces are often misrepresented in this way; salvaged antique boards, when reassembled into a new object, are smaller than authentic examples. Fakers might call such a piece a rare form in the hopes that a naive consumer will be attracted to the supposed uniqueness and miss any inconsistencies that might point to a fraud. Even accounting for regional differences in construction techniques and ornament, most period furniture possesses consistency of design. Far too many collectors have been fooled by pursuing the unique, so just remember that a true rarity is unlikely.

REMADE PIECES

The next category, remade antiques, requires less creativity and resourcefulness on the part of unethical individuals. While a new object built from old parts may require some cabinetmaking skills to pass the object off as genuine, remade pieces often require minimal talent. Remade objects are given new life through the separation of parts. A two-part high chest may be split so that the lower half can be offered as a dressing table, a piece more marketable to today's collectors and scaled-down households. The remaining top may then appear in the marketplace as a chest of drawers to which feet have been added. Another such practice is the addition of desirable elements to an object to increase its appeal and its profit potential. An example of this practice is the addition of fancy pediments or cornices to an unadorned Queen Anne flat-top high chest to create a more coveted form.

ENHANCED AND AESTHETICALLY ALTERED PIECES

Perhaps the practice that proves most problematic for the untried American furniture collector is one that enhances pieces through "aesthetic surgery." This practice is closely aligned with trends in collecting. When a Philadelphia piecrust tea table set a record for the form at auction,

many lesser examples were instantly endowed with a piecrust edge and rigorous carving. Astute collectors and professionals recognize that these fraudulent pieces are most likely to enter the market shortly after impressive prices are registered for that particular form.

Aesthetic surgery also comes disguised through additional carving, re-painting, inlay enhancement, and re-veneering. Be warned: Carving is one of the primary ways that furniture is augmented. Shell and fan designs can add panache to a high chest or desk—and create false value in the eyes of a novice. In reality, however, the later addition of shell or fan carving may be masking small holes where simple drawer pulls may have once hung. Paint can also be used deceptively. Rarely does original paint remain on American furniture examples, and many pieces that were originally unpainted have been enhanced at a later date. Many japanned objects purporting to have eighteenth-century origins were originally bare, with decorative detail and embellishment supplied sometime in the nineteenth century. As was mentioned in the style chapters, original eighteenth-century japanning on American objects is believed to exist on fewer than forty pieces—most of which reside in museum collections—making it highly unlikely that examples turning up today have original period japanning. On less complicated painted surfaces, painted-in nicks and gouges suggest that the paint and the surface to which it was applied cannot be traced to the same point in time. Together with re-veneering, inlay enhancement—particularly prevalent on Federal or early Neoclassical furniture—is one of those fraudulent techniques that might render an otherwise authentic piece nearly worthless. Re-veneering often shows up as a patch to the original surface where exact matches are nearly impossible because of differences in the age, color, or grain of the surfaces. Some types of inlay enhancement appear where inlay never existed before as a means of adding pizzazz to an otherwise plain form. While honest repairs are acceptable, these practices work against the original intent of the designer and are most unwelcome.

A separate but equally despicable method of enhancement is the application of labels and/or inscriptions whose purpose is to lure the collector with a "brand name." Would-be collectors should be aware that creating false provenance is relatively easy and requires no cabinetmaking skills. A lengthier discussion of provenance appears in the section on determining value.

MARRIED FURNITURE

In certain instances, fakers use two disparate pieces to create one salable form. Consider that the upper half of a high chest might become estranged from its base, with the base cavorting in the marketplace as a re-

made dressing table. Somehow a suitable partner must be found for the upper chest. Enter the faker. When a partner is located for the upper chest, the new "married" piece is passed off to unsuspecting purchasers. Married pieces are the opposite of remades. Remades were originally one piece that is split up so that it can be sold as two separate objects. High chests, desks, and bookcases are prime targets for these two methods of chicanery. Married examples also "borrow" parts, such as drawers from one desk fitted into another case, to create a single, salable object.

ENGLISH OR EUROPEAN OBJECTS
PASSED OFF AS AMERICAN

As is emphasized many times in this text, the stylistic influence on much American furniture is conclusively English. A great deal of English furniture, especially from the provincial areas of London, may in fact pass as American. Generally speaking, authentic American furniture is often more expensive than its English antecedent. Unfortunately, the profit motive encourages unscrupulous vendors to acquire less costly English pieces with the intent of passing them off to naive consumers as their costlier American counterparts. Among the varied methods that can be employed to ascertain authenticity, the increasingly used method of primary and secondary wood analysis has and continues to be of help in distinguishing American pieces from others. Professionals in wood analysis begin by examining a small sample taken from an inconspicuous spot on the object for a specific species. If the origin of the wood is not common to American soil, the analyst can refute the object's so-called American attribution.

TERMINOLOGY AS CLUE TO AUTHENTICITY

Another authenticity issue concerns the impact of reproductions in the marketplace. A reproduction is a facsimile that heralds the originality of design and craftsmanship that marks a period piece. Some reproductions are fairly accurate copies; others are more noticeable as loosely adapted pastiches. Most reproductions have been constructed using contemporary techniques and tools and were not intended to deceive but to mimic a particular style. A reproduction is not a problem when labeled as such or when, after careful examination, the purchaser knows that he or she is buying a reproduction having no historical value. Such reproductions are distinct from outright fakes that seek to deceive by employing what at first glance appear to be period construction techniques and materials. The danger with reproductions comes only when

a dishonest seller, falsely representing the object as a period design, is matched with an untrained and uninformed purchaser, who misses the inaccuracies of the piece and believes it to be a genuine antique.

To a trained eye and hand, subtle differences in design, proportion, material, or ornament can yield clues to period authenticity or point to reproduction. Again, connoisseurship skills can be a big ally in knowing what to look for in assessing furniture. Blatant mixing of disparate regional attributes is a dead giveaway of the non-authentic item. Highly organic Philadelphia-type carving found on a *bombé* form from Boston may have all the ingredients of the Rococo style, but such an object shows total disregard for regional traits by adding Philadelphia carving to a typically Boston form.

To cite another example, a chair made of oak with a pierced splat, claw-and-ball feet, and "runny" carving may suggest a Chippendale design, but savvy collectors and professionals can spot oak and "runny" carving as inconsistencies. An authentic period Chippendale chair would be made of mahogany, possibly walnut, but never of oak, and runny carving is lifeless and the antithesis of the flowing, organic carving that adorns so many eighteenth-century designs.

Acquainting oneself with some commonly used terminology is an additional step the collector can take to help differentiate true period pieces from revivals or reproductions. Quality organizations that conduct business in the marketplace of American furniture usually strive to classify or label pieces to avoid confusion in the collecting public. Consider the following examples:

1. An American Chippendale chair might be described as "Philadelphia Chippendale chair, circa 1770." This definitive label, also known as a definition of authorship (covering the identity of the creator if known, period, origin, or any other specific fact relating to the object), describes its regional attribution and asserts that the chair is being presented as an original period design. The supplied information can be verified through careful examination of the chair itself.

2. A similar-looking chair to the one noted above might be described as "Chippendale chair, nineteenth century," or as "Chippendale centennial chair." The astute collector recognizes this description as one of a reproduction. In the mid- to late nineteenth century, many styles from the past were reproduced. Known in the trade as centennials, many of these objects made their debut in the marketplace roughly one hundred years after the original period style, hence the name. Centennials are often quite close renderings of the authentic period piece. The year 1876 was popular for centennials in all mediums commemorating America's one-hundred-year history. Although centennials are old, their status and value in the

marketplace are diminished because they are reproductions. The term "centennial" simply sounds more palatable than "reproduction." Why, then, if a centennial is old does it not command the same status and value in the market that a period piece does? The answer relates to the concept of originality of design. Because they are copies made sometime after the true period object, centennials do not have the originality of design that marks a period arrangement. The market calculates this information accordingly in the evaluation process.

The description "centennial" or "nineteenth century" clearly distinguishes the second chair from the period chair. Thus, even if a collector is not fully familiar with the visual evidence provided by the actual object, knowledge of the terminology alone provides a clue for further analysis. Those who are confused by centennials often have not firmly committed to memory the fundamentals of the style—in this case the dates when the period style predominated. The words "nineteenth century" should instantly trip an alarm in a potential buyer's mind that the second chair was not made during the original reign of the Chippendale style in America, from 1755 to 1790. Collectors should also recognize that centennial descriptions are often far less specific than those found on the true period object. Some dealers and auctioneers don't differentiate between chair one and chair two described above, leaving it to the purchaser to understand the difference. Using the connoisseurship skills listed earlier, a dedicated beginner will come to understand the difference—and what a seasoned collector already knows.

3. Another chair may be described as "Chippendale-style chair." On a label such as this, the term "style," rather than age, is a clue. There is no date or regional attribution mentioned with this example, so obviously, the amount of information that can be gleaned from this description is ambiguous, bordering on useless. The most popular and enduring styles have been reproduced for years, and many are still copied today. A reproduction chair of this type shares the visual attributes of the original period style it emulates. However, it is not an antique, and may be as new as a chair found in the local furniture store. Remember that with regard to the first chair, the market awards value based on originality of design.

With the second type, the centennial, value is significantly reduced. The primary value of this third type of chair is purely decorative, with no originality of design noted. Be aware that objects of this type turn up surprisingly frequently in the secondary marketplace (any forum other than where the object was originally sold when new) for American furniture, but the most respected firms rarely offer these reproductions for sale, because there is no real financial incentive to do so.

OBJECT-SPECIFIC CHECKLIST

Another step in the authentication process centers on a checklist of object-specific properties a collector can utilize to determine period authenticity. What will become obvious as one moves through this list is how thoroughly one needs to study—or really look at—the object. When perusing an object, the best scholars and collectors continually challenge themselves by asking "Does this make sense given the purported age or period of the object?" Some of these manifest properties include:

- economy of labor;
- economy of materials;
- consistency of construction;
- labels appropriate for the period;
- personalized inscriptions;
- technological or scientific evidence; and
- sight, sound, and touch.

ECONOMY OF LABOR

Economy of labor relates to the opportunity cost of the cabinetmaker's time. A cabinetmaker would not expend effort where it would not be appreciated visually. Recall, for example, how seventeenth-century joiners did not ornament the sides of case work since custom dictated that furniture be placed about the perimeter of a room, which in turn meant that the object was usually viewed head-on. A cabinetmaker would not stain, varnish, or smooth any part of a case work interior that did not have contact with its contents. Time spent on these activities would detract from other work in which the cabinetmaker might otherwise be productively engaged. Therefore, finding stain or excessive finishing on a drawer bottom or on the underside of case work should put a sleuth on alert. Economy of labor prevailed in American furniture until the advent of the machine age in the mid-nineteenth century, when machines performed finishing details that an individual cabinetmaker could not economically justify.

ECONOMY OF MATERIALS

Economy of materials is closely related to economy of labor. The best woods and materials were used judiciously and only where their presence was sure to be noticed. With few exceptions, costly mahogany would be used to create thin veneer for surfaces while a secondary wood such as pine would likely be chosen for frames or drawer sides and bot-

toms. It should not arouse unnecessary suspicion, however, if an occasional piece of scrap wood turns up on a drawer bottom if all other evidence points to period construction and materials.

Similarly, whereas it would be curious to find a knot on the surface of a high-style piece, economy of material might justify the inclusion of knotted or blemished wood in a component not meant to be visible. Those with disingenuous intentions often contradict such utilitarian practices in the faking process. Fakers may expend more effort and materials "antiquing" parts based on their contemporary vision of how an old object should look, potentially at odds with the way in which authentic pieces actually aged. On a faked piece, sometimes this ardor translates into wear and tear that is too obviously uniform. Original objects often show signs of age randomly—specifically, where one part received more sun exposure than another or where parts (including drawers and legs) had more contact with hands and feet. Further, a varnished, painted, or otherwise too-smooth finish on an unexposed surface is often a misguided attempt at eighteenth-century detailing, but, as discussed, these surfaces were originally unfinished.

CONSISTENCY OF WORKMANSHIP

Consistency of workmanship must also be evaluated. Again, remember that a true rarity is unlikely. Regardless of whether one is analyzing a seventeenth-century piece or a later product of the specialized cabinetmaking shops, consistency of workmanship prevailed. Dovetails or other methods of joinery should be similar throughout the piece. Specifically, dovetails on the top of drawers should match those on the bottom. Deviations in joinery might signal a marriage of parts. Tool marks and general assembly procedures can also proffer clues as to authenticity. Exceptionally smooth and glass-like drawer bottoms on an eighteenth-century form don't match up with period practice.

Circular saw marks on surfaces are the hallmark of late construction found no sooner than the mid- to late-nineteenth century. Prior to that time, linear marks made from a manual planer indicate the hand finishing process employed in the seventeenth and eighteenth centuries.

LABELS AND INSCRIPTIONS

Affixed items such as labels and inscriptions are both a blessing and a curse. In a label-hungry market, their presence can add a degree of personalization by the maker, increasing desirability and cost along the way. On the downside, they must be authenticated along with the objects to which they are attached. Some common problems include the later at-

tachment of altered stationery or billheads (the dated invoices of the period). Unlike billheads, labels are usually undated and have decorative borders. Historically, labels grew out of the European tradition established by tightly regulated guilds of signing or labeling work. While labeling was more common to English and European work of the eighteenth century, it is noted rarely on American objects of this time frame, because cabinetmaking did not operate under a guild system in colonial America. When labels appear on American pieces, they are usually found on objects dating from the nineteenth century and later, when the practice became more widespread.

An easy way to begin the investigative process on an affixed label is to determine if the object and label started life together. This is done by examining the label and the area to which it has been affixed for signs of age. Most period labels have experienced a degree of loss. Paper turns yellow and glue dries and turns brittle. Common sense dictates that if the label looks too perfect, especially around its edges, it is probably not authentic. The wood beneath the label should look different from the wood that has been exposed to air over many years. The covered portion will have experienced less oxidation and therefore will be lighter in color than the remainder of the wood. This rule holds true for all areas that have had differing degrees of exposure to air, regardless of whether an object is labeled. Unvarnished drawer sides, for example, are darker in front where air, debris, and the oil from owners' hands all combine. The rear part of the drawer, on the other hand, would have experienced less handling and less exposure to air, which accounts for the graduated color on the true period drawer side.

Labels that state a name and perhaps an address with no other identifiers can be further cause for alarm. Many a collector has been duped into accepting a label only to find out at a later date that the individual whose label it was supposed to be was never in the furniture trade. Label-hungry collectors have often been led astray by attaching too much importance to one component when others within the same piece may have been sending a conflicting message. Never accept a label as complete verification, no matter the source. Intent to deceive aside, dealers, museums, and auction houses occasionally err in the identification process. City directories, newspapers, and town records can often confirm or deny a hunch about whether the name on the label was truly that of a cabinetmaker. Many historical societies have published lists of known cabinetmakers and will readily share this information with the public. Approach each piece, especially those with easy to fake labels and inscriptions, with suspicion. The catch phrase is "guilty until proven innocent."

Inscriptions come with their own set of problems. While they are coveted for bringing one closer to the spirit of the maker, they may not be the true inscription of the maker. Rather, they may have been added much

later to enhance a piece. Alternately, inscriptions may have no relationship to the maker because owners often inscribed their furniture, as did other craftspeople, including those who repaired or restored the piece at a later date. A careful collector will assess each of these possibilities.

Another form of documentation relates to an object's provenance, or history of ownership. Provenance is any printed or verbal information relating directly to the object. In the market for American furniture, provenance influences value, and it is a general rule that, given two comparable objects, the one with the more interesting or desirable provenance will command a premium.

Offering a bill of sale is one way to convey provenance, but one that is ambiguous or incomplete can be problematic. A bill that generically describes tables or chairs without specific details could be describing virtually any table or chair in a household from a Pilgrim-era turned chair to a Victorian balloon-back chair. A faked bill of sale is an easy way to lend historical significance and status to an otherwise uninspired work. An original bill of sale can be authentic to the period in question but not related to the object in question, or it can be totally fake. Unless a bill of sale can be documented as corresponding with a high degree of certainty to a specific piece, it is really no bill of sale at all. Genuine bills of sale either lock in a location and possibly a date of manufacture or are highly specific in their description of the items. Similar standards should apply to later bills of sale, such as those pertaining to an alleged second or third owner; namely, they must be as precise as possible in identifying the object in question. Other printed documentation, including wills, that record the passing of furniture from one individual to another can be of value in tracing provenance—if the details they provide are explicitly related to the object.

Verbal provenances present yet another set of problems. Far too many individuals have placed faith in verbal histories or attributions. As a result, there are some objects circulating in the market that have mysteriously acquired incorrect lineage. Never assume a verbal history is entirely accurate. Many deceitful individuals prefer to fabricate verbal provenances since they are more difficult to pin down. It's far easier to separate oneself from a false word-of-mouth statement should a problem arise. Further, don't assume that because a piece of furniture was once part of a prominent or public collection that it is what it alleges to be. Museums discharge collections for other reasons than the pieces not conforming to the institution's acknowledged collecting interests. They also sell their mistakes. The topic of provenance is discussed in greater detail later in this section.

TECHNOLOGICAL OR SCIENTIFIC EVIDENCE

Using scientific or technological evidence can help confirm or deny authenticity. Cut nails used in furniture purportedly dating from before 1790 are cause for apprehension, because wire and round-headed nails were not used in furniture until the last quarter of the nineteenth century. Prior to that time, irregularly shaped rose-headed or hand-forged nails were used consistently. These are important technological details that can alert the collector to trouble, but old nails do not alone confirm period authenticity as they can be salvaged and reused. They can, however, be examined to establish whether the wrought nail has been in place for an extended length of time. Corroding wrought iron called ferrous oxide blackens the wood surrounding the area in which it has been residing. Due to warping and shrinkage of wood, many of these fasteners are now no longer flush with the surface.

Technological innovations such as the X ray have long been used in the medical community with great success, but their value to the decorative arts is relatively new. Used mostly by scholars working in the field, X rays have revealed hidden round dowel joints that now replace the older and stronger mortise-and-tenon joint. Modern machine-made dowels (a wooden pin that prevents slipping between two parts) signify at the very least a repair, if not a much later work in its entirety. Black or ultraviolet light has been used successfully to spotlight later applications of paint to an original surface. Later additions of paint fluoresce differently than the original work, often revealing telltale black patches where restoration has occurred. Accessing X-ray machines and ultraviolet lights requires unusual effort and is not commonly used by individual collectors. This technology should be employed only in special cases after other, less laborious methods of authentication have been exhausted and when large amounts of money are involved.

The science of wood, including its species, how it ages and warps, and other characteristics such as hardness or softness, is a complex one—one that requires more time and space than this text allows. Suffice it to say that the ability to recognize the most commonly used primary and secondary woods is a useful tool not only for connoisseurship purposes but also for the authentication process as well. Microanalysis of woods, whereby a small sliver of wood running with the grain is taken from an inconspicuous spot and analyzed to determine its species and place of origin, has added an additional level of confidence to many scholarly attributions. This technological innovation has recently helped to recategorize some American antique furniture. Unlike X rays and ultraviolet lights, microanalysis is available to a wider audience through many state agricultural offices or extensions, although it, too, should be used with discretion. Before attempting to take a sample, check to see if the individual or institution offering the furniture item for sale has already had

microanalysis done. If the test has already been performed, the resulting information should be shared with a potential purchaser. Most tests are done using a very small sample. In any case, check with a professional in the field for the correct procedure before removing anything for testing.

As previously discussed, unfinished wood darkens with age. Secondary woods need to be examined for the mellow color they acquire with hundreds of years of service. Each part should be analyzed in relation to its source of air. Surfaces closest to the source of air will darken more. Use common sense to determine the color changes you find. The artificially aged color acquired through the use of stain, coffee, or tea is frequently too uniform and opaque in consistency to replicate nature's effects. Untreated wood—used on all secondary surfaces such as drawer sides and bottoms—does not darken when exposed to air; it remains clear, with a grain. It doesn't take on the cloudy, opaque appearance that altered pieces do in their deliberate attempt to hide new wood with stain.

Finish makes another statement about authenticity. Unfortunately, most antiques no longer display their original finishes. When the trend called for a high-gloss sheen, some pieces were stripped to within an inch of their lives, taking away years of patina—matured, encrusted coloring. Most stripping occurred earlier in the twentieth century, when the value of the original patina was not yet recognized by collectors. It occasionally happens today in the hands of an incompetent restorer. Furniture with a glaringly high-gloss finish is inferior to an old, carefully executed refinish or a new finish that shows respect for the history of the object. Seasoned collectors favor pieces with more conservative refinishing that leaves some of the rich patina supplied by years of wear and waxing. On these items the personality of the finish remains. In some styles, the quality of the finish is paramount; for example, the colonial styles and Arts and Crafts pieces can be significantly devalued by a poor finish. Historical societies, dealers, and museums are often good sources for names of quality restorers.

Sight, Sound, and Touch

Technology-driven analysis is not always necessary when authenticating American furniture. Just as with the squint test used for identifying style, the informed collector can use his eyes, ears, and hands to good effect when investigating a potential treasure from the past. All furniture, no matter how lovingly it has been preserved, shows signs of normal wear and tear inflicted through generations of use. It would be extremely atypical to find a piece in perfect condition, and one should approach with caution an object that looks as if it just walked out of a cabinet-maker's shop. Chances are it just did—perhaps the result of a heavy dose of aesthetic surgery. Wear and tear is indicative of age, but it doesn't oc-

cur in the exact same way for all pieces. Depending on different patterns of usage, a piece will show its age in one spot and not another. Finishes, for example, show uneven wear due to the differing degrees of sunlight to which parts have been exposed. Fakers often forget these principles when they alter a work or compose a fake. An individual can use his or her hands to feel for the gentle rounding that softens sharp edges on tabletops or on arm supports over two hundred years. Again, this is something that is object-specific and something that doesn't show up well in photographs. It must be experienced firsthand.

Some experts devise tests based on what they know about period furniture. In the "shake test," for example, sleuths check so-called period chairs for a degree of movement or yielding. Due to warping, shrinkage, and general loosening of joints, most old chairs have some movement response. Totally unyielding models are suspicious. Conversely, in case work, rubbing sounds signal wear, where wood is moving against wood. When a wear spot is detected, it should have a corresponding point of contact or friction. An informed collector will touch every piece he evaluates. This practice is extremely helpful in determining authenticity. While it would be inappropriate in a museum setting, it is a common sight at auction previews, for example, to see collectors, dealers, and scholars opening drawers, turning chairs upside down, or using a flashlight to look in and under case pieces for any clues of possible adulteration.

WHAT TO LOOK FOR IN REPAIRS AND RESTORATIONS

The subject of repairs and restorations is a complex one that requires time to master. Listed below are some of the more commonly occurring major repairs and restorations to American furniture. The presence of one of these major repairs or alterations might eliminate such a piece from the discerning collector's consideration. Watch out for:

CASE WORK

- Replacement of one or more legs
- Splicing; shortening or building up of legs
- Enhancement through carving or reshaping, especially on apron, drawers, or top
- Reduction of case to accommodate smaller living quarters
- Change in shape from one form to another, such as from flat surface to blocked
- Conversion of flat-top case to one with arched pediment
- Marriages of old tops and bottoms that originally belonged to other objects
- Replacement or enhancement of original pediment
- Replacement of one or more doors or drawers
- Replacement of turned legs, stretchers, and feet
- Total replacement of veneered surface
- Re-inlay of large areas

- Replacement or embellishment of interiors
- Replacement of lids
- Replacement or addition of tambour (sliding wood) doors

SEATING

- Replacement of one or more legs
- Reshaping of seat frame into more desirable shape, such as balloon shape
- Replacement of stretchers
- Replacement of splat
- Replacement or enhancement of crest rail
- Embellishment through carving of crest or legs
- Replacement of arm supports
- Addition of arms to create armchair out of side chair
- Reshaping of arms, wings, or crest rails on wing or easy chairs
- Reshaping of crest rail, arms, or seat frame into more desirable forms on sofas

TABLES

- Replacement of feet, legs, stretchers, or drawers
- Reshaping of tops, leaves, or apron
- Replacement of stretchers or gates, tops, or leaves
- Reshaping of pedestal
- Enhancement of form through carving of base or legs
- Replacement of top
- Re-veneering, re-turning, or a large amount of restoration to frame
- Marriage of disparate top and pedestal or base
- Embellishment through inlay

Those American antiques that are most coveted are those that are best preserved. Since finding such examples is virtually impossible due to the fact that furniture made in the past was never intended to survive in perpetuity, then those forms with honest repairs are acceptable. What constitutes honest and acceptable repairs differs within the professional and collecting community, but certain repair standards are generally acknowledged. Honest repairs are considered those that are either meant to stabilize a piece that would otherwise be lost, or are those that faithfully resurrect, from evidence or from similar examples, features that have been damaged. The purpose of repair and restoration is to assure the remaining integrity of the object, not to enhance or alter it into a more desirable form for profit, as may be the case with frauds.

Replaced drawer pulls are usually considered acceptable repairs. Most case furniture has lost its hardware at some point during its life-span. Replaced brasses, therefore, are not at all uncommon, and if the replacements are sensitively conceived, with the original pulls in mind (perhaps from a remaining pull), they are acceptable. Needless to say, something as simple as placing reproduction brasses of the wrong period on case work can alter an object's marketability, and absolute purists may be content with a case piece on which only several original pulls are present and no attempt has been made to reconstruct the lost ones. Collectors in the American marketplace accept far fewer repairs and restoration than do collectors of other artifacts.

Common sense and patterns of usage suggest that feet are the most susceptible parts on many forms. They can be ravaged by moisture, breakage, and years of abuse inflicted by constant contact with the floor. A careful and respectful replacement of one foot based on three remaining examples would be preferable to four replaced feet with no precedent. And it would be far more acceptable to find deliberately new wood shoring up the bottom of a case piece or securing seats than to find totally replaced legs or seat frames. These are only a few examples of what might constitute an honest repair or restoration. Just as it takes time to develop connoisseurship skills, it takes practice and patience to understand the fine line between honest repairs and scurrilous alteration. Within the confines of the market, collectors must ultimately decide what they can tolerate. Some collectors are more willing than others to live with an object that has been repaired; others will pass it by in the hope of finding an example with fewer fixes. You must decide what is personally acceptable to you.

\mathcal{H}OW TO UNDERSTAND VALUE

Another component that figures in the evaluation process is the issue of value. Some of the components that affect value have been analyzed in the discussion of connoisseurship and authenticity listed earlier. However, there are additional factors that beg to answer the question that began this section: "How can one understand the difference between an object that sells for $100,000 and one that sells for $10,000?" Collectors want to pay a fair price for their objects, whatever amount they have to spend, and a closer look at the topic of value will shed additional light on the evaluation process as it occurs in the marketplace. Collectors also need to understand the impact of the following criteria:

- design;
- quality;
- provenance;
- historical importance; and
- rarity.

DESIGN

These criteria all impact the value of an antique, and depending on the object being evaluated, some criteria have a greater degree of influence on value than others. There is no precise formula that one can apply to these criteria except to be aware that many permutations are possible. When analyzing design, remember what was stressed earlier: THE MARKETPLACE AWARDS THE ORIGINALITY OF DESIGN INHERENT IN THE PERIOD OBJECT. The remaining yardsticks are more subjective

and may or may not exist while the issue of originality of design is clear-cut; either the object has it or it doesn't.

QUALITY

Throughout the style chapters of this text, a recurring theme has been that quality counts. In the marketplace for American furniture, quality can be measured in terms of materials and workmanship. The highest value is registered for those pieces that employ both. By this point, it should be obvious that, given two pieces of the same period and form, the one fashioned with the better materials and craftsmanship will sell for more. Further, due to the economic vagaries that affect every market—including that of the arts—objects of the highest quality tend to appreciate more on the upside, and in a down market tend to either maintain their value or depreciate less than objects of lesser distinction. What the beginner should infer from this fact is that he should buy the best example he can find AND afford.

PROVENANCE

Some of the concerns about provenance have already been discussed in the object-specific checklist. From a value perspective, remember that a provenance is a written or verbal pedigree regarding a particular object's history that may increase its marketability or worth. Though not always obtainable or mandatory, a provenance can serve as an endorsement, especially if it points to authorship by an important maker or ownership by an important collector, or points to something that truly distinguishes the piece from all other objects of its kind. Following are some examples of what constitute provenance:

- an original bill of sale or receipt;
- correspondence relating directly to the object;
- citations in books or exhibition catalogues;
- a written, signed statement from a person who is engaged in the profession;
- newspaper or magazine articles discussing the piece; and
- verbal information provided by previous owners, their descendants, or professionals.

The challenge for collectors is to determine what a good provenance means to them and how much extra value this history lends an object. Some collectors are more interested in finding the right form than in having their purchases validated in the eyes of the public. In that case, a

provenance should assume a lower priority than overall quality of the object. Others in the marketplace attach a high degree of importance to provenances. This latter group includes museums, historical societies, and dealers. Whether you fall into the first category, the second, or somewhere in between, the most important point to bear in mind is that a provenance is no provenance at all if it is not verifiable. You can begin by checking whatever information you have on the furniture in question. For example, some collectors trace the family genealogies, death certificates, and inventory listings of probate records of the previous owners as far back as they can in hopes of finding a paper trail or some other type of additional documentation about the object. This information can be helpful in bringing forth names of family members who may have inherited the furniture, acquired other pieces from the same estate, or own examples similar to the one being researched. Genealogical librarians can sometimes guide research efforts in a direction you may not have thought of taking on your own. Additionally, exhibition histories can be helpful; major art libraries maintain exhibition catalogues, many with photographic images. Information obtained from exhibition catalogues is often more detailed than that provided in auction catalogues, in which space is so limited. As you search, keep in mind that dealers and auction houses don't always have the resources or the time to check every detail, and in some instances they will not divulge information because they are protecting a source or respecting an owner's wish for anonymity. In this case, you may be able to obtain some information by asking the dealer or auction house to request details on your behalf. In your quest to confirm provenance, no detail should be considered too insignificant for it may be the missing information you are seeking. A question as simple as "Do you know anyone else who can provide me with additional information?," when asked of a previous owner, dealer, curator, or department expert at an auction house, can often yield important clues for further investigation. Remember that any action you can take to confirm and establish a solid provenance can result in an upward valuation of the piece. Generally, the older the object, the more effort a potential purchaser will need to expend on the investigation. As a bonus for your diligence, however, you may find that the piece has a more interesting history than when it first came to your attention.

HISTORICAL IMPORTANCE

Historical importance can be closely related to provenance. For example, a Federal period chest-on-chest made in Salem for a prominent shipping magnate and his family and passed down through that family has a history that becomes part of its provenance. But the chest also has

historical significance, because it represents an object of material culture as expressed in one of Federal America's most important cities. Another way to evaluate historical importance is to evaluate significant occurrences during the time frame in which the object was created. A chest made by an individual cabinetmaker in the Federal period, when America was in its political infancy, logically carries more historical importance than a machine-assembled object made in a large-scale Victorian factory. The Federal chest has also gained historical importance by virtue of having survived almost two hundred years.

How a work fits in an artist's *oeuvre*, or body of work, can also be analyzed for its historical importance. A fully blown Queen Anne high chest with scrolled pediment is more historically significant than a flat-top high chest by the same maker done several years earlier, because it is a more fully realized expression of the Queen Anne format. Separately, given two examples of carving by the same artist, the first, depicting a flowing, spirited arrangement that compliments the area to which it is applied, is considered more historically important than a second example with flatter, less animated carving. This second example is not considered as desirable inasmuch as it is not as well integrated with the form and because it lacks some of the technical depth of the first example.

RARITY

Remember what was stated previously: A TRUE RARITY IS UNLIKELY. Most pieces of American furniture display consistency of joinery, cabinetmaking, or ornamental techniques. When the term "rarity" is used today, it more accurately signifies that few examples of the form are extant, not that the object was necessarily a rarity when first produced. It is known, for example, that the most abundant seating form in Pilgrim-era furniture, the simple joint stool, has not survived due to the frequently rough treatment it received as an object of everyday use. Consequently, it is rare to find one. This "rarity," however, does not necessarily translate to a higher price. Today's marketplace would place a larger premium—and therefore a higher price—on a seventeenth-century wainscot or great chair, due to its prestigious association with important figures of the past, than on an object of everyday use such as the joint stool.

MISCELLANEOUS AND INTANGIBLE FACTORS

Before deciding to purchase American furniture, don't forget to consider the more abstract issues that influence the evaluation process. Important points to consider include:

1. As sophisticated as it has become, the American decorative arts marketplace is still governed by extraneous, immeasurable variables, including matters of personal taste.
2. The relationship between a piece of antique furniture and its price is not always obvious. What is considered a fair price varies from one collector to another, and there are no formulas or precise standards for pricing furniture.
3. American furniture is a commodity like any other, but purchasing it for investment purposes or in the hopes of cashing in on a trend is a downright perilous proposition.

This last point deserves special attention. Since the marketplace for American furniture is subject to some of the same economic ebbs and flows that influence disposable income, it would take an omniscient investor to predict with accuracy the timing and direction of these shifts. Compared to stocks, bonds, or other financial investments, antiques—or real assets—do not lend themselves well to the standard financial equations used to ascertain value in capital markets. The danger of this approach was illustrated by what happened in the fine arts market in the late 1980s. Many collectors were attracted to two so-called hot collecting areas: Impressionist and contemporary paintings. Both genres appeared on the surface to be experiencing rapid escalation in value. Many new and unsophisticated collectors entered the market, lured by the potential of making some quick money by buying works and then turning them over at higher prices. Many of these speculators wound up paying inflated prices for assets that were not liquid or had to accept less for the works when they needed to sell quickly. What happened?

While some outside economic factors were at work that helped precipitate these events, some market-specific observations can be made. Art is not liquid and should never be evaluated as being so. Second, there is a distinction between real increases in value (put forth by experts in the field) and artificial increases in value based on hype or artificial price setting (by some auction houses or dealers who arbitrarily raise estimates and prices in the hopes that someone will take the bait). Unsophisticated buyers can easily get trapped in this negative scenario. Last, recall that the marketplace rewards quality. Many works of art that were acquired during the 1980s spend fest were not the best examples of their kind, and consequently they were harder to turn over in a discriminating market. Some of the same factors are at work in the market for American furniture. One of the lessons to be learned from occurrences such as this is that it is far easier on the nerves—and the pocketbook—to live with and enjoy a purchase than it is to constantly try to anticipate or predict the market, or to purchase with some specific return in mind. The ultimate "return" should be your enjoyment. NEVER BUY FURNITURE OR ANY OTHER ART FOR INVESTMENT PURPOSES.

FAIR MARKET VALUE

As previously mentioned, collectors want to pay a fair price, regardless of the amount they have to spend. Not only must collectors decide what their limits are in terms of how much they can spend and what factors influence value, but they must also decide whether what they're being asked to pay is reasonable. At the heart of the matter is the issue of how the seller arrived at the asking price. Asking prices do not always reflect reality, nor do they make a definitive statement about what the piece is truly worth: Some dealers build in higher profit levels, and auction houses often provide high estimates because their motivations include luring new sellers with comparable examples. Conversely, sometimes estimates are set low to attract potential bidders to the sale. No matter what the underlying intent of the seller, a buyer must establish his or her own fair market value. There are several methods that seasoned collectors use to determine fairness. These include:

SALES HISTORY

Obtain from the seller previous sales results (including dates and dollar amounts) for pieces that are nearly identical or by the same maker. Another important step many beginners don't take is finding out which other professionals are selling or have sold objects like the one they are contemplating purchasing. These details give the potential purchaser the "breadth of the market," an indication of the strength, weakness, and size of the market. For example, the fact that only one dealer offers for sale furniture by a particular maker or is the only purveyor of a particular style may say something about value and resale potential in the market, or it could indicate that these objects are so collectible that they rarely come to market. Along similar lines, keep in mind that wide disparities in prices are a clue that further research needs to be done. These disparities can mean many things, among which might be a question about authenticity or quality. It's important to find out which scenario is accurate. Therefore, it is necessary to account for sporadic price history. Reputable dealers will provide potential purchasers with enough market-specific information so that they can determine independently that the asking price reflects fair market value.

AUCTION CATALOGUES AND PRICE LISTS

Another way to answer the question "Is this a fair price?" is to examine what may be happening in other segments of the market, namely the auction world. Checking the auction record for the type of furniture you

are thinking of purchasing is an excellent way to assess the breadth of the market. By their very nature, auctions are considered somewhat neutral, with the potential to bring together many buyers and sellers in an open market. In a snapshot, they can convey a lot about the overall strength of the market. It is a fact of the auction process that when particular pieces sell at record prices, similar objects soon come to light (fakes and frauds excluded) that may not have been previously known.

Using auction catalogues and price lists can prove helpful in the investigative process of determining fair market value. Catalogues list all the pertinent information relating to an object coming up for sale, and price lists record the sales information for the object after the auction has been held. Auction houses have these records in their own libraries and may permit you to access them. Most public institutions, including libraries and museums, have catalogues and price lists that beginners can use. For current auctions, interested parties can subscribe to auction catalogues by contacting the auction house. Even if you never show up at the specific auction, catalogues can be a very valuable resource. From catalogues and price lists you can:

- check for price results, starting with the most recent auctions, for the type or piece of furniture you are considering, then work backward until you have enough information to establish the breadth of the market;
- compare as many similar examples as possible to the one you are evaluating;
- obtain images of works by the same artist or sharing the same characteristics of the furniture you are researching;
- see how prices change over time;
- compare prices for furniture offered in the open market to that offered by private sources, such as dealers, other collectors, or art consultants acting on their behalf;
- follow a trail of information that may hold clues for further research; and
- make some generalizations about the market or the specific object.

PROFESSIONAL APPRAISALS

Any would-be collector can learn to assess the fair market value of the furniture they are considering purchasing. In some instances, however, one should rely on an unbiased source, namely a professional in the field who has no conflict of interest in the potential transaction and no financial commitment at stake. Unbiased sources can be found among dealers, other collectors, or other professionals who may be associated

with museums, historical societies, or organizations where American furniture is collected. Since they deal with evaluation and disposition of assets for their clients, banking and legal firms are another source for names of professionals who act in a consulting capacity.

One caveat: Should you seek the services of an unbiased adviser, make sure the individual has a working knowledge of the area in which you are seeking advice. In the realm of English and European furniture, for example, collectors are more forgiving of repairs and restorations than are collectors of American furniture. A professional has a certain responsibility to be conversant with a fact like this, and while the person may be knowledgeable about furniture in general, there is a big difference between knowing something about French Rococo and knowing its separate manifestations in English and American work. Avoid having interior designers make purchases for you, unless they are educated specifically in period American furniture, because some will go for a "look" rather than originality of design, historical significance, provenance, authenticity, or value—all of which are of paramount importance in a decision to purchase.

There are two specific instances when consulting an unbiased professional becomes practical: (1) when a collector has exhausted many of the resources listed above and either still has unanswered questions or can't locate enough information to make an informed decision, or (2) when a large amount of money is involved in the potential transaction. Standard fees for this service may be charged as a fixed amount or a percentage of the sales price. Common sense dictates that it takes time to cultivate a relationship with these individuals and that it wouldn't be economically justifiable to seek their opinion about every potential purchase, but the more informed a collector you become, the more visible these individuals will become as helpful consultants.

The American furniture market is a surprisingly small one, and seasoned collectors know who the trusted professionals are and the areas in which they specialize. Further, again due to the size of the marketplace, the unbiased party may in fact have direct knowledge of the object that is for sale, especially if it is a noteworthy work by a recognized maker. He may know something about the object's provenance or aesthetic merit from current scholarship that may not have reached the wider market yet. Last, should you prefer, some advisers will bid at auction or negotiate with the trade on your behalf.

*W*HERE TO ACQUIRE AMERICAN FURNITURE

Armed with the information listed throughout this text, the next step for the beginner is to determine the best places to acquire American furniture. For purposes of this discussion, there are generally three sources for buying American furniture: (1) dealers; (2) auction houses; and (3) flea markets, country auctions, estate sales, or private parties. While space does not permit the listing of every plus and minus for each of these sources, some of the general pros and cons listed below should help the novice focus on the source or sources that may be best, given such factors as time, temperament, and resources.

DEALERS

PROS

- Dealers often have more time and motivation to develop relationships with potential collectors.
- They specialize in the type of furniture they sell, so they usually have a good selection. There is a big difference between saying "I sell American furniture" and "I sell American furniture of the early colonial period."
- They have experience selling and researching the works.
- For the most part, dealers have their own capital tied up in the inventory, which motivates them to be knowledgeable.
- They will usually permit a client to view an object in the client's own setting before purchase.

- Dealers will often buy back or take on consignment furniture a client wishes to dispose of or trade up.
- Dealers have a vested interest in helping you develop as a collector.

Cons

- Dealers can be somewhat secretive about how they acquired a piece as they prefer to hide their sources from the competition. This secrecy, while it protects them, makes provenances difficult to trace.
- Occasionally dealers are the sole market for some styles, which can make re-sale difficult, especially if that dealer withdraws from the market.
- Sale prices are generally not published.

Important Summary Point: Patronize only those dealers who provide guarantees and are willing to work with you. Many dealers belong to professional associations, some of which are listed in Chapter 20, that set forth certain standards for the trade as a whole. Seek them out.

AUCTION HOUSES

Pros

- Auction houses often offer a great quantity of furniture that is "fresh to the market," meaning that it has not been shopped around to different dealers or has not been for sale in the market in the recent past.
- They can match a large group of sellers with potential buyers.
- Anyone can purchase at an auction—regardless of skill level—and individuals can compete for objects with dealers.
- Auction previews, where the furniture can be viewed prior to the sale, are open and available to any interested party; potential bidders can examine objects closely for authenticity and condition.
- Important information relating to such details as provenance or ownership is sometimes more forthcoming than from private sources.
- Larger firms have on-staff specialists who view hundreds of examples and can advise on such matters as condition.

Cons

- There is the risk of "auction fever," where potential purchasers get caught up in the bidding process due to competitive instinct or emotional excitement.
- Uneducated or manipulative bidders can create the false illusion of value.
- Due to the quick pace, some bidders experience artificial time constraints and feel pressured to bid or get locked out of the process.
- What you see is what you get. Everything is sold "as is." With few exceptions, there are no guarantees of quality or condition.

Auction Terminology

For the auction novice, the terminology can be confusing at first. It's akin to viewing a sporting event at which you don't know the rules governing the game. Be sure to check the auction catalogue for the important terms you need to know to both understand and bid for furniture. Some important terminology and points to bear in mind:

1. Pre-sale estimates are just that—estimates. They are an attempt to establish a low and high price range for an object, but be aware that they may have little impact on the final sale result or whether the object is sold at all. As emphasized in the section on value, an estimate is simply a starting point for further research and evaluation. Factors that can weigh heavily in the final hammer price, or the amount a piece sells for excluding any premiums (fees paid to an auction house to cover costs associated with marketing and selling an object), include the desirability of the object, who is bidding on it, and issues of authenticity. There is also the possibility that an object will gain status or desirability should the hammer price exceed the pre-sale estimate by a wide margin. This happens occasionally with highly coveted pieces that encourage furious and competitive bidding. In general, estimates are usually set so that bids will be forthcoming within—or above—a certain range. Auction houses often publish estimates because in their pre-sale evaluation process, they have determined the "reserve," a minimum acceptable price known only to the auction house and the consignor. If bidding ends below the reserve, the object is not sold. Theoretically this is the case, but don't be prompted solely by the estimate, for no sale is made unless a buyer willingly commits to it. Complete, to the best of your ability, independent research that confirms authenticity and value, then establish a bid that is your

best estimate of the fair market value—or have a trusted adviser do so on your behalf.

2. Items that fail to meet their reserve are "passed" or "bought-in" by the auction house to protect their reserves. In the auction price lists available after the sale, these items are not registered as sales. The result of a no-sale in the auction room itself is treated differently by the auctioneer depending on the rules established by the state agencies that govern such public sales. (Some auctioneers are more successful than others in shrewdly acknowledging that an object did not sell. Some seemingly mumble the word "passed" or say it so quickly that only the most observant attendees pick up on the fact that the object did not find a buyer.) As the purpose of the auction is to sell the merchandise, auction houses would rather not announce the number of no-sales unless mandated by law. Many professionals assess the success or failure of any given sale by looking at the percentage of lots (specific objects for sale) that did not sell and the performance of the lots versus their pre-sale estimates. This analysis is an important ingredient in determining the breadth of market mentioned above. In rare instances, objects that did not sell during the auction may sell in separate negotiations known as post-auction sales.

3. Be mindful that when a bid prevails and a purchase has been recorded at auction, the purchaser is required to pay a buyer's premium, usually 15 percent of the successful bid price up to a certain amount and 10 percent thereafter on amounts in excess of that price point. State and local taxes, as well as packing and transportation costs, must also be factored in since they can add significantly to the final cost.

Important Summary Point: Get in the habit of attending previews and sales for a while before buying. Before the sale, decide what is a fair price based on your research, establish a maximum bid, and stick to it. Know the rules governing each sale (listed in the front of the catalogue) as rules differ from state to state and from one firm to another. Patronize those firms that have department specialists in American furniture.

FLEA MARKETS, COUNTRY AUCTIONS, ESTATE SALES, AND PRIVATE PARTIES

Due to the highly transient nature of these sources, beginners are cautioned that acquiring authentic American furniture through these sources is a risky proposition. Realize that in many instances, the individuals engaged in offering furniture through these sources may have little

or no experience in the genre or in American furniture specifically. Anyone can conduct an estate sale or sponsor a flea market to raise money, and newspapers are full of ads promoting a weekend event at a high school, church, or public hall. This is not the forum where most established dealers offer their wares. And while some individuals are convinced that they can find a bargain at a country auction, keep in mind that even at an event that might seem unsophisticated, there are generally no bargains. Should a quality piece somehow find its way into the sale, there are frequently "pickers," individuals working on behalf of top-notch dealers and advanced collectors, there ahead of you. Endowed with deep pockets, they often prevail.

At these types of outlets, there is often no oversight network to ensure that the article for sale is a genuine object, and unscrupulous profiteers know how to take advantage. In contrast, at more established antique shows or auctions, there is always some degree of professional scrutiny, whether formal or otherwise, from fellow dealers or professionals whose full-time business it is to know the forms being sold. While purchasing through established sources is no guarantee—and the collector should always perform his own due diligence to confirm authenticity and value—it offers more protection than purchasing a piece of furniture from a source that won't be in the same location the next week should a problem arise. One final word of advice: As with other transient sources, sales between two private parties can be equally fraught with pitfalls if one or both of the parties lack the mandated experience or skills in connoisseurship and evaluation necessary to make an enlightened decision.

Important Summary Point: Use caution; think twice before buying.

These warnings aside, should you be determined to purchase furniture from the providers in this last grouping, remember to use the connoisseurship, authentication, and valuation protocols mentioned earlier. Recognize that furniture offered in these situations may be of dubious quality, have no provenance, or have authenticity questions, all of which will impact its value. In offerings of this type, labeling is sometimes nonexistent or may be limited to a price tag. This should be a clue: that which says the least may in fact be telling you all you need to know, whether it points to the seller's lack of expertise or—more likely—the fact that what he is selling may be of little value.

\mathscr{H}OW TO CARE FOR AND PROTECT YOUR AMERICAN FURNITURE

The same effort that went into the evaluation and purchase of a piece of American furniture should be devoted to its care and protection. Following are some general guidelines. On the issue of caring for a purchase, recall that the marketplace places a premium on those objects that are unsullied. Repairs and restorations, therefore, should be kept to a minimum—made only when a piece is in danger of deteriorating significantly without intervention. The current trend in restoration work is to take reversible action. For example, a new layer of finish or paint should be removable at some later date without damaging what remains of any original surface below. Reversible techniques allow for the possibility of new methods of preservation or repair in the future and are especially important with intricate treatments such as japanning. Repairs and restorations that seek only to enhance a piece or somehow change its character from the original design can border on tampering, especially if done for purely commercial reasons. Intent separates honest revision, such as trying to restore the integrity of a finish that was poorly done in the past, from outright tampering. Whereas the profit motive is never a reason to undertake restoration, trying to protect historical value or integrity of design is customarily justifiable.

As important as repair and restoration is knowing how to properly care for a piece of period furniture so that extensive restoration is not

required. Aside from normal wear and tear, the two most damaging assaults on furniture are: (1) wide fluctuations in temperature and humidity and (2) exposure to sunlight. As previously discussed in chapters on specific styles, some objects are more prone to damage from changes in temperature and humidity and, generally, the more processes or materials employed in construction, the greater the potential for damage. Warping, shrinkage, and splitting are just some of the outcomes of vacillations in environmental quality. Pieces that make extensive use of veneering with different woods having dissimilar shrinkage points, and pieces that have received special treatment, such as applications of paint, are highly prone to damage when the underlying structure pulls away from the veneered or painted surface. When the disparate materials making up a *papier-mâché* object—compounded paper, glue, paint, varnish, and possibly inlay—get damaged, restoration is difficult and sometimes impossible to accomplish. As a general rule, try to maintain a relatively constant temperature; it's the fluctuations that are most stressful on the woods, because they worsen any shrinking and swelling that occur as a natural consequence of the organic material. Use a humidifier, especially in the winter, when extremely dry air causes wood to lose moisture and split.

Sunlight bleaches and dries out wood and damages fabric. Nothing looks worse than a piece of richly colored mahogany that's been bleached by the sun. And any seating piece lucky enough to have survived with an old or original covering deserves even more consideration since extant examples are so few and far between. While wood can sometimes be repaired, once fabric deteriorates, it can be salvaged only by a costly and time-consuming process performed by an experienced textile conservator. The warnings about how dangerous the sun's rays can be to people can also be applied to furniture. The message is the same: Avoid exposure to sunlight. Some museums and historical societies have installed sun-blocking film on windows in an effort to shield their collections from ultraviolet light. This option, along with regular light-filtering shades available at the hardware store, may be justifiable should you amass a large collection of furniture or other susceptible collectibles, including textiles, paintings, or rugs.

RESTORATION

In the event an object is damaged somehow or you decide to purchase a piece that requires some stabilization, there is only one piece of advice to follow: Have a furniture restoration expert repair the damage. NEVER ATTEMPT TO REPAIR AMERICAN FURNITURE BY YOURSELF. The result can be disastrous for you and the object in question. Remember that what one collector might consider repair, another might

consider unnecessary, or, in the worst case, fraudulent. Unless they were artists themselves, few individuals would attempt to repair a damaged painting. The restoration of furniture is no different. It is a specialty that requires great practice to accomplish successfully. Given modern advances in technology that permit such miracles as separating finishes one layer at a time, there is no excuse for the novice to try it alone.

The additional benefit of seeking the advice of qualified restoration professionals is that they can often provide guidance in terms of what constitutes honest and acceptable restoration and what doesn't. Dealers, auction houses, historical societies, and museums can provide the names of qualified professionals who work with individual collectors, and some even have their own conservation departments. Further, the American Institute for Conservation of Historic and Artistic Works in Washington, D.C., may be able to provide you with the names of restoration experts working in your area. Conservators should be able to provide adequate references for the type of restoration you are seeking. Most experts will accept visits to their workshops, where they can document damage and advise on the proper repair. They may at that point also point out previous repairs. Besides repairing an object, the most helpful service a restorer can perform is educating a collector about what types of damage are easy—or impossible—to repair. Some professionals document furniture by taking "before" and "after" photographs. If this happens in your case, be sure to obtain copies for your own records. Two parting reminders: (1) The more damage there is to the furniture, the more the object is devalued and (2) the location of the damage is just as important as the amount. A large flaw in the veneer of a tabletop has a greater negative impact than a missing corner block on the inside of a seat frame.

RECORD KEEPING AND INSURANCE

Another way for the collector to protect a collection is to keep accurate records beginning with the purchase. Thought should also be given to insuring the furniture, which ranges from "self-insuring," in which the owner is solely responsible for the collection's care, repair, and replacement should some damage or loss occur, to a formal policy in which the owner pays a premium for coverage and the insurance company protects the collection against damage or theft. The self-insurance concept is not recommended unless a collector has unlimited resources with which to replace or repair his antiques in case a mishap should befall them. Be aware that some home-owners' insurance policies do not cover one-of-a-kind antiques. Should this be true in your case, you can still obtain a policy with a fine arts rider or a separate policy that applies exclusively to art objects. In essence, all of the decisions that you will

undertake to document and insure your furniture entail taking on some of the responsibilities of a curator. The following guidelines will prove helpful if there are ever questions of authenticity, damage, or theft, or if the collection becomes so large that it gets difficult to remember every purchase made over an extended period of time. Keeping accurate records also comes in handy if an object is sold as this material becomes part of the continuing provenance. Another caveat: Although it seems obvious, if you ever need the services of an appraiser, make certain he or she has experience appraising American furniture. For sources of professional appraisers, consult Chapter 21. Start a file from which you can easily get your hands on:

- receipts from the seller that reference the date, authorship, or any pertinent detail related to the object. Receipts must be as specific as possible. Be sure to hold on to guarantees.
- condition reports spelling out any noted repairs or restoration and where performed.
- materials relating to the furniture's provenance.
- photographs or videotape (dated) to be used in the event of loss or theft.
- correspondence or other information that pertains to pieces in the collection, including any proof of the age of the collection.
- written appraisals that may be done from time to time for insurance purposes.

Some of the procedures outlined in this section may seem daunting to the beginner, but with time and practice they become almost second nature. By following them, you will gain confidence with which to enter the marketplace. The objective of developing broad-based knowledge in issues of connoisseurship, authentication, and evaluation, as well as in knowing some of the ins and outs of where to purchase the best examples you can find and afford, is to make the process an enjoyable, exciting experience rather than one filled with trepidation and regret. As you pursue the objects of beauty known as American furniture, it will become easier to understand the complex factors that determine each piece's value to you individually and the marketplace as a whole.

SOURCES

*W*HERE TO VIEW AMERICAN FURNITURE

The best way to enhance connoisseurship in the field of American antique furniture is to view as many objects as possible. Following are some of the many institutions where American furniture can be found.

EAST COAST

Albany Institute of History and Art, Albany, New York
Baltimore Museum of Art, Baltimore, Maryland
Boscobel Restoration, Garrison, New York
Brooklyn Museum, Brooklyn, New York
Concord Antiquarian Museum, Concord, Massachusetts
Connecticut Historical Society, Hartford, Connecticut
Craftsman Farms, Morris Plains, New Jersey
Daughters of the American Revolution Museum, Washington, D.C.
Diplomatic Reception Rooms, U.S. Department of State,
 Washington, D.C.
Essex Institute, Salem, Massachusetts
Henry Francis du Pont Winterthur Museum, Winterthur, Delaware
Historic Deerfield, Deerfield, Massachusetts
Maryland Historical Society, Baltimore, Maryland
Metropolitan Museum of Art, New York, New York
Monmouth County Historical Association, Freehold, New Jersey
Museum of the City of New York, New York, New York
Museum of Fine Arts, Boston, Massachusetts
New Haven Colony Historical Society, New Haven, Connecticut
Newport Historical Society, Newport, Rhode Island

New York Historical Society, New York, New York
Old Sturbridge Village, Sturbridge, Massachusetts
Peter Foulger Museum, Nantucket Historical Association, Nantucket, Massachusetts
Philadelphia Museum of Art, Philadelphia, Pennsylvania
Pilgrim Hall, Plymouth, Massachusetts
Rhode Island Historical Society, Providence, Rhode Island
Rhode Island School of Design, Museum of Art, Providence, Rhode Island
Society for the Preservation of New England Antiquities, Boston, Massachusetts, and various locations in New England
Strawberry Banke, Portsmouth, New Hampshire
Wadsworth Atheneum, Hartford, Connecticut
Yale University Art Gallery, Mabel Brady Garvan and Related Collections, New Haven, Connecticut

SOUTH

Colonial Williamsburg, Williamsburg, Virginia
Grove Park Inn, Ashville, North Carolina
High Museum of Art, Atlanta, Georgia
Historic Charleston Foundation, Charleston, South Carolina
Museum of Early Southern Decorative Arts, Winston-Salem, North Carolina

MIDWEST

Art Institute of Chicago, Chicago, Illinois
Cincinnati Art Museum, Cincinnati, Ohio
Frank Lloyd Wright Home, Oak Park, Illinois
Henry Ford Museum and Greenfield Village, Dearborn, Michigan
Missouri Historical Society, St. Louis, Missouri
Museum of Fine Arts, Bayou Bend Collection, Houston, Texas
The St. Louis Art Museum, St. Louis, Missouri

WEST

Fine Arts Museum of San Francisco, San Francisco, California
Gamble House, Pasadena, California
Los Angeles County Museum of Art, Los Angeles, California

CHAPTER 20

*H*OW TO LOCATE DEALER AND TRADE ASSOCIATIONS

Art and Antiques Dealers League of America
353 East 78th Street
New York, New York 10021
(212) 879-7558

National Antique and Art Dealers Association of America
12 East 56th Street
New York, New York 10022
(212) 826-9707

\mathcal{H}OW TO LOCATE AMERICAN APPRAISAL ASSOCIATIONS

American Society of Appraisers
555 Herndon Parkway, Suite 125
Herndon, Virginia 22070
(703) 478-2228

Antique Appraisers Association of America
11361 Garden Grove Boulevard
Garden Grove, California 92643
(714) 530-7090

Appraisers Association of America
386 Park Avenue South, Suite 2000
New York, New York 10016
(212) 889-5404

New England Appraisers Association
5 Gill Terrace
Ludlow, Vermont 05149
(617) 523-6272 or (802) 228-7444

United States Appraiser Association, Inc.
886 Linden Road
Winnetka, Illinois 60093
(708) 446-3434

WHAT TO READ ABOUT AMERICAN FURNITURE

Aron, Joseph. *The Encyclopedia of Furniture*. 3rd ed. New York: Crown Publishers, 1965.

Bamberger, Alan S. *Buy Art Smart*. Radnor, Pennsylvania: Wallace-Homestead, 1990.

Boorstin, Daniel J. *The Americans: The Colonial Experience*. New York: Random House, Inc., 1958.

Bowman, Leslie Greene. *American Arts & Crafts: Virtue in Design*. Los Angeles: Los Angeles County Museum of Art, 1990.

Brooks, H. Allen. *Frank Lloyd Wright and the Prairie School*. New York: George Braziller, Inc., 1984.

Butler, Joseph T. *Field Guide to American Antique Furniture*. New York: Facts on File, Inc., 1985.

Cathers, David M. *Furniture of the American Arts and Crafts Movement*. New York: The New American Library, 1981.

Chippendale, Thomas. *The Gentleman and Cabinet-Maker's Director*. 3rd ed. London: Privately printed, 1762. Reprint, New York: Dover Publications, 1966.

Clark, Robert Judson, ed. *The Arts and Crafts Movement in America, 1876–1916*. Princeton: Princeton University Press, 1972.

Comstock, Helen. *American Furniture, Seventeenth, Eighteenth, and Nineteenth Century Styles*. New York: Viking Press, 1962.

Cooper, Wendy A. *In Praise of American Decorative Arts 1650–1830/Fifty Years of Discovery Since the 1929 Girl Scouts Loan Exhibition*. New York: Alfred A. Knopf, Inc., 1980.

Davidson, Marshall B. *The Bantam Illustrated Guide to Early American Furniture.* New York: Bantam Books, 1980.

————, ed., *Three Centuries of American Antiques.* Vol. I: *The American Heritage History of Colonial Antiques.* Vol. II: *The American Heritage History of Antiques from the Revolution to the Civil War.* Vol. III: *The American Heritage History of Antiques from the Civil War to World War I* (3 vols. in 1). New York: Bonanza Books, 1979.

————, and Elizabeth Stillinger. *The American Wing at the Metropolitan Museum of Art.* New York: Harrison House, 1987.

Downs, Joseph. *American Furniture in the Henry Francis du Pont Winterthur Museum, Queen Anne and Chippendale Periods.* New York: Macmillan, 1952.

Dubrow, Eileen and Richard. *American Furniture of the 19th Century 1840–1880.* Exton, Pennsylvania: Schiffer Publishing, 1983.

Eastlake, Charles L. *Hints on Household Taste in Furniture, Upholstery, and Other Details.* London: Longmans, Green and Co., 1868. Reprint, New York: Dover Publications, 1969.

Fairbanks, Jonathan L., and Bates, Elizabeth Bidwell. *American Furniture 1620 to the Present.* New York: Richard Marek, 1981.

Fales, Dean A., Jr. *American Painted Furniture, 1660–1880.* New York: E. P. Dutton, 1972.

Federico, Jean Taylor. *Clues to American Furniture.* Washington, D.C.: Starhill Press, 1988.

Flanigan, J. Michael. *American Furniture from the Kaufman Collection.* Washington, D.C.: National Gallery of Art, 1986.

Forman, Benno M. *American Seating Furniture 1630–1730.* New York: W. W. Norton & Company, 1988.

Garrett, Elisabeth Donaghy. *At Home: The American Family, 1750–1870.* New York: Harry N. Abrams, Inc., 1990.

Garrett, Wendell D. *Victorian America: Classical Romanticism to Gilded Opulence.* Rizzoli International Publications, Inc., 1993.

Grand Rapids Museum. *Renaissance Revival Furniture.* Grand Rapids: The Grand Rapids Museum, 1976.

Gray, Stephen, ed. *The Mission Furniture of L. & J. G. Stickley.* New York: Turn of the Century Editions, 1983.

Gruber, Frances. *The Art of Joinery: 17th-Century Case Furniture in the American Wing.* New York: The Metropolitan Museum of Art, 1972.

Hanks, David A. *The Decorative Designs of Frank Lloyd Wright.* New York: E. P. Dutton, 1979.

Hayward, Helena, ed. *World Furniture.* London: The Hamlyn Publishing Group Limited, 1965.

Heckscher, Morrison H., and Leslie Greene Bowman. *American Rococo, 1750–1775: Elegance in Ornament.* New York: The Metropolitan Museum of Art, 1992.

Hepplewhite, George. *The Cabinet-Maker and Upholsterer's Guide.* 3rd ed. London: I. & J. Taylor, 1984. Reprint, New York: Dover Publications, 1969.

Honor, William Macpherson, Jr. *Blue Book Philadelphia Furniture, William Penn to George Washington.* Philadelphia: privately printed, 1935. Reprint, Washington, D.C.: Highland House Publishers, 1977.

Horton, Frank L. *The Museum of Early Southern Decorative Arts: A Collection of Southern Furniture, Paintings, Ceramics, Textiles, and Metalware.* Winston-Salem, North Carolina: Old Salem, Inc., 1979.

Howe, Katherine S., and David B. Warren. *The Gothic Revival Style in America, 1830–1870.* Houston: The Museum of Fine Arts, 1976.

Hummel, Charles F. *A Winterthur Guide to American Chippendale Furniture: Middle Atlantic and Southern Colonies.* New York: Crown Publishers, 1976.

Jobe, Brock, ed. *Masterworks of the New Hampshire Seacoast.* Boston: Society for the Preservation of New England Antiquities, 1993.

———, and Myrna Kaye. *New England Furniture: The Colonial Era.* Boston: Houghton Mifflin Company, 1984.

Johnson, Bruce E. *The Official Identification and Price Guide to Arts and Crafts. The Early Modernist Movement in American Decorative Arts: 1894–1923.* New York: House of Collectibles, 1992.

Kane, Patricia E. *Furniture of the New Haven Colony—The Seventeenth-Century Style.* New Haven: New Haven Colony Historical Society, 1973.

———. *300 Years of American Seating Furniture: Chairs and Beds from the Mabel Brady Garvan and Other Collections at Yale University.* Boston: New York Graphic Society, 1976.

Kaye, Myrna. *Fake, Fraud, or Genuine?* Boston: Little, Brown, and Company, 1987.

Kirk, John T. *American Chairs: Queen Anne and Chippendale.* New York: Alfred A. Knopf, 1972.

———. *American Furniture and the British Tradition to 1830.* New York: Alfred A. Knopf, 1982.

———. *Early American Furniture: How to Recognize, Evaluate, Buy and Care for the Most Beautiful Pieces—High-Style, Country, Primitive, and Rustic.* New York: Alfred A. Knopf, 1970.

Makinson, Randell L. *Greene & Greene: Architecture as a Fine Art.* Salt Lake City: Peregrine Smith, Inc., 1977.

Manson, Grant Carpenter. *Frank Lloyd Wright to 1910: The First Golden Age.* New York: Van Nostrand Reinhold Company, 1958.

Montgomery, Charles F. *American Furniture: The Federal Period, in the Henry Francis du Pont Winterthur Museum.* New York: Viking Press, 1966.

Page, John F., and James L. Garvin. *Plain & Elegant, Rich & Common: Documented New Hampshire Furniture, 1750–1850.* Concord, New Hampshire: New Hampshire Historical Society, 1979.

Pierce, Donald C., and Hope Alswang. *American Interiors New England and the South.* New York: Brooklyn Museum, 1983.

Quimby, Ian M. G., and Polly Anne Earl, eds. *Technological Innovation and the Decorative Arts.* Charlottesville, Virginia: The University Press of Virginia, 1974.

Randall, Richard H., Jr. *American Furniture in the Museum of Fine Arts, Boston.* Boston: Museum of Fine Arts, 1965.

Rinker, Harry L., ed. *Warman's Furniture.* Radnor, Pennsylvania: Wallace-Homestead Book Company, 1993.

Sack, Albert. *Fine Points of Furniture Early American.* New York: Crown Publishers, 1950.

———. *The New Fine Points of Furniture.* New York: Crown Publishers, 1993.

Sack, Harold; Albert M.; and Robert M. *American Antiques from Israel Sack Collection.* 6 vols. Washington, D.C.: Highland House Publishers, n.d.-1979.

Schiffer, Nancy and Herbert. *Woods We Live With: A Guide to the Identification of Wood in the Home.* Exton, Pennsylvania: Schiffer Publishing Ltd., 1977.

Schwartz, Marvin D. *American Interiors, 1675–1885: A Guide to the American Period Rooms in the Brooklyn Museum.* New York: Brooklyn Museum, 1968.

Sheraton, Thomas. *The Cabinet-Maker and Upholsterer's Drawing-Book.* 3rd rev. ed. London: T. Bensley, 1802. Reprint, Charles F. Montgomery and Wilfred P. Cole, eds. New York: Praeger Publishers, 1970.

Spencer, Brian A., ed. *The Prairie School Tradition.* New York: Whitney Museum Library of Design, 1979.

Stillinger, Elizabeth. *American Antiques, the Hennage Collection.* Williamsburg, Virginia, 1990.

Stitt, Susan. *Museum of Early Southern Decorative Arts.* Winston-Salem, North Carolina: Museum of Early Southern Decorative Arts, Old Salem, Inc., 1972.

Toller, Jane. *Papier-mâché in Great Britain and America.* Newton, Massachusetts: Charles T. Branford, 1962.

Tracy, Berry B., and William H. Gerdts. *Classical America, 1815–1845.* Newark, New Jersey: The Newark Museum Association, 1963.

Vincent, Gilbert T. "The Bombé Furniture of Boston." In *Boston Furniture of the Eighteenth Century,* Walter Muir Whitehill, Brock Jobe, and Jonathan Fairbanks, eds., pp. 137–196. Boston: Colonial Society of Massachusetts, 1974.

Volpe, Tod M., and Beth Cathers. *Treasures of the American Arts and Crafts Movement 1890–1920.* New York: Harry N. Abrams, Inc., 1988.

Ward, Gerald W. R., and William N. Hosley, Jr. *The Great River Art & Society of the Connecticut Valley, 1635–1820.* Hartford, Connecticut: Wadsworth Atheneum, 1985.

Warren, David B. *Bayou Bend: American Furniture, Paintings and Silver from the Bayou Bend Collection.* Houston: The Museum of Fine Arts, 1975.

Watson, Sir Francis, introduction by. *The History of Furniture.* New York: Crescent Books, 1982.

Weidman, Gregory R. *Furniture in Maryland 1740–1940.* Baltimore: Maryland Historical Society, 1984.

Wilson, Richard Guy, introduction by. *From Architecture to Object. Masterworks of the American Arts and Crafts Movement.* New York: Dutton Studio Books, 1989.

————, et al. *The American Renaissance, 1876–1917.* New York: Brooklyn Museum, 1979.

Winterthur Museum. *Neoclassicism in the Decorative Arts: France, England and America.* Wilmington, Delaware: Winterthur Museum, 1971.

GLOSSARY

Aesthetic movement Late nineteenth-century movement that stressed simplicity of form and low-relief, stylized ornament. Largest component was art- or Japanese-inspired design taken primarily from Japanese print sources.

Apron Horizontal member below a case piece, seat, or tabletop that meets with legs. Also known as a skirt.

Arabesque Lacy patterns cut out of solid wood. Popular treatment on Rococo Revival chairs.

Arts and Crafts movement Late-nineteenth-century Design Reform philosophy that stressed the return of the artisan to furniture making. Simple, honest construction using oak and exposed tenons, pegs, and handwrought metalware, as well as architect-designed pieces, are its hallmark.

Balloon-back chair Popular nineteenth-century shape with a swollen, rounded shape that narrows at its juncture with the seat.

Baluster Upright support or turned vertical post, often resembling a vase or column. Also called a banister.

Banister-back chair Chair back made up of turned, upright banisters or balusters topped by a crest rail and supported by a lower cross rail above the seat. Popular eighteenth-century form.

Baroque Seventeenth-century design of European origin that stressed ornate and exaggerated forms. Important component of William and Mary and Queen Anne styles.

Bat wing Drawer hardware resembling the wing of a bat. Popular choice for eighteenth-century case forms.

Bentwood Laminated and steam-shaped wood, often birch, shaped by attaching the wood to metal strips with clamps for several days for the shape to take hold.

Birdcage support A supporting section of a tilt-top table, comprised of two blocks with columns between the top and base, that allows the table to tilt and pivot.

Block front Exclusive to case forms with a front divided into three vertical sections; the center section is concave and the two flanking sec-

tions are convex. Popular in Newport and Boston case work of the eighteenth century.

Bombé Also called a kettle base. Case pieces of this shape have bases that are rounded with bulging sides. Found extensively on Chippendale furniture made in the Boston area.

Bonnet top A pediment on case pieces that forms a hood or top. Popular in colonial furniture of the Queen Anne and Chippendale styles.

Boss Raised, applied ornament of oval or round shape found on Pilgrim-era case furniture. Also called a jewel.

Boston chair Period term used to describe a leather-upholstered chair that was the linchpin of the Boston furniture trade. Form shipped throughout the colonies.

Boulle work Process credited to André-Charles Boulle that implanted wood or exotic materials in a surface for embellishment. Primarily a Baroque inlay technique, it enjoyed a revival in Empire designs, especially with brass.

Brewster chair A turned chair of the Pilgrim era with spindles in the chair back and below the seat and arms. Named for a like chair owned by Elder William Brewster of Massachusetts.

Bun foot A turned foot that is slightly compressed on top and bottom. Popular treatment on late Pilgrim and William and Mary pieces.

Butterfly table Descriptive term for winged brackets that support the large leaves on a small drop-leaf table. Form especially popular in Connecticut William and Mary pieces.

Cabriole leg A curved leg with an out-curved knee and an incurved ankle in the shape of an inverted S-curve. Usually terminates in a pad or claw-and-ball foot. Appears frequently on Queen Anne and Chippendale furniture.

Carver chair Named for a chair once belonging to Governor John Carver, the seventeenth-century form has spindles only on the back.

Case furniture Based on the box shape, case pieces are used for storage.

Chest-on-chest Case form made of two separate chests placed one on top of the other and meant to function as one object.

Chinoiserie Name given to Western interpretation of Oriental motifs. Popular in William and Mary, Queen Anne, and Chippendale styles.

Chippendale A highly ornamental style popular in America from the mid-eighteenth century until the Revolution and incorporating elements from the Rococo or modern French, mixed with Gothic and Chinese novelties. Irregular and naturalistic forms predominate.

Claw-and-ball foot A carved foot that depicts a claw grasping a ball. Popular terminus for cabriole leg, appearing in many regional variations in colonial America.

Colonette Miniature column used ornamentally on furniture to imply support.

Commode A low chest of drawers or cabinet based on a popular French form and not often found in American cabinetmaking.

Compass seat Also called a horseshoe seat. The term *compass* was coined from the flared outline made by a compass tool.

Corner chair Chair with one leg in front, one in rear, and one at each side. Also known as a roundabout chair, it was often paired with a desk.

Cornice Horizontal molding that projects from the top of the case piece to which it is attached.

Cornucopia A horn-shaped container filled with flowers and fruit. Often affixed horizontally to early to mid-nineteenth-century forms.

Cottage furniture Moderately priced factory-made furniture on which Elizabethan spirals are reduced to simple ball turnings. Most cottage pieces are gaily painted to cover an inexpensive base wood or to conceal mediocre workmanship.

Credenza Low-slung horizontal cabinet based on Renaissance models.

Crest rail Horizontal top rail of a chair or sofa. Shape depends on prevailing style, but many are elaborately curved.

Cromwellian chair Alternately called a farthingale chair and it is an armless square form, resembling a stool, with an upholstered back. Popular in seventeenth century.

Cupboard Status case form in seventeenth century. Models with enclosed storage space above and an open shelf below are called court cupboards while models with enclosed upper and lower storage areas are called press cupboards.

Daybed A multilegged armless lounge chair also called a couch. Usually upholstered or covered with cane or rush, it was used for repose during the day. A popular form of the William and Mary period.

Dovetail The pattern that is formed from interlocking flared tenons that resemble a dove's tail. Cabinetmaking technique used in modern furniture beginning with the William and Mary period.

Ears The projections on Chippendale period chairs that curve outward where the crest rail or horizontal member meets the stiles or vertical members of the back.

Easy chair A wing chair once used exclusively by the elderly and infirm, this padded and upholstered chair was usually used in the bedchamber beginning in the William and Mary period.

Ébéniste French term for a cabinetmaker skilled in the high style of furniture making based on codes established by guilds.

Églomisé Decorative reverse painting on glass. Popular ornamentation on early Neoclassical furniture of the Federal period, especially in Baltimore.

Elbow chair Period terminology for an armchair.

Elizabethan Revival Victorian style of the 1840s featuring spool turnings. Low-end, mass-produced pieces in this style were part of the furniture type called cottage furniture.

Empire The second stage of Neoclassicism characterized by an increased awareness of archeological accuracy in furniture design from 1815 to 1840. French Empire and English Regency styles were multiple influences.

En suite Term used to refer to furniture made as companion pieces to other forms.

Étagère French term for Victorian display piece used to house collectibles on a series of shelves.

Fancy furniture Objects painted with polychrome paint and depicting floral motifs or scenery. Popular in Baltimore furniture of the Empire period.

Fat classical Furniture of the late Empire period characterized by swollen forms of classical inspiration.

Federal First stage of Neoclassicism in America coinciding with the formation of the federal government. Forms are geometric in shape and fine in scale.

Finger-rolled carving Unadorned rounded molding that decoratively outlines a shape.

Finial Carved or turned decorative element of various shapes used as a crown in case work. A pendant finial drops downward and is usually found on the apron or skirt of case pieces.

Flemish scroll Primary decorative device of the William and Mary period. Found mostly on chairs, shape is formed with C- and S-scrolls.

Fluting Parallel horizontal concave channels used as a decorative finish.

Fretwork Decorative open-work pattern formed from the fretsaw or carved. Popular treatment on tops and sides of case work, especially in the Chippendale format.

Gateleg table A drop-leaf table with legs connected by stretchers. The legs act as swinging gates and extend to support the top. Models without stretchers are called swing-leg tables.

Gilding Decoration made from gold leaf or gold powder.

Gondola chair Also a chair *en gondole*. Design of the Restauration era with an open back and a wide, solid back splat. The upright stiles forming the back curve downward to form supports for the arms.

Gothic A novelty of the Chippendale style drawing on several periods of English architecture and incorporating the skeleton framework. Novelties included pointed arches and foils, often mixed with Chinese and Rococo elements. Elements revived in Victorian furniture of the 1840s and in limited degree in Design Reform furniture of the late nineteenth century.

Grisaille Monochromatic tones of gray paint used on the Dutch *kas* to simulate the floral carvings of expensive European models.

Hadley chest Seventeenth-century case piece named for the Hadley area of Massachusetts in the upper Connecticut River Valley. Fea-

tures drawers of joined construction and three-panel front carved with meandering floral motifs.

High chest Case piece in two sections, the lower portion standing on legs. Considered the status object in eighteenth-century households, its modern name is highboy.

Hunt board A long, high table of shallow depth popular in some southern locales. Originally a board or frame from which to serve drinks after a fox hunt. Called a sideboard when combined with drawers or cabinets.

Hunzinger chair Chairs patented by George Hunzinger, usually with folding mechanism and a cantilevered seat.

Incising Shallow linear decoration originating in the machine age. Machines moved along a surface chipping out the design and filling it in with paint or gilding.

Inlay A decorative treatment set into the surface that uses wood or other materials to form texture or bands of color (stringing), pictorial images (marquetry), or geometric shapes (parquetry).

Innovative Label used to describe late nineteenth-century furniture that relied on technology, mechanical contrivance, or exotic materials.

Jacobean Related to the reign of King James I (1603–1625) in England, this term is occasionally used to describe American furniture of the seventeenth century.

Japanning Western practice of imitating Oriental lacquerwork. A wood base was covered with paint, and motifs were built up with gesso and then gilded or silvered. A fragile process, the technique was popular in the early to mid-eighteenth century, especially in Boston.

Joinery Seventeenth-century practice of constructing objects based on the mortise-and-tenon joint. A tenon, or tongue, was fitted into a mortise, or hole, at right angles and secured by a pin or peg.

Kas Made by settlers from the Low Countries for the Dutch inhabitants of the New York area, a large wardrobe or press with heavy raised and carved panels or painted surfaces.

Klismos A side chair first designed by the ancient Greeks with a concave curved back and splayed legs. Became the prototype for the majority of Empire seating forms.

Kylix Flat or low-profile urn shape popular in classical designs.

Lamination The nineteenth-century process practiced by John Henry Belter and his followers whereby they pressed and glued together extremely thin strips of veneered wood that were then steamed and pressed into a very durable form.

Lolling chair A specialty of New England cabinetmakers, an armchair of the Federal period with a high upholstered back and seat and exposed arms. Also called a Martha Washington chair.

Lowboy Modern term for a low case piece on legs often made *en suite* with a high chest.

Marlborough leg A straight, square leg, sometimes ending in a blocked foot; prevalent on Chippendale forms.

Méridienne A sofa of asymmetrical form, based on French examples, with one arm lower than the other.

Monopodium An animal foot and head in a single arrangement based on ancient models. Found frequently on case pieces of the Empire era.

Mortise-and-tenon A system of seventeenth-century joinery that fitted a tenon, or tongue, from one piece of wood into a mortise, or hole, on another piece, the joint of which was secured by a peg.

Neoclassicism Nineteenth-century trend in furniture design that sought inspiration from antiquity. Progressed through three stages in America: Federal, Empire, and Restauration (or Pillar and Scroll).

Ogee An S-shaped molding. Also called a cyma curve.

Ormolu Bronze decorative mounts covered in gilt and appearing on many Empire designs, especially in the work of Charles-Honoré Lannuier.

Oxbow front Also called a reverse serpentine curve, the oxbow moves first out, then in, and then out across the surface. Popular treatment for Chippendale case pieces.

Pad foot Gentle rounded or oval foot found on Queen Anne and occasionally on Chippendale legs as terminus for cabriole leg.

Paintbrush foot Carved treatment for foot in the shape of bristles on a paintbrush. Also dubbed a Spanish foot, although the true origin of the foot is Portuguese.

Papier-mâché Innovative process resulting from compressed ground paper pulp and glue.

Patina The texture and color of a finish on antique objects resulting from years of wax, dirt, and oxidation.

Pattern book Design renderings targeted to cabinetmakers that helped disseminate specific styles beginning in the Queen Anne period and continuing to the twentieth century.

Paw foot Carved to represent an animal's paw; used infrequently on very high-style American Chippendale pieces but more commonly appearing on English furniture. Reappeared in swollen form during the Empire period, the largest forms of which were called "fat classical."

Pedestal table Tables with a columnar base derived from those found at ancient digs in Rome. Popular Neoclassical form.

Pediment On larger case pieces, the crowning top that replicates architectural projections on classical buildings in the shape of a triangle or in some type of arch.

Pembroke table Variant of the drop-leaf table, usually with four

square legs and drop leaves that are wider than the center section. Sometimes called a breakfast table, it was popular in the Chippendale and Federal styles.

Piecrust table A tripod table in the shape of a piecrust with a circular top and scalloped edges. Also labeled a tea table in the eighteenth century.

Pier table Form originally built to stand against a pier or wall between two windows. This form reached its height of popularity in the nineteenth century.

Pilgrim Seventeenth-century furniture with sturdy rectilinear forms, mortise-and-tenon construction, and turned and carved members. Influenced by medieval and Renaissance-inspired forms of Anglo-Flemish origin.

Pillar and Scroll Last stage of Neoclassicism in nineteenth-century furniture forms, characterized by simple, square section components in the shape of pillars and scrolls.

Provenance Written or oral history associated with an antique object.

Queen Anne Late Baroque colonial furniture dating from 1725 to 1755 and characterized by the S-curve as well as strong architectural underpinnings.

Rail Horizontal piece of wood that joins vertical members.

Reeding Carved repetitive vertical convex ornament.

Renaissance Revival Large-scale nineteenth-century style that loosely adapted Renaissance architectural forms and ornament, often mixing them with other mid-nineteenth-century revivals.

Restauration Simplified version of French Empire style favoring broad, plain veneers and simple scrolled shapes cut with band saws. Also known as Pillar and Scroll style, it marks the last stage of Neoclassicism, from 1830 to 1840.

Rococo Style originating in France, also called the modern French taste, it was one component of the Chippendale style in England and America. It is marked by free-form organic ornament and curvilinear shapes.

Rococo Revival Style of the mid-nineteenth century that evocatively recalled some of the curvaceous forms and organic ornament of the original eighteenth-century style. Proportions are notably larger than those of the original Rococo. Foremost advocate was John Henry Belter.

Rose-headed nails Hand-forged nails made during eighteenth century. The name derives from the rose shape of the hammered nails.

Saber leg Leg shape found commonly on the *klismos* form and having inward-curving elements that form a graceful S-shaped profile.

Scroll-back chair Period label for the Greek *klismos*.

Scroll foot Also known as a whorl foot, rolled-up shape found on high-style Chippendale chair legs as an alternative to the claw-and-

ball foot. Label also used alternately to describe the William and Mary, Spanish, or paintbrush foot popular on early Baroque designs of the early eighteenth century.

Serpentine A popular choice for Chippendale case pieces, this opposite of the oxbow curve moves in, out, and in across the surface.

Settee Small sofa with arms and back.

Settle Wooden bench with a high back and arms formed from boards and often used in front of fireplaces and as informal room dividers. Primarily an object of the Pilgrim era, with later revivals, especially in the Arts and Crafts style.

Shield-back chair Chair with a shield-shaped back commonly found in the Federal style. Called a vase back if the shield was pointed and an urn back if the shield was rounded.

Sideboard Dating from the Federal period, a low, wide cabinet with drawers or compartments on legs. Used against a wall or in an alcove of the dining room to display and serve food.

Trestle table A board-top table that is permanently placed on trestles or horses.

Tufting A method of sewing buttons through upholstery to secure it. Used primarily in the nineteenth century, espeically with the plump seating forms of the revival styles.

Wooton desk Patented desk that hinged open to create a large work area. When closed, many of these massive desks had Renaissance Revival features imposed on walnut bodies, with exotic panels and carving.

\mathcal{I}NDEX

ABOUT THE AUTHOR

Born in Charleston, South Carolina, Patricia Petraglia is a graduate of New York University and a former investment professional. She trained in the fine and decorative arts at the Parsons School of Design and at Sotheby's American Arts Program. Patricia has worked with individual collectors and with institutions. The author of numerous works on the museum and auction scene, fine arts, and American furniture, she lives in Dover, Massachusetts, where she presently is refurbishing an early nineteenth-century home.